LONDON

GERALD & MARC HOBERMAN

LONDON
GERALD & MARC HOBERMAN

PHOTOGRAPHS IN CELEBRATION OF LONDON
AT THE DAWN OF THE NEW MILLENNIUM

TEXT BY JOHN ANDREW

UNA PRESS, INC.
in association with
THE GERALD & MARC HOBERMAN COLLECTION
CAPE TOWN • LONDON • NEW YORK

To my sister, Cecile, my lure to London,
with esteem and lifelong affection.

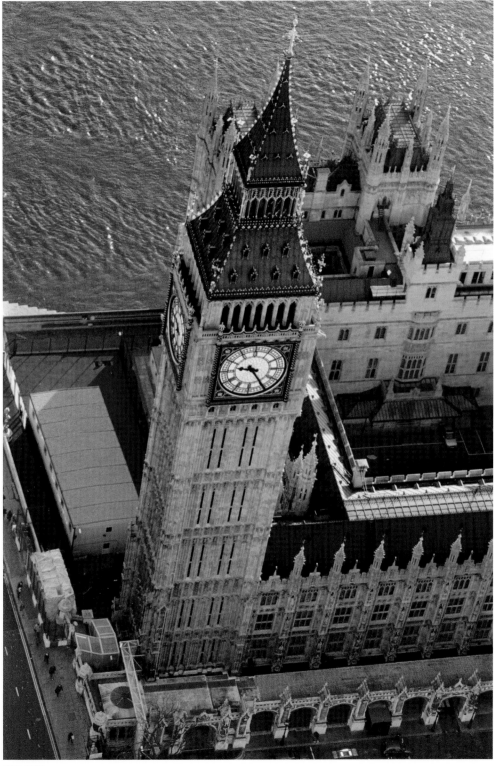

BIG BEN

CONTENTS

Concept, photography, design and production control: Gerald & Marc Hoberman
Reproduction: Marc Hoberman
Text: John Andrew
Editor: Roelien Theron
Indexer: Sandie Vahl
Cartographer: Peter Slingsby

www.hobermancollection.com

ISBN 0-9729822-5-6 / 978-097298225-2

London is published by The Gerald & Marc Hoberman Collection (Pty) Ltd
Reg. No. 99/00167/07. PO Box 60044, Victoria Junction, 8005, Cape Town, South Africa
Telephone: +27 (0)21 419 6657/419 2210 Fax: +27 (0)21 425 4410 e-mail: office@hobermancollection.com

International marketing, corporate sales and picture library

United Kingdom, Republic of Ireland, Europe
Hoberman Collection UK
250 Kings Road, London, SW3 5UE
Telephone: 0207 352 1315 Fax: 0207 795 1655
e-mail: uksales@hobermancollection.com

United States of America, Canada, Asia
Hoberman Collection USA, Inc. / Una Press, Inc.
PO Box 880206, Boca Raton, FL 33488, USA
Telephone: (561) 542 1141
e-mail: hobcolus@bellsouth.net

For copies of this book printed with your company's logo and corporate message contact
The Gerald & Marc Hoberman Collection. For international requests contact Hoberman Collection UK.

Agents and distributors

London
DJ Segrue Ltd
7c Bourne Road
Bushey, Hertfordshire
WD23 3NH
Tel: (0)7976 273 225
Fax: (0)20 8421 9577
e-mail: sales@djsegrue.co.uk

United Kingdom, Europe and Far East
John Rule Sales & Marketing
40 Voltaire Road,
London SW4 6DH
Tel: 020 7498 0115
email: johnrule@johnrule.co.uk

United States of America, Canada
Perseus Distribution
387 Park Avenue South
New York
NY 10016
Tel: (212) 340 8100
Fax: (212) 340 8195

South Africa
Hoberman Collection
6 Victoria Junction
Prestwich Street, Green Point
Tel: +27 (0)21 419 6657
Fax: +27 (0)21 425 4410
e-mail: office@hobermancollection.com

Namibia
Projects & Promotions cc
PO Box 656
Omaruru
Tel: +264 64 571 376
Fax: +264 64 571 379
e-mail: proprom@iafrica.com.na

Printed in Singapore

ACKNOWLEDGEMENTS

John Andrew combines a career in banking in London with writing. A Freeman of the City of London, he has lived in West London for over 20 years. John is a regular contributor to *The Independent* and *The Scotsman*, and in 1996 he was awarded the title Regional Personal Financial Journalist of the Year for his regular columns in the Scottish press. His writing, like his interests, are diverse. His features embrace antiques, travel, numismatics and personal finance and his regular columns on coins appear in publications in the United States, Switzerland and the United Kingdom. John's published books include a volume on Fabergé and one on coins as well as several on personal finance. John and I met in 1982 through our mutual interest in coins and our activities as contributors to various numismatic publications. We have remained friends ever since. John's passion for London, his incisive journalistic style and his standards of excellence have been an invaluable contribution to the book. For this I am most grateful.

In addition, I want to thank the many individuals and organisations, listed below, who have generously shared their knowledge of London and its traditions or arranged photographic shoots in order to make this volume possible. Special thanks are also due to Douglas H. Saville of Spink & Son Ltd for suggesting a book on London on seeing my book on Cape Town, and to Siân Snelling for her useful suggestions as the text progressed.

GERALD HOBERMAN

INDIVIDUALS

Sergeant-Major Appleby, The Royal Hospital, Chelsea
Dickie Arbiter, Director of Media Affairs, Buckingham Palace
Lord Archer of Weston-Super-Mare
Ruth Blum, London Borough of Camden
Christine Brandt, Royal Botanic Gardens, Kew
Milly Broughton, Joseph E. Seagram & Sons, Inc.
Drill Sergeant Brown, Horse Guards, Whitehall
Donald Buttress, Surveyor of the Fabric of Westminster Abbey
Captain D.W. Creswell, BBCM PSM, Royal Military School of Music, Kneller Hall
Timothy H.S. Duke, Chester Herald, The College of Arms
James Dunseath, The London International Financial Futures and Options Exchange
B.C. Edwards, Managing Director, Mullins & Westley
Martin FitzPatrick, The Royal Borough of Kensington and Chelsea
Masami Fujimoto, Embassy of Japan, London
Lieutenant Gale, Assistant Regional Naval Officer for London
Debbie Garrity, Ye Olde Cheshire Cheese
Suhana Gibson, Chalk Farm Gallery
Lieutenant Colonel S.V. Gilbart-Denham, CVO, Crown Equerry, Buckingham Palace

Paul Gill, British Airways London Eye Ltd.
P.L. Gwynn-Jones, Garter Principal King of Arms, The College of Arms
Lucia Hadjiconstanti, City of Westminster Council
Roger Harrison, Eurostar (UK) Ltd.
Peter Howard, Architect for the redevelopment of the Criterion Building
Mark Hudson, Stanfords
R.H. ('Chips') Jaggard, Chelsea Pensioner
Louise King, South Bank Management Services, Oxo Tower Wharf
Barry Klein, Taylor of Old Bond Street
George Kyriacou
John Hunter Lobb, Chairman and Managing Director, John Lobb Ltd.
Victoria Lowry, Fortnum & Mason
Sarah Millar, Regent Street Association
Richard Naylor, More O'Ferrall
Alderman Richard Nichols, Lord Mayor of London
Julian Owen, Court Manager, Central Criminal Court
Miles Pargiter, Covent Garden Area Trust
John Ray Parker, James Lock & Co. Ltd.
Colonel Christopher Pickup, OBE, Secretary, The Royal Warrant Holders Association
Michael Ragg, Berry Bros. & Rudd
Chris Reeves, Manager, Prospect of Whitby
Christine Reynolds, Library, Westminster Abbey
John Sinkins, Wildy & Sons

Kenneth Sparks, Taxi driver No. 22529
Jonathan Spencer, MVO, Secretary, Lord Chamberlain's Office, Buckingham Palace
Tom Stapleton, Fox & Anchor
Keith Stevens, Managing Director, The Traditional Victorian Shoeshine Company Ltd.
Georgina Sullivan, The Ritz
Colonel (retired) J.W.S. Trelawny, OBE, Horse Guards, Whitehall
Mr S.H.G. Twining, LVO, OBE
Bettina Vinson, Spink & Son Ltd.
Lora Walsh, Corporation of London
Clare Wilkinson, Hampton Court Palace
Peter Willasey, Harrods Ltd.

INSTITUTIONS and COMPANIES

Abbey National plc
Apollo Leisure Group, Owners of The Lyceum Theatre
Bank of England
British Waterways
BT plc
Business Data Base, Yellow Pages
The Campaign for Real Ale
Canary Wharf Ltd.
Canary Wharf Tourist Information Centre
The Clerk, The Worshipful Company of Cutlers
Coopers & Lybrand
Docklands Light Rail
Docklands Tourist Information Centre
Environment Agency
Floris

Free Form Arts Trust
Granny Woods' Research Bureau
Guards Museum, Wellington Barracks
Guildhall Library
Liberty plc
Library, House of Commons, Palace of Westminster
Library, House of Lords, Palace of Westminster
Licensed Taxi Driver's Association
Lloyd's of London
London Underground Ltd.
London Wildlife Trust
Metropolitan Police
The Museum of London
The Natural History Museum
The New Millennium Experience Company Ltd.
Paxton & Whitfield
Peretti Communications Ltd. for the Oxo Tower Restaurant and Brassiere
Portobello Road Antique Dealers Association
Public Carriage Office
Railtrack plc
The Royal Albert Hall
The Royal Mews, Buckingham Palace
Rules Restaurant
The Thames Barrier Visitors Centre
Thomas Pink
Tower Bridge
The Tower of London
The Wig & Pen Club

LONDON

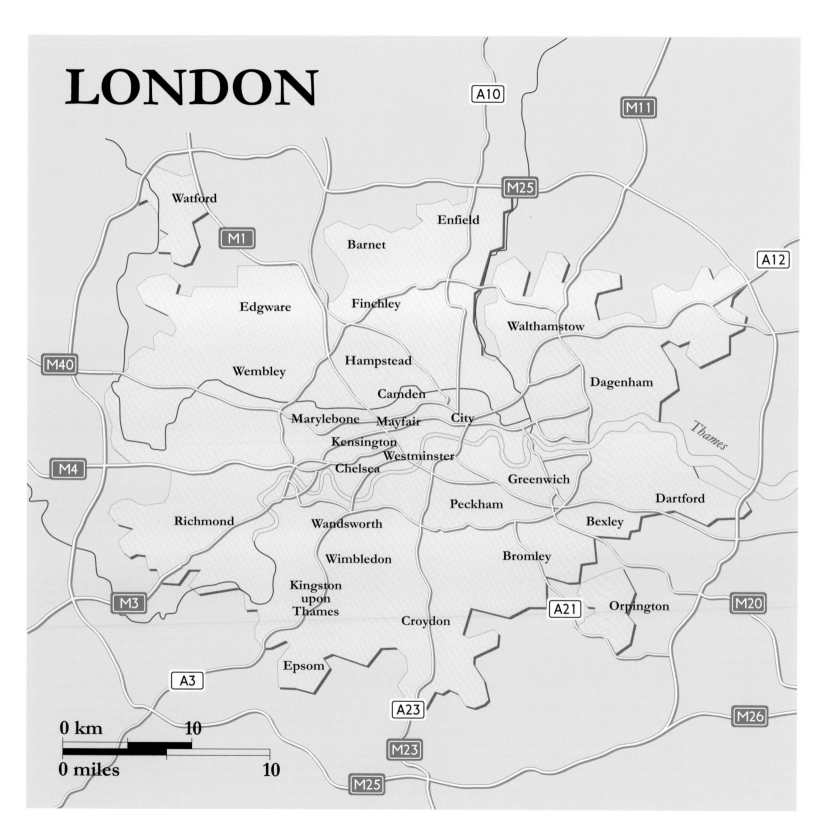

Watford

M1

Barnet

Enfield

A10

M11

M25

Edgware

Finchley

A12

Walthamstow

Wembley

Hampstead

Dagenham

Camden

M40

Marylebone Mayfair City

Kensington

Westminster *Thames*

Chelsea

M4

Greenwich

Peckham

Dartford

Richmond

Wandsworth

Bexley

Wimbledon

Bromley

Kingston
upon
Thames

M3

A21 Orpington M20

Croydon

Epsom

A3

A23

M23

M26

M25

0 km 10

0 miles 10

N

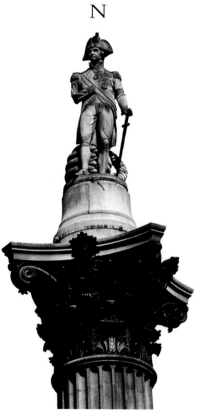

FOREWORD

BY JOHN SUCHET

Author and award-winning television journalist and newscaster

Gerald Hoberman photographs things he loves. He's travelled to some of the world's most exotic and inaccessible places to record them; he's waited interminable hours to capture a wild and beautiful creature in its habitat. His photographs of his home town, Cape Town, show it to be one of the most naturally beautiful urban settings in the world. This book of London has opened my eyes to the beauty of the city in which I was born and bred.

Gerald Hoberman loves London – it shines through in this book. London is a city like no other. Turn the map of Europe a half turn to the right, and you will see how Britain sits balanced on the continent of Europe, threatening to overbalance and fall in, but never quite doing so. It remains free – to absorb all it wants from Europe, yet to develop its own unique culture. That is the essence of Britain's capital city: it absorbs all cultures, yet it remains the London all Londoners can recognise.

Then look at Gerald Hoberman's pictures, and you will see why London is more of a melting pot than New York, more exotic than Buenos Aires, more exciting than Los Angeles, more frenetic than Tokyo, and yes, more romantic than Paris.

A typical Londoner, I have passed the Houses of Parliament, Westminster Abbey and Big Ben a thousand times, but I have never actually seen them. Gerald's photographs seem almost to penetrate the stone.

Traditional London is here. Rules Restaurant in Covent Garden, where Edward VII met clandestinely with his mistress Lily Langtry, is represented. Young London is here. Look at the students outside Buckingham Palace, a photograph that sums up the meaning of 'culture clash'.

The faces of London are here. The street trader's face – set, defiant, indomitable. No wonder the East End survived the Blitz! Look at the faces of the Pearly King, Queen and Princess. If you spoke to them, they'd probably answer in Cockney rhyming slang ... by looking at their faces you can almost hear their voices.

Punks with Mohican hairstyles are here too – one can imagine the Romans 2000 years ago looking at their Celtic forebears with dread. Regal London as well as everyday London are featured – what Londoner hasn't seen the dreaded figure of a traffic warden crouched over his or her car writing out a ticket?

I learned from the book too. To the writer, John Andrew, thank you for telling me the origin of the name Rotten Row, and that the Globe – my local – is so named because it meant Portuguese wines were available, the globe being the emblem of the King of Portugal. I shall never pass St Paul's Cathedral again without thinking of the frustrations poor Christopher Wren had while building it, or Cleopatra's Needle without remembering that placed in its foundations are the photographs of 12 beautiful women.

In my travels as a television news correspondent, I grew used to being asked what London was like. How can you describe a city that has been at the centre of world events for 2000 years?

Far better to linger over Gerald Hoberman's photographs – from palaces to pubs, broad avenues to back streets, soldiers to street traders – and to thank him for recording so many facets of the world's greatest city.

JOHN SUCHET
London

INTRODUCTION

My maternal grandparents were Londoners who emigrated to South Africa just before the end of the 19th century. Sarah, my grandmother, was in her early twenties when she arrived in Cape Town. Although she lived happily there for more than seventy years, until the day she died, she always referred to London as home!

My association with London is both long and ongoing. Although I am a Capetonian – born and bred – I regard Britain's capital as my second home. Since my early teens I have visited relatives in London each year and in the 1970s I studied photography there under the direction of Ted Harrison, then of Studio Briggs. Later I ran a colour processing laboratory and studio near trendy Carnaby Street. Richard, my eldest son can claim to be a Londoner, for it was during this period that he was born there.

During the Opec oil crisis in the early 1970s I was lured back to Cape Town to become a managing director of a bulk coal distribution company with family connections spanning four generations. However, I took early retirement in order to pursue my lifelong passion for photography full time, as well as to publish my work.

London, a major capital at the crossroads of the world, is ever-vibrant with a constantly changing ebb and flow. The city is the enviable quintessence of proud tradition and style and is at the cutting edge of modernity. Quaint customs from a past age and the world's best pageantry dovetail into the hustle and bustle of everyday life in the 21st century, giving London its unique dimension.

It is of course not possible to include every facet of London in any one book. It is a special privilege, however, to be able to share my selection of London's attributes and optimism with others through the medium of photography. It is a record for posterity of a great city and its people at the dawn of the new millennium.

Gerald Hoberman

GERALD HOBERMAN
Cape Town

'LONDON IS THE EPITOME OF OUR TIMES, AND THE ROME OF TO-DAY.'

RALPH WALDO EMERSON, 1803–1882

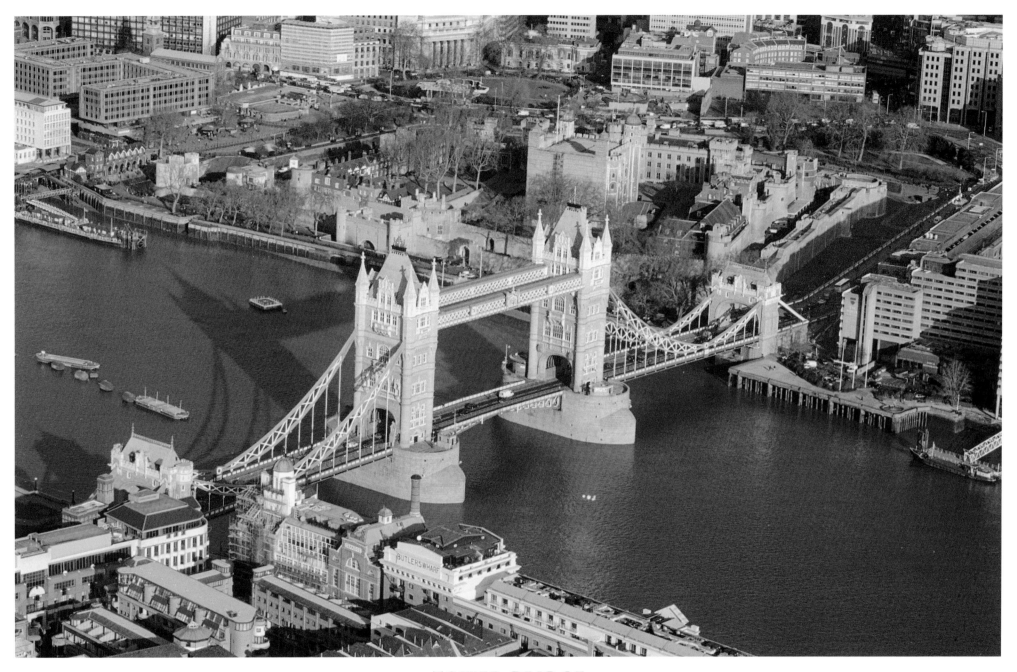

TOWER BRIDGE

Opened in 1894, this is London's best-known bridge. With the 787-feet (240m) roadway between the two towers raised, there is a clear width of about 197 feet (60m) and headroom of some 131 feet (40m) through which vessels may pass. It is a superb example of the Victorians' skill in combining engineering and architecture. Although the bridge was built in the neo-Gothic style to blend with the nearby Tower of London, its engineers did not use traditional construction methods. The towers, which conceal the machinery for raising the bridge, consist of metal frameworks clad with stone. Although this was initially severely criticised, today the bridge is regarded with considerable affection by Londoners and visitors alike.

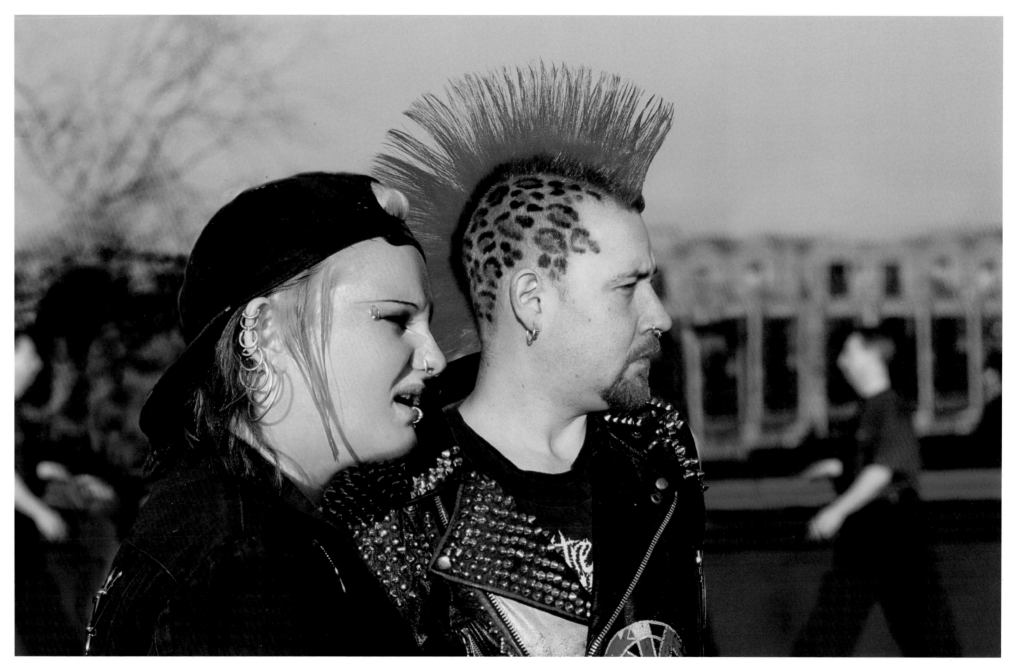

PUNK WITH MOHICAN HAIRSTYLE

There are nearly 700 hairdressers in central London and thousands more in outer London and the suburbs. Among the more amusing trading names are: Brush and Clippers; City Snippers; Crazy Curl; Crops and Bobbers; Hair 2 Day; Hair We Do; Making Waves; Mane Line; Snipping Image; Spend Loads Please; Toffs and Tarts; and Scissors Palace. Where Punks have their hair styled is unknown. However, it is unlikely to have been at Truefitt and Hill, the oldest established barbers in the United Kingdom. Located in the heart of London, the company has been hairdressers to royalty since 1805 and is currently entrusted with cutting the Duke of Edinburgh's locks.

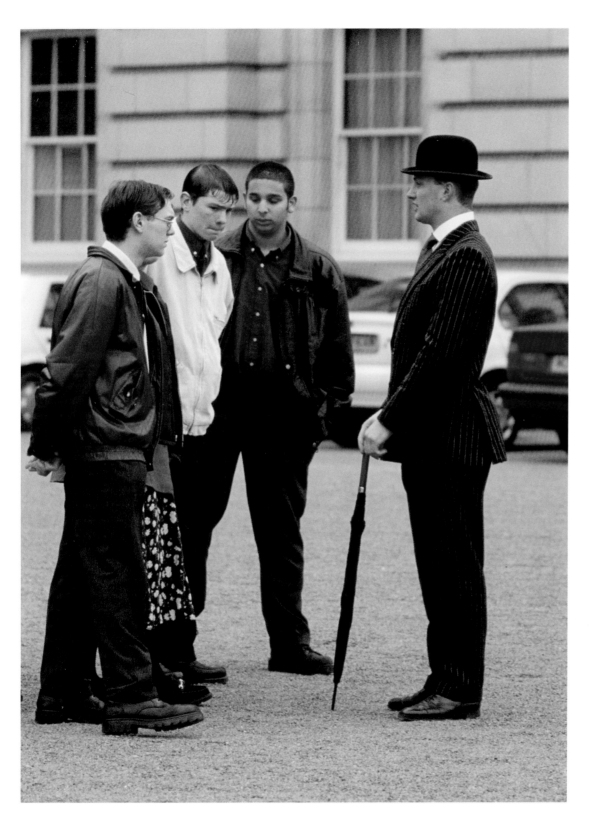

STUDENTS AND
A GUARDS OFFICER

It is not just dignitaries who are invited to London's most famous address – Buckingham Palace. A Guards officer – looking quite the City gent from another era with his pinstriped suit, bowler hat and rolled umbrella – explains the Changing of the Guard to a group of students visiting the palace.

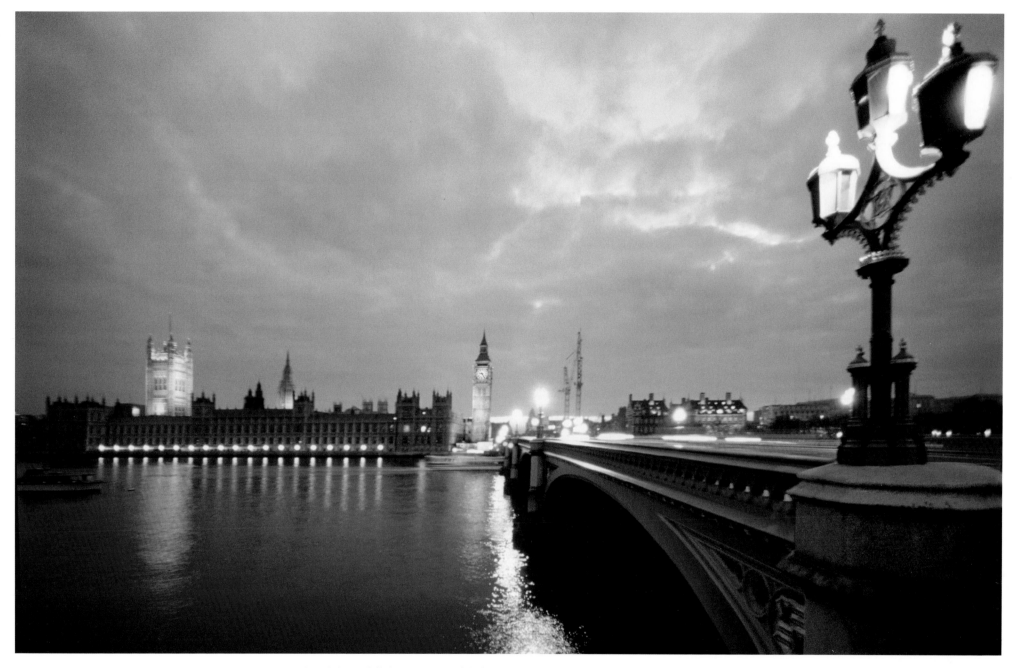

ALL-NIGHT SITTINGS AT THE PALACE OF WESTMINSTER

At the conclusion of each day, the Speaker leaves the chair and the corridors echo with the cry, 'Who goes home?'. At that moment the light inside the lantern of the Clock Tower, which always burns when Parliament is sitting during the hours of darkness, is extinguished. Although all-night assemblies are now rare, this has not always been the case. The record for the longest one was the occasion of the debate on the Protection of Person and Property (Ireland) Bill in 1881 – it lasted 41.5 hours. In more recent times, between 1979 and 1988, there were seven occasions when sittings extended beyond 24 hours.

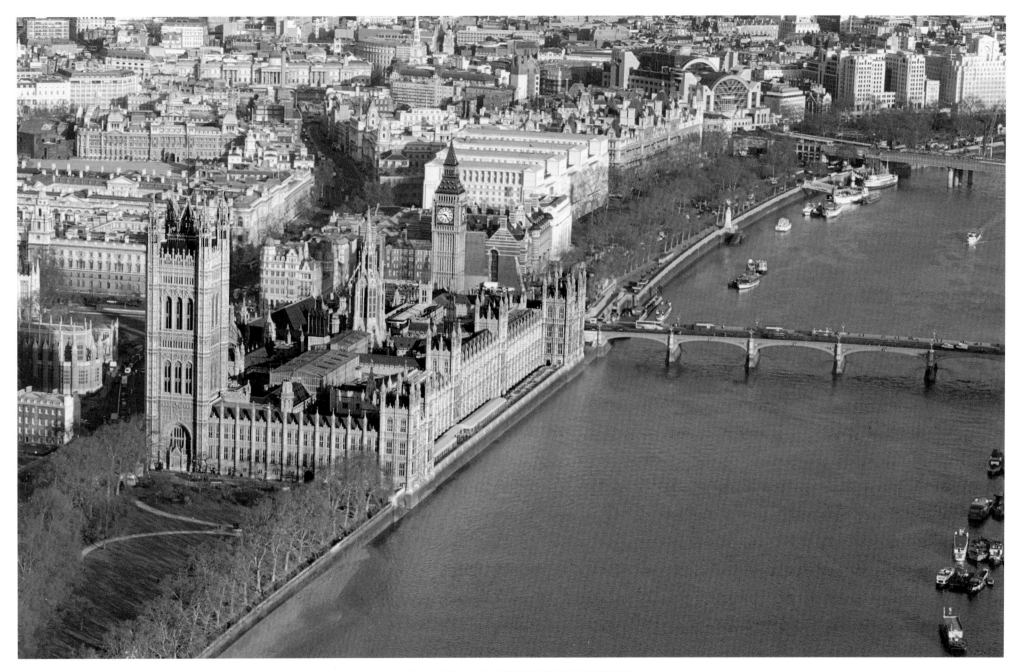

PALACE OF WESTMINSTER

Steeped in history and traditions, the seat of the legislative body of the United Kingdom has an imposing 800-feet (244m) frontage on the banks of the Thames River. The complex now contains 1100 rooms, 100 staircases and about 2.8 miles (4.5km) of passageways. The palace was virtually destroyed by fire in 1834. In 1840 the architect Sir Charles Barry, assisted by Augustus Pugin, was responsible for designing the present complex in the Gothic style. The medieval Westminster Hall (dating from 1097), the cloisters and the crypt of St Stephen's Chapel were retained. Following Guy Fawkes's attempt to blow up Parliament in 1605, the Yeomen of the Guard still check the cellars before any State Opening of Parliament.

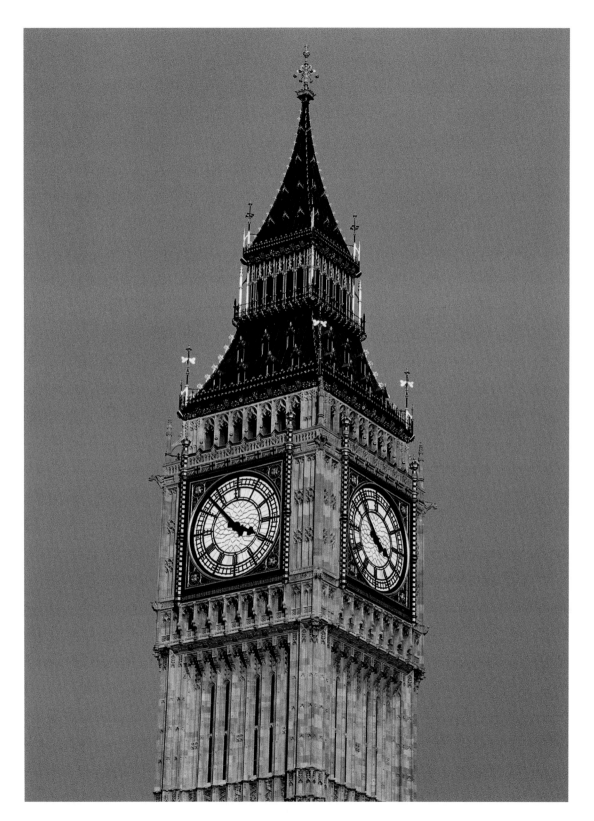

CLOCK TOWER, PALACE OF WESTMINSTER

It is the world's best-known clock and one of its most famous landmarks. Globally it is an instantly recognisable symbol of London, England and the British. Although the structure is affectionately known as Big Ben, this is in fact the name of its great hour bell.

As Big Ben booms over London, it is inconceivable that it had a very troublesome start to life. The first bell was cast in 1856 and hung on gallows at Westminster for daily testing. This was fortuitous, for in October the bell cracked. The replacement was cast in April 1858. It was officially named Victoria, after the Queen, but inscribed with the name Sir Benjamin Hall, the Commissioner of Works. With a diameter of 9 feet (2.7m), a height of 7 feet (2.2m) and a weight of 13 tons (13,720kg), the public no doubt felt that Victoria was too delicate a name for the bell. As Sir Benjamin was of generous proportions, it became known as Big Ben.

The mouth of the new bell was too wide for the shaft of the tower, so it was turned on its side and winched up in a cradle. Although the new bell was lighter than the original one, it took teams of men 30 hours to raise it. When the clock became operational in July 1859, people complained that it was too loud. Two months later Big Ben cracked and for three years it was silent. It chimed again in 1862 after it had been turned a quarter, a square had been cut to prevent further cracking, and the weight of its hammer had been reduced. It has been trouble-free ever since.

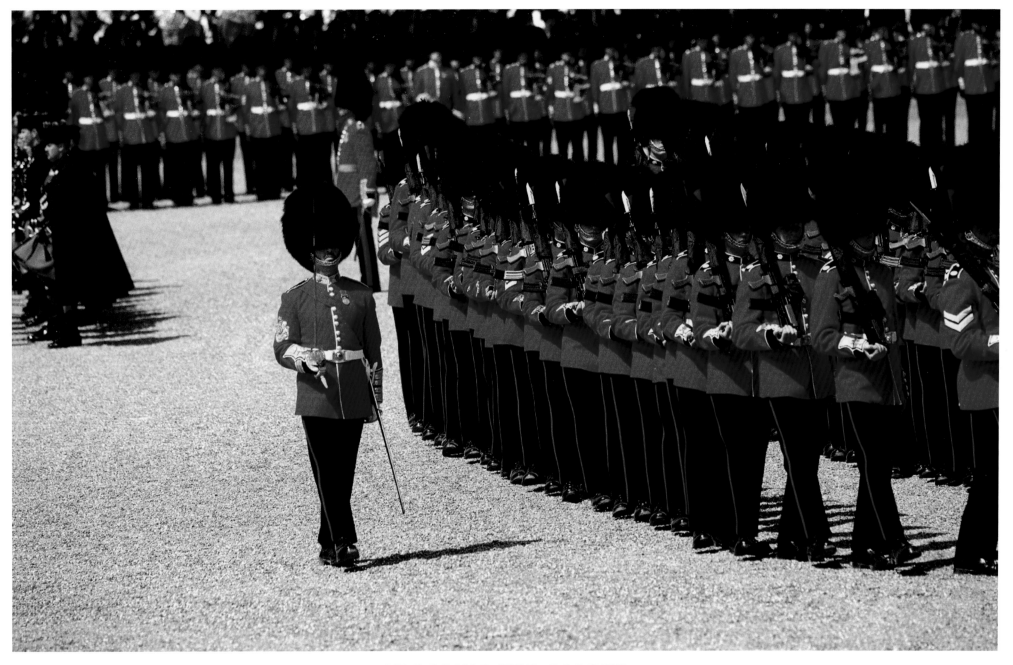

TROOPING THE COLOUR

This is pageantry at its best. It dates from the days of land warfare, when the flags (colours) of the battalions were carried (trooped) down the ranks so that they could be recognised by the soldiers. Since the mid-18th century the ceremony has marked the sovereign's official birthday. The Queen is greeted by a royal salute and undertakes an inspection of her troops. The ceremony includes massed bands, the trooping of the colours and a march past. Her Majesty then rides ahead of her Guards before taking the salute from a dias at Buckingham Palace. The two-hour ceremony ends with a Royal Air Force fly-past.

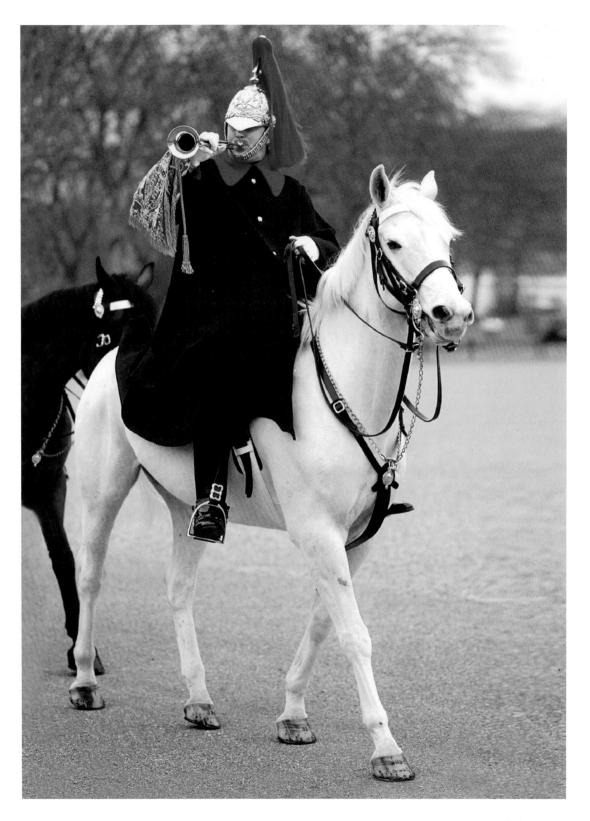

TRUMPETER OF THE HOUSEHOLD CAVALRY

There are two regiments of Household Cavalry. The Blues and Royals wear blue tunics and have a red helmet plume. This regiment was formed in 1969 from the amalgamation of two existing regiments. The Blues were formed by Cromwell in 1650 and became King's troops in 1661, the same year that Charles II created the Royals.

The Life Guards wear red tunics and have a white helmet plume. This is the senior regiment of the British Army and is descended from a Company of Horse which was formed in 1659 as a bodyguard for King Charles II during his exile in Flanders.

Traditionally the trumpet is a 'royal' instrument. As in the past, trumpet fanfares are used to herald royal processions and entrances on state occasions and at ceremonial parades. The trumpeters of the Household Cavalry have a dual role. While in the normal course of their duties they are regular regimental musicians, this changes when the Queen or another member of the royal family is officially present. They are then state musicians who wear state dress.

In addition to the Mounted Regiment, the Life Guards and the Blues and Royals are equipped as Armoured Regiments or Armoured Recce Regiments, which serve both at home and overseas.

They are the only remaining cavalry regiment in today's British Army.

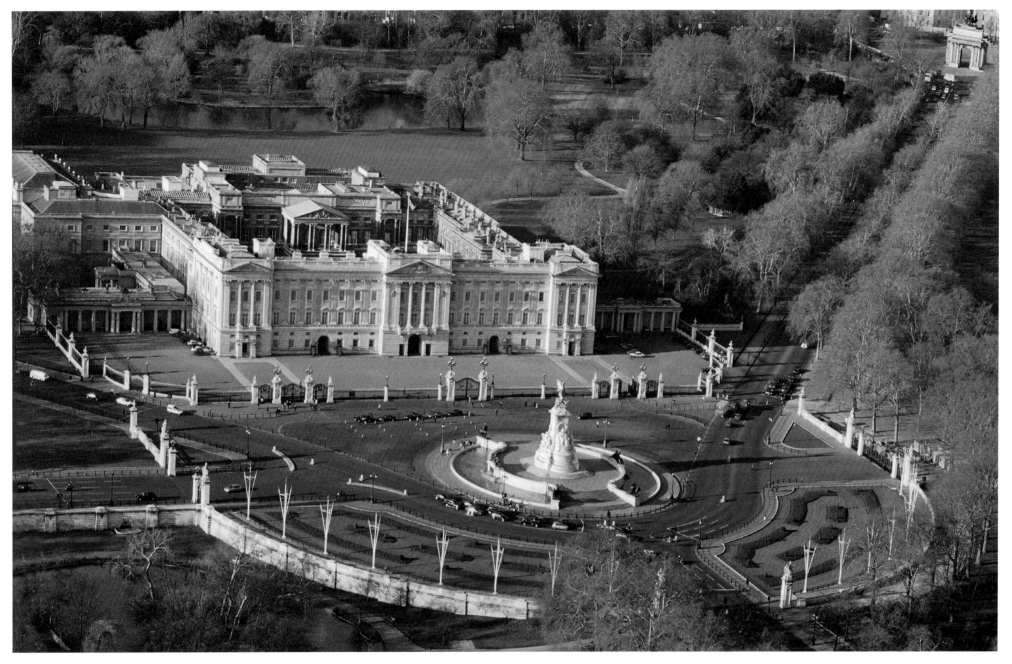

THE GROUNDS, BUCKINGHAM PALACE

Few people realise that Buckingham Palace has grounds of some 45 acres (18.2ha). The lake used to be home to pink flamingos, a gift to the Queen from the Zoological Society of London. Unfortunately they were killed one freezing winter night during the mid-1990s by a fox that walked across the ice to their island quarters. The cunning fox correctly judged the thickness of the ice – in 1841 Prince Albert did not, and he skated to the bottom of the lake instead of on its surface. Each summer the Queen holds three garden parties in the grounds and about 10,000 people are invited to each.

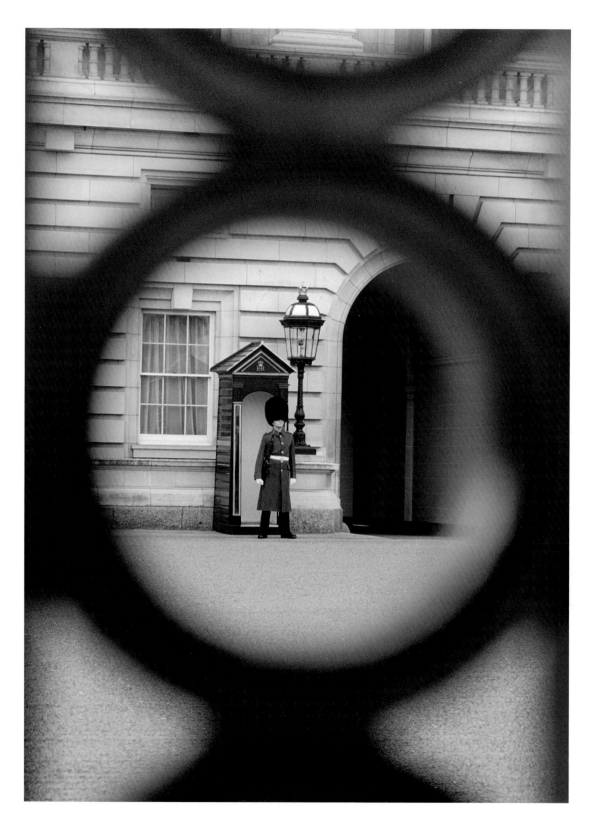

SENTRY ON DUTY, BUCKINGHAM PALACE

The Queen's London home is protected day and night by Her Majesty's Foot Guards. There are five regiments of Foot Guards.

The Grenadier Guards are descendants of the Company of Gentlemen formed in 1656 to protect the exiled Charles II. They are the senior regiment of Foot Guards.

The Coldstream Guards date from 1650 when they were founded as a parliamentary regiment. They played an important part in the restoration of Charles II in 1660 and were recommissioned as Household Troops in 1661.

The Scots Guards were originally raised in 1642 as a Scottish regiment before Scotland joined the United Kingdom. They were reformed in 1660 and incorporated into the English Army in 1686.

The Irish Guards were created under Queen Victoria in 1900 in recognition of the bravery shown by the Irish troops during the South African War of 1899–1902.

The Welsh Guards were formed by King George V in 1915 to complete the Foot Guards' representation of each of the countries of the United Kingdom during the First World War.

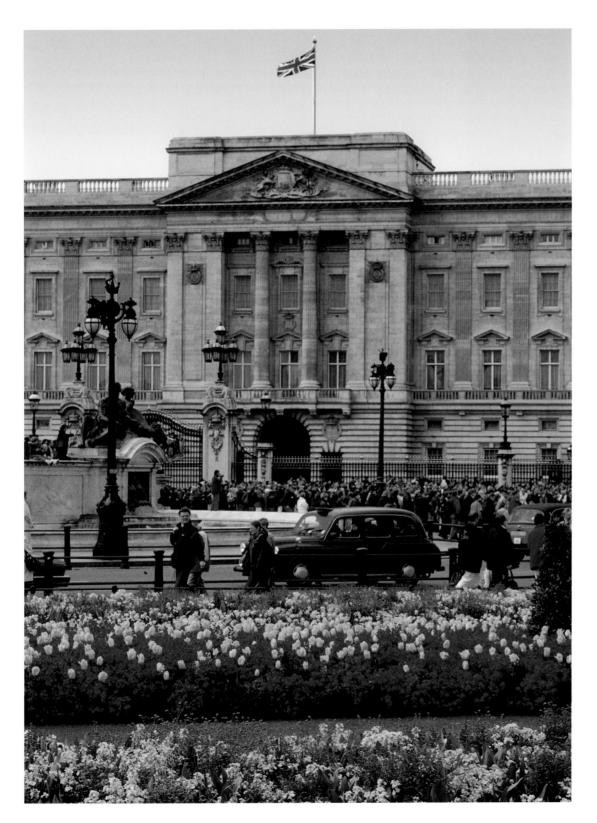

BUCKINGHAM PALACE

Although relatively new compared to other London palaces, Buckingham Palace nevertheless has an interesting history. The land upon which it was built was used by James I for a speculative venture – silk. A manual published in London during 1607 advised that the first step to untold wealth was the breeding of silkworms. Unfortunately, the King failed to note that the worms only favoured white mulberries – he planted the commoner black variety. The mulberry plantation flourished, but there was not a silkworm in sight.

Lord Goring built a mansion on the site in 1633, but it was destroyed by fire some 40 years later. In 1677 the Earl of Arlington had a new house constructed on the property. It was rebuilt by the Duke of Buckingham in the early 18th century. George III acquired the property in 1761 and remodelled it as a villa – known as Queen's House – for the private use of the royal family.

In 1826 George IV decided to convert the property into a palatial residence where he could hold his courts and conduct official business. John Nash was charged with responsibility for the project. Hampered by a shortage of funds, he chose to extend the existing building rather than construct an entirely new palace.

In 1837 the 19-year-old Queen Victoria was the first royal to move in to the new official residence. It was barely habitable: the drains were faulty and some of the 1000 windows would not open. However, by 1843 the Queen had become fond of the palace. It has always been regarded with affection by her descendants, who made further alterations, including adding the present façade in 1913.

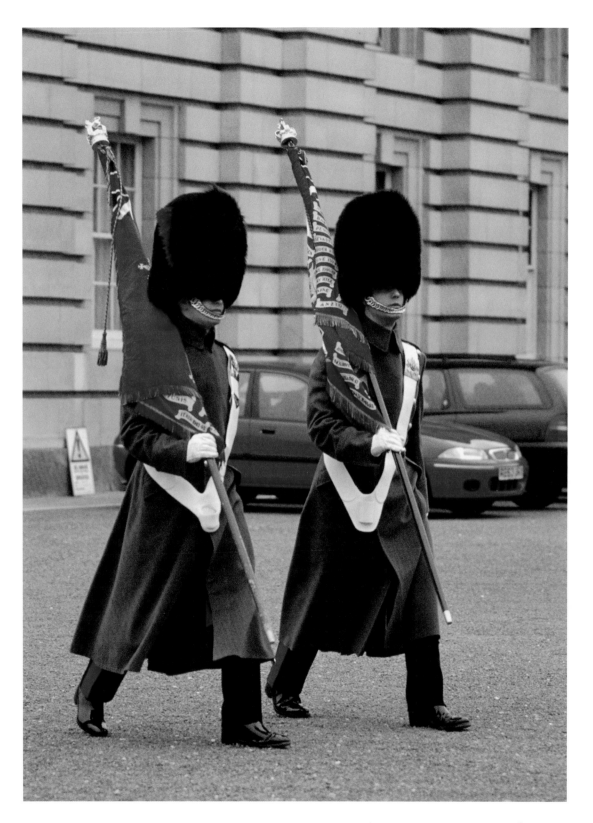

CHANGING THE GUARD
AT BUCKINGHAM PALACE

From the reign of Henry VII (1485–1509) until the Civil War between the Royalists and the Parliamentarians (1642–1649), the Yeoman Warders were responsible for guarding the monarch. Indeed, to this day their full and proper title is 'Yeoman Warder of Her Majesty's Royal Palace and Fortress the Tower of London, also Members of the Queen's Bodyguard of the Yeoman Guard Extraordinary'.

When Charles I fled London in January in 1642, he was not accompanied by the Yeoman Warders; the responsibility of guarding him fell upon his loyal troops. During Charles II's exile in Flanders, he was protected by his Life Guards. After the restoration of the monarchy in 1660, protection of the sovereign became increasingly the duty of the Life Guards and the three original regiments of Foot Guards. Centuries later the Household Division provides the sovereign's personal bodyguard.

Although the Queen has a number of homes, both official and private, it is only at the London palaces – Windsor Castle and Edinburgh Castle – that a Guard is mounted. Buckingham Palace has been the permanent London home of the royal family since 1837, while St James's Palace has remained the centre of the Court. Although the regiments of Foot Guards mount the Queen's Guard in the forecourt of Buckingham Palace, its headquarters are established at nearby St James's Palace where the Colour is lodged.

When marching to and from their barracks, the Queen's Guard is in three main groups: the regimental band with a Corps of Drums; the St James's Palace detachment, including the ensign who carries the Colour; and the Buckingham Palace detachment.

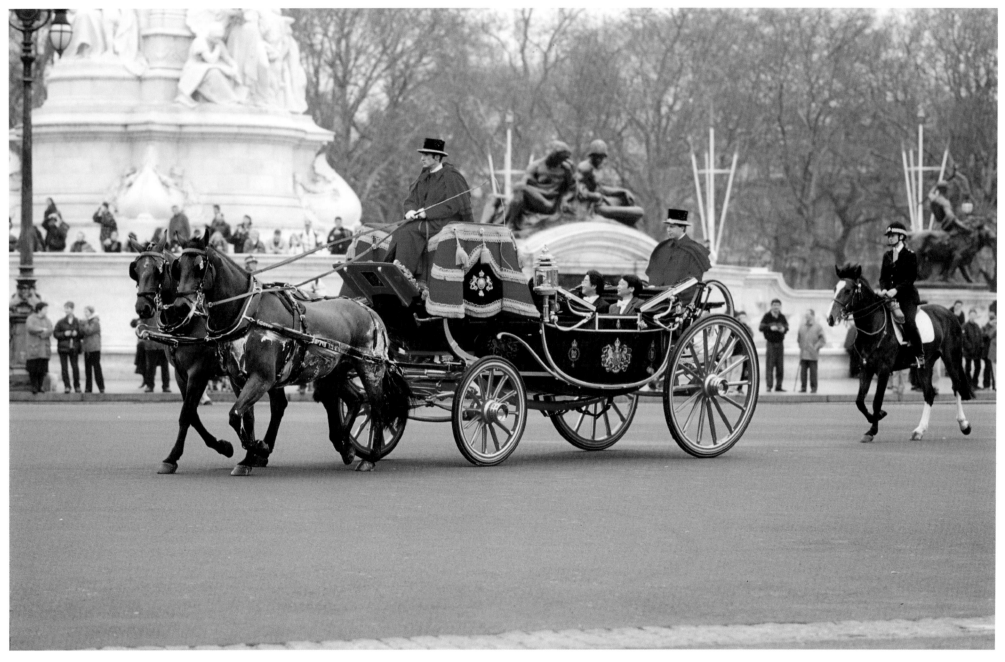

AN AMBASSADOR VISITS BUCKINGHAM PALACE

His Excellency, Sadayuki Hayashi, the newly appointed Japanese ambassador, rides past the Queen Victoria Memorial at the head of the Mall en route to Buckingham Palace to present his letters of credence to the Court of St James. He is accompanied in a state landau by his wife. Traditionally ambassadors are received by the Queen in the Audience Room of the palace. The official title of the royal court remains St James, even though ambassadors have not been received at St James's Palace since the 19th century.

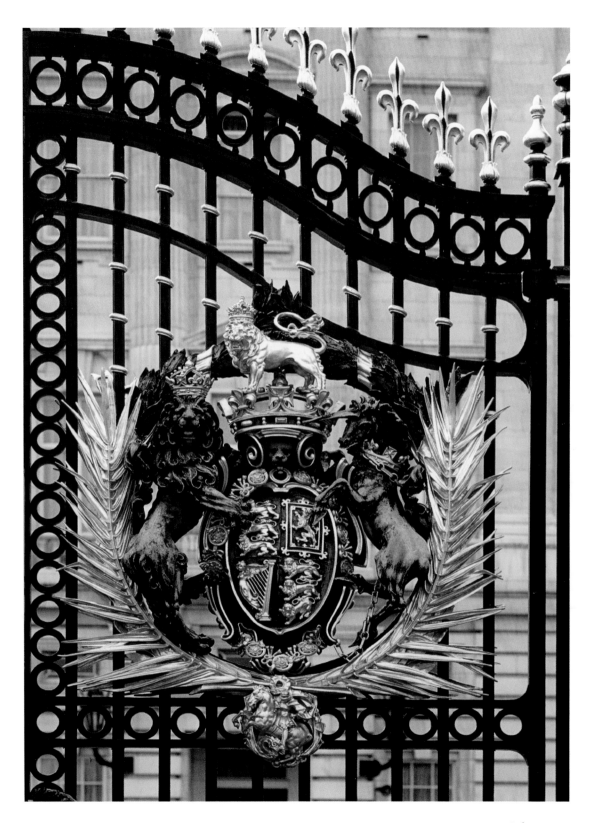

THE GATES OF BUCKINGHAM PALACE

Heraldry originated as a means of identification in the days when the majority of people were illiterate. It was particularly important during medieval warfare as it allowed knights wearing suits of armour to quickly distinguish between friend and foe. Early heraldry was relatively simple, but armorial bearings became more elaborate, especially later when heraldic devices were no longer used as identification in conflicts.

The English Royal Arms were adopted by Richard I (1189–1199). A grand version appears on the gates of Buckingham Palace where the usual Garter Ribbon encircling the shield has been replaced with the Garter Collar and the suspended St George and the Dragon. The two branches of palm have no heraldic significance and are purely decorative.

It is not just around the royal palaces that the Royal Arms are encountered. As emblems of state, they appear on government publications and buildings, in courts of law and are used by the armed forces. Certain shops and the packaging of particular products also feature the Arms, signifying that the service provider or manufacturer holds a royal warrant of appointment. Throughout the ages, the favour of this recognition from the sovereign has been regarded as the ultimate honour and the accolade is still much sought after today.

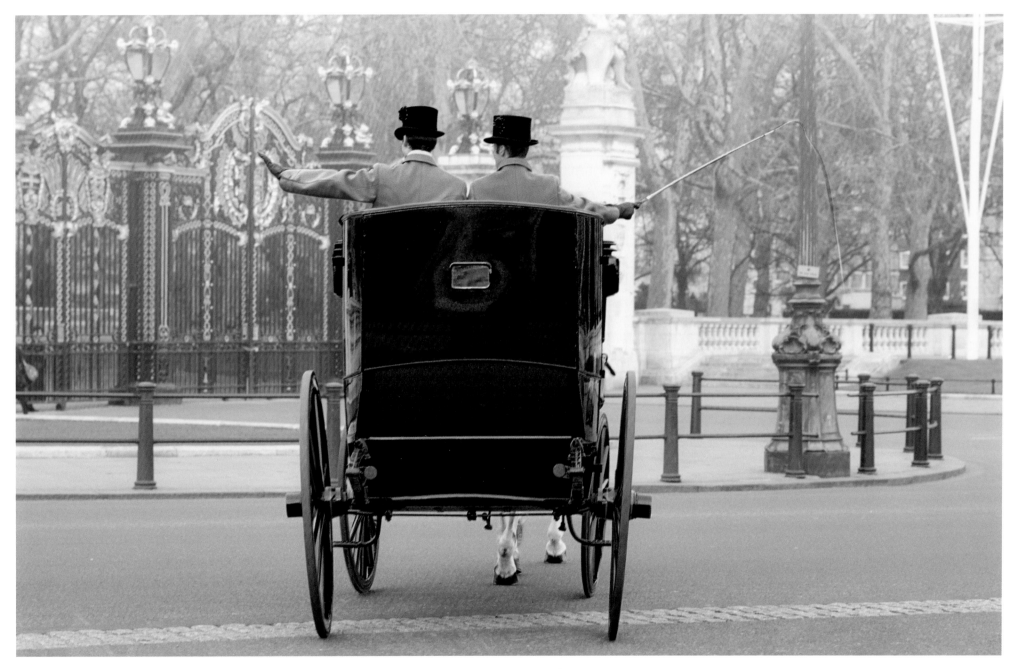

ROYAL MESSENGERS ON THEIR ROUNDS

Today, when commercial couriers speed through the streets of London on motorbikes and cycles, the royal messengers take a far more sedate form of transport – a Brougham. In the days of horse-drawn transport, it was considered the most useful carriage ever invented. The first was imported into England from Paris by Lord Brougham in 1837. Twice daily throughout the year, a Brougham leaves Buckingham Palace carrying messengers on their official rounds.

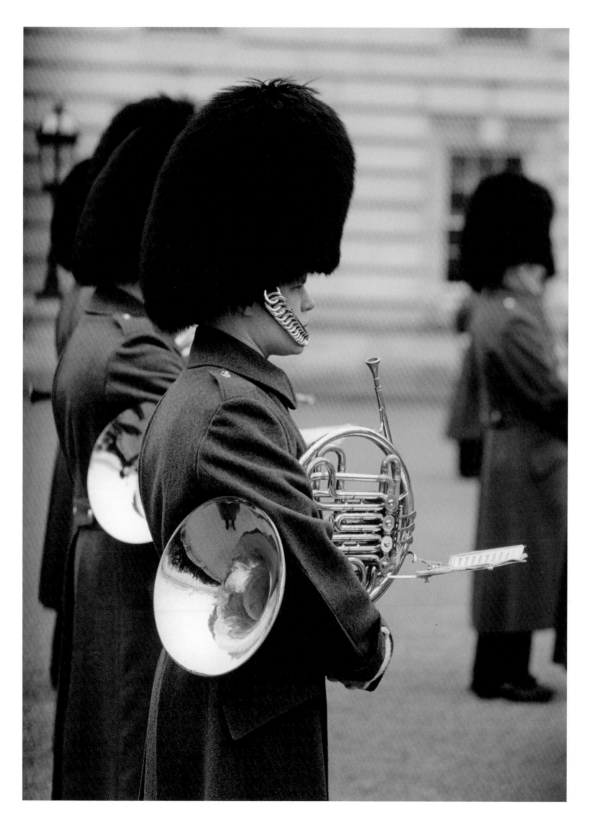

CHANGING THE GUARD
– THE MUSICIANS

The Household Division's five Foot Guards regiments, which provide the sovereign's personal bodyguard, all have bands, each one comprising some 46 highly accomplished musicians. Additionally, each has its Corps of Drums with six to eight drummers and percussionists. While the Coldstream, Grenadier and Welsh Guards also have about a dozen fifers playing their small flute-type instruments, the Irish and Scots Guards have 25 or so pipers instead. These musicians are an integral part of their battalions as opposed to being part of a regimental band. In the past, one of the duties of the Corps of Drums and pipers was to broadcast their commander's orders using a series of set musical phrases. Of course, they also had the role of playing routine calls and tunes. However, as they march along to Buckingham Palace, it is all too easy to forget another function which they served – to raise the spirits of their fellow men as they went into action.

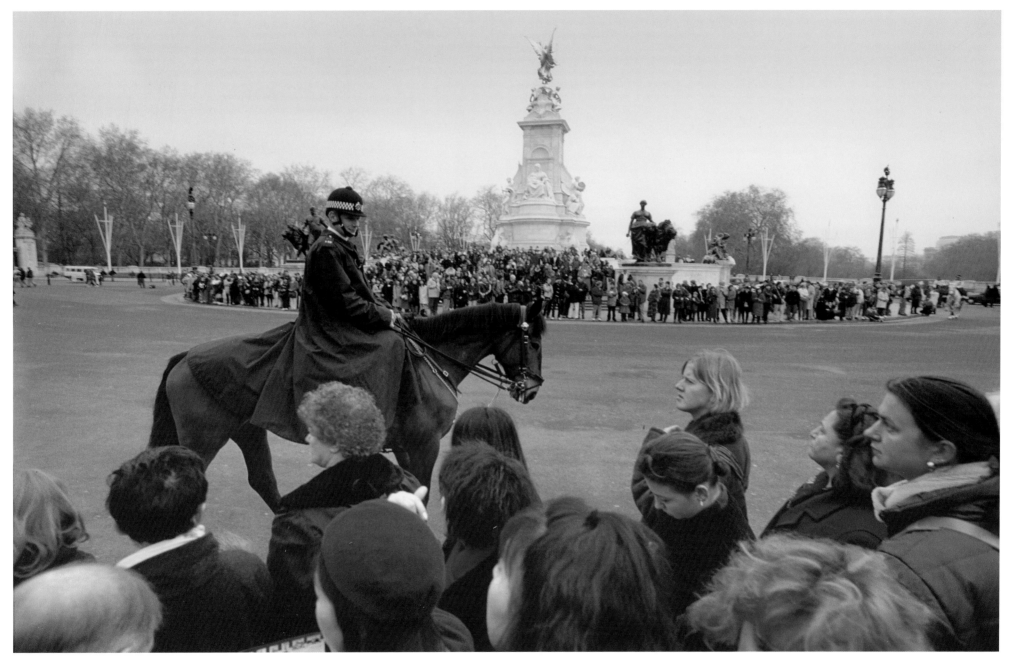

WAITING FOR THE CHANGING OF THE GUARD

The Changing of the Guard at Buckingham Palace is one of the finest regular displays of pageantry in London. However, because the area of the parade is large and the vantage points are few, it is not necessarily ideal for spectators. Crowds therefore begin to form early to watch the spectacle which begins at 11.30am daily in the summer and generally every other day in the winter. The ceremony may be cancelled during adverse weather conditions.

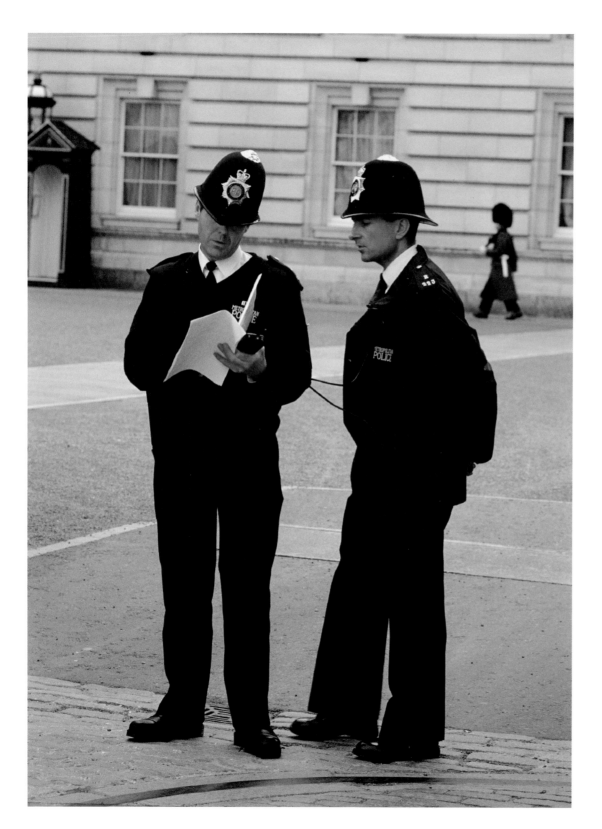

POLICEMEN, BUCKINGHAM PALACE

In 1838, a footman patrolling the corridors of Buckingham Palace discovered a fifteen-year-old youth – one Edward Jones – lurking behind a pillar in the hall. Master Jones was covered in soot and appeared to have made his entrance by creeping down a chimney. Despite the fact that he had damaged a picture and extracted a couple of letters from a desk, the authorities were broadminded enough to treat the episode as a juvenile prank.

It can be no coincidence that the following year the Royal Palaces Division of the Metropolitan Police was formed with responsibility for policing Buckingham Palace, St James's Palace and Windsor Castle. This did not deter Master Jones, for on 2 December 1840 he was discovered skulking under a sofa in Queen Victoria's dressing-room. According to *The Times*, 'The daring intruder was immediately secured, and safely handed over to the custody of the police…'.

Questioned by Privy councillors, it was established that Master Jones had entered the palace by an unfastened window and hidden in an attic for two days. He confessed that, prowling round the palace at night, he had sat on the throne, entered the royal larder and taken a meat pie. While his action was perilously near high treason, the magistrate showed some compassion and sentenced him to a modest three months' oakum-picking and the treadmill in the House of Correction. It did not work – Jones returned to the palace, was caught and after three months' hard labour was drafted into the navy.

Today, the Royalty and Diplomatic Protection Department of the Metropolitan Police is responsible for royal protection.

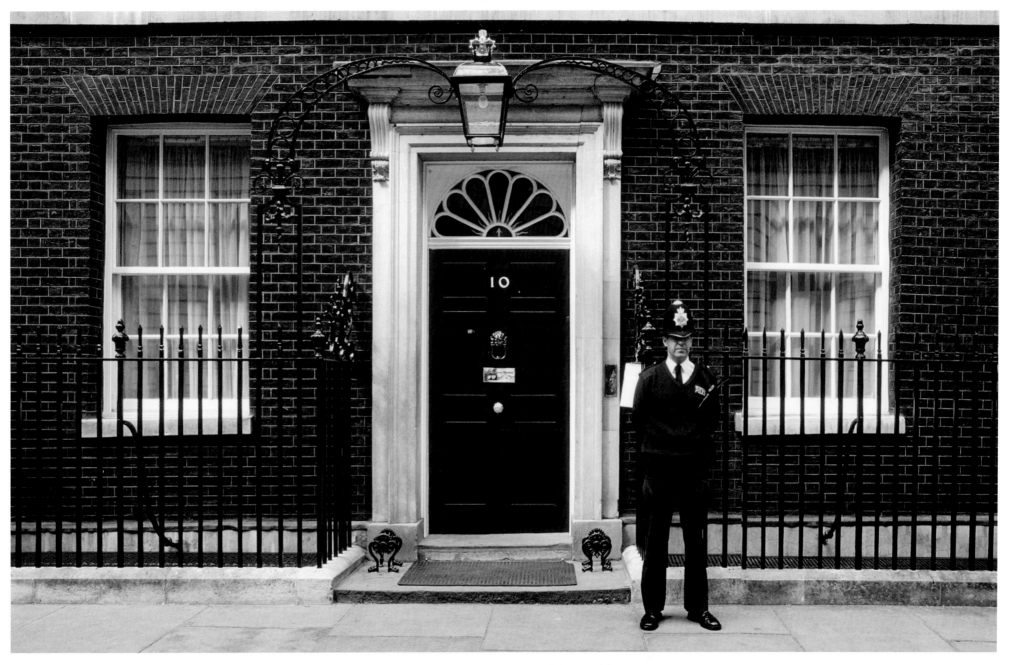

10 DOWNING STREET

The official residence of the prime minister is modest externally, but behind the façade there is a series of state rooms and offices. The building is in fact two houses, for in 1732 George II offered to give his principal minister, Sir Robert Walpole, 10 Downing Street and a house behind overlooking Horse Guards Parade. Walpole refused the personal gift, but asked the King to give the houses to the government as the official residence of the First Lord of the Treasury, a title modern prime ministers still hold. The two houses were linked to create a single large residence before Walpole took up residence in 1735.

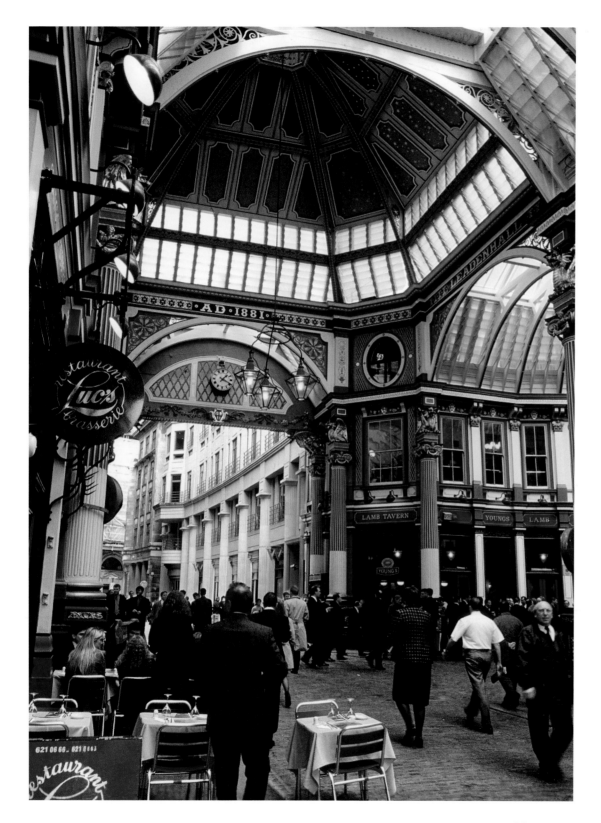

LEADENHALL MARKET

The first recorded mention of this market was in 1321, when it was held in the courtyard of La Ledene Halle, an early 13th-century mansion with a lead roof. In the mid-14th century it was stipulated that 'foreigners' – that is non-Londoners – could sell their poultry here as the main market for chickens and the like was exclusively for the citizens of the City of London. In 1439, by which time the site was owned by the Corporation of London, it was decided to build a grain store in order to make the City less dependent on outside suppliers. However, a general market continued and was rebuilt after the Great Fire of 1666. By this time meat, poultry, fish, cheese, herbs, fruit and vegetables were being sold.

During 1880–1881 the present glass-roofed alleys were constructed by the building firm of B.E. Nightingale from designs by Sir Horace Jones, the architect responsible for both Smithfield and Billingsgate markets. At ground level there are shops and on the first floor, offices. The inspiration for the design of the market was Mengoni's great Gallery in Milan, constructed from 1865–1877. Built on a cross plan, the crossing shown here is treated as an octagon with shorter diagonal sides and a square dome above. The market was restored during the early 1990s with the decoration being picked out in rich colours.

Shops in Leadenhall Market include a fishmonger, fruit and vegetable shop, delicatessen, grocer, florists and butchery. The latter specialises in game and stocks gulls' eggs in season.

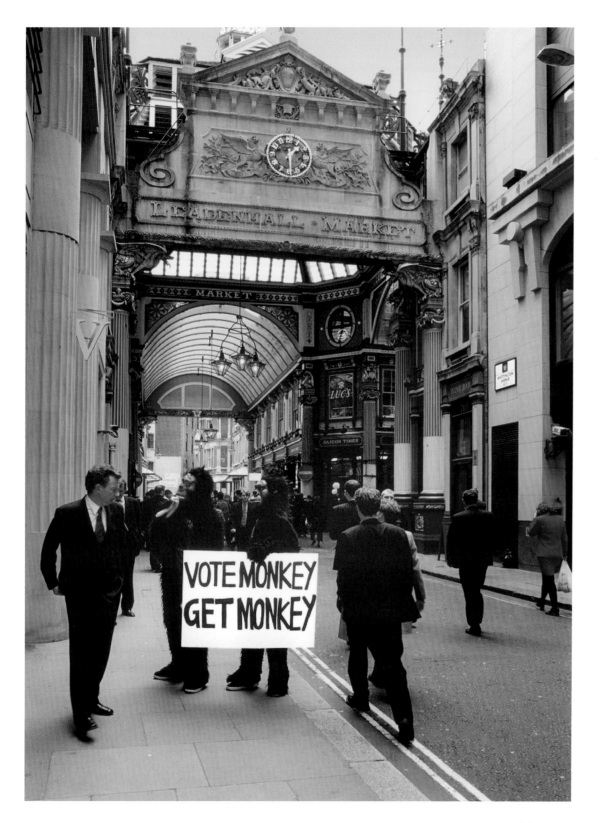

PUBLICITY STUNT, LEADENHALL MARKET

The two men dressed as monkeys were carrying their placard in the hope of capturing a certain Lord of the Realm on camera as they offered him a banana. He was considering standing for election to a public office. The Lord had wind of their stunt and their wait was in vain.

Londoners witness many stunts, usually of a promotional nature. Europe's busiest thoroughfare is London's Cromwell Road and it has several hoardings which are used to stunning effect. In the early 1980s a yellow car was stuck on one to promote a certain brand of adhesive. The caption read, 'It also sticks handles to teapots'. After a month it was removed, but a year later it reappeared exactly as before, but with the caption, 'The suspense continues'. Ten days later this changed to, 'The tension mounts' – a red car had been stuck on the yellow one. Just over a week later the hoarding was still there, but with a gaping hole. This time it only carried the words, 'How did we pull it off?'.

On another occasion, a realistic model of the front of a pub appeared in a promotion for an Irish stout. According to legend, two Irishmen spent three days trying to open its front door before they moved on.

An airline company promoting regular flights to a tropical destination filled a hoarding with large life-like models of exotic birds. It certainly became a talking point, but confused the capital's pigeons.

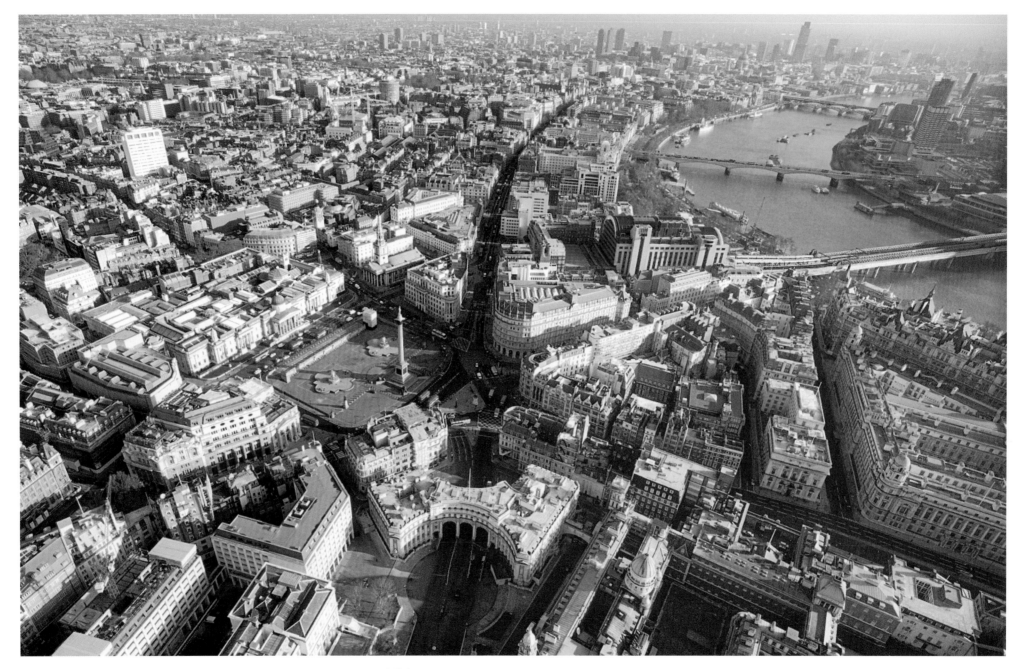

GETTING AROUND IN LONDON

The drivers of London's traditional black cabs probably count among the finest in the world. Today there are approximately 18,000 licensed taxis and 22,000 drivers. Those wishing to ply for fares in central London must have a thorough knowledge of the capital. This requires a detailed cognisance of the 25,000 streets within a six-mile (9.6km) radius of Charing Cross. Before a licence is issued, applicants must demonstrate to the Public Carriage Office that they are able to take passengers to their chosen destination by the most direct route. Acquiring the required standard of knowledge usually takes 12–24 months, during which time the trainees are likely to cover 20,000 miles (32,180km).

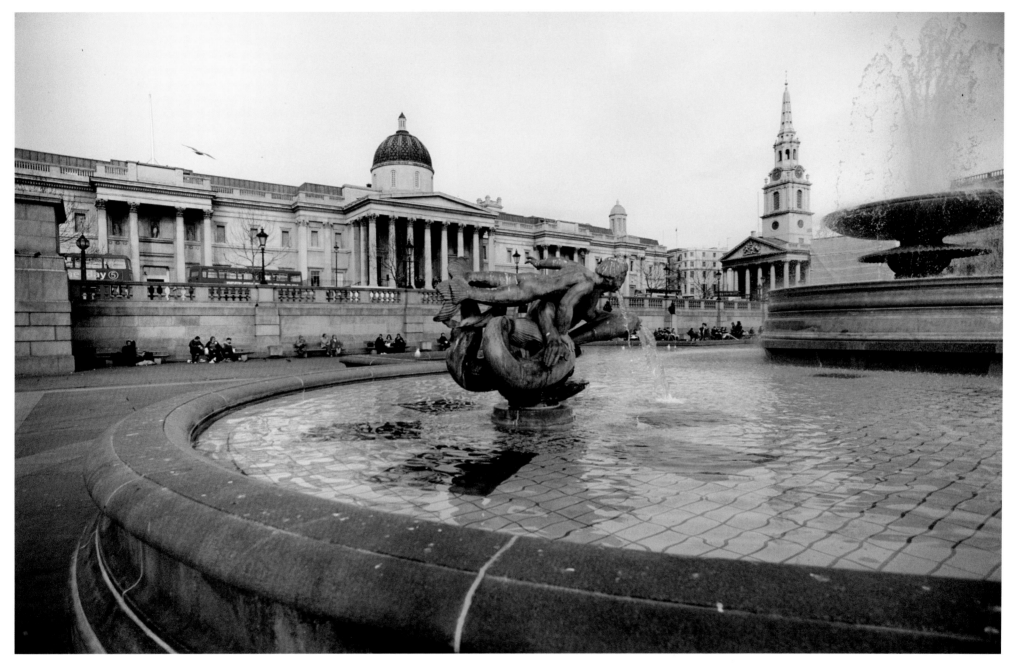

TRAFALGAR SQUARE

At Christmas an enormous fir tree adorned with white lights is erected in Trafalgar Square. It is a gift from the people of Norway as a 'thank you' for the assistance given by the British during World War Two. Traditionally the New Year was boisterously celebrated here, but in recent years the festivities have been discouraged because of the fear that overcrowding could result in tragedy. While in the past thousands of pigeons could be seen in the Square, this is no longer the case. Under a 2003 by-law introduced by the Mayor of London, anyone caught feeding the birds could face possible prosecution and a £50 fine.

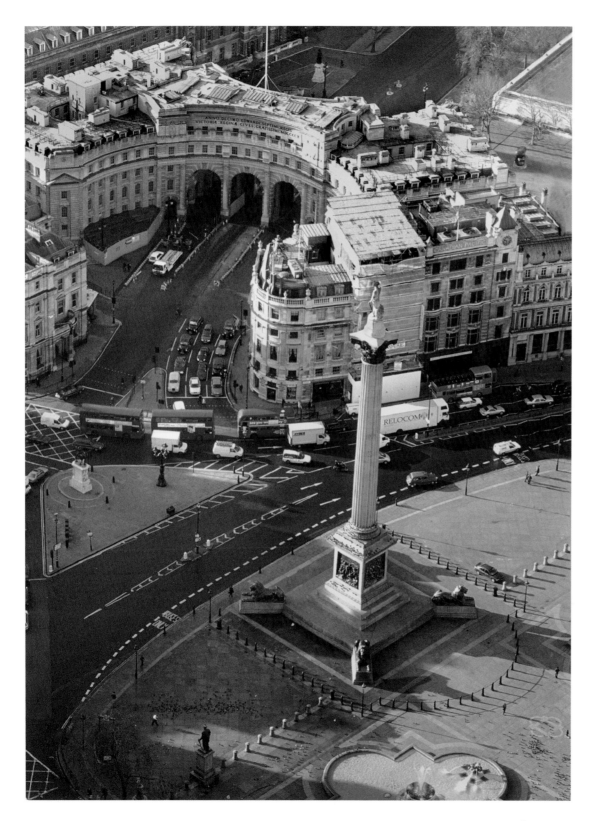

NELSON'S COLUMN AND ADMIRALTY ARCH

Trafalgar Square is now the main hub of London. In medieval days it was the location of the King's Mews that housed the royal hawks and provided accommodation for falconers. By the Tudor period, stables had been added and in the 17th century lodgings were built for court officials. In 1732, one observer remarked that the motley collection of buildings 'looks like a common inn-yard'. All were cleared in 1830 as part of John Nash's plans for the area, which included the square. Following Nash's death, the architect Sir Charles Barry completed the design of the square.

Named in 1835 to commemorate Admiral Nelson's victory at the Battle of Trafalgar in 1805, the square has one of London's most famous landmarks as its centrepiece – Nelson's Column. Sir Edwin Landseer designed the splendid bronze lions at its base. They were not put into place until 1867, nearly 25 years after completion of the column. Although the fountains were built in 1845, they were not part of the original plan. Lutyens remodelled them in 1939, adding the blue tiling to give light to the water. After the war, bronze dolphins, mermen and mermaids were added. A £25-million refurbishment of Trafalgar Square was completed in 2003.

Admiralty Arch is located southwest of the square. Built in 1910 as part of the memorial project to Queen Victoria, it leads to the Mall, the processional route to Buckingham Palace. The wrought-iron gates to the middle arch are only opened during ceremonial occasions.

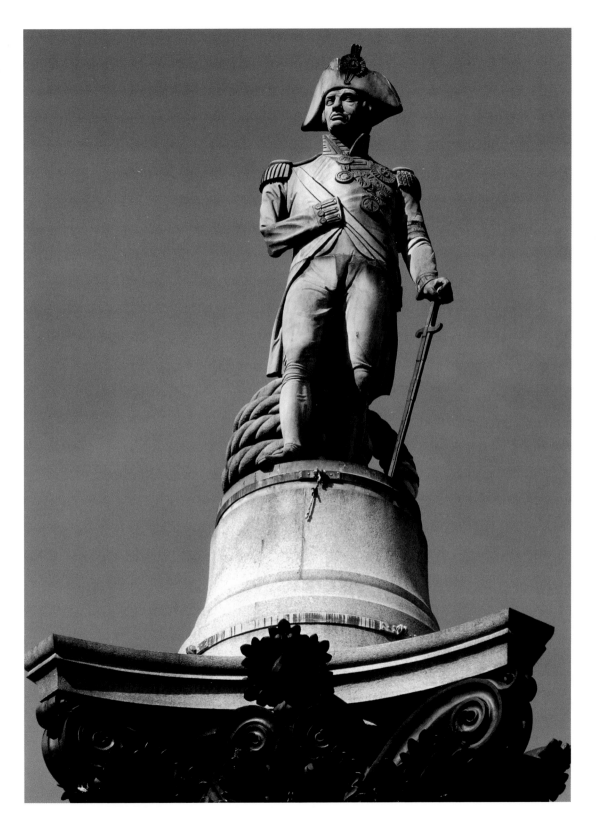

NELSON'S STATUE

Although it may look minute from the ground, the statue of Vice Admiral Horatio, Lord Nelson is in fact 16 feet (5m) high. He has been a major British hero for two centuries. Small in stature and with a frail constitution, he lost an eye and an arm in battle. A brilliant tactician with a mind of his own, he was not averse to disobeying orders. During the Battle of Copenhagen in 1801, his Admiral, who was under the impression that the British were losing the day, sent the signal from his flagship, 'Disengage action'. Nelson, feeling that the battle was turning in his favour, placed his telescope to his blind eye and stated, 'I really do not see the signal'.

His special gift for inspiring leadership has never been surpassed. Prior to the Battle of Trafalgar in 1805 his famous signal, 'England expects that every man will do his duty', will never be forgotten. This Battle removed the threat of invasion hanging over Britain. The turning point was when Nelson destroyed one of the main French and Spanish fleets. Unfortunately Nelson was fatally wounded while standing on the deck. His body was preserved in a barrel of brandy and shipped back to London for a hero's funeral. The procession for this was so long that those leading it had entered St Paul's Cathedral before the last mourners had left the Admiralty.

Although climbing Nelson's Column is a 'prohibited act', it is a favourite for protestors. In May 2003 one parachuted to the ground while his three companions unfurled a banner from the top.

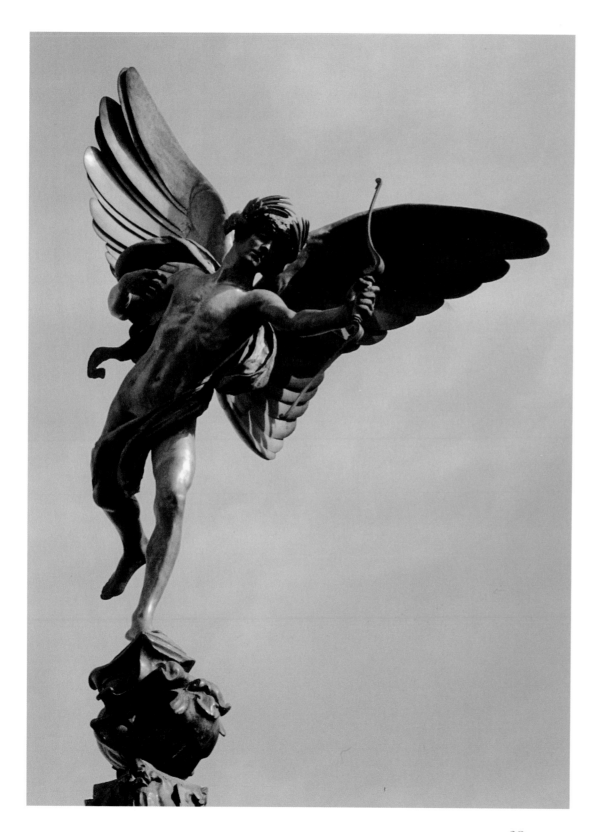

EROS, PICCADILLY CIRCUS

In the 1960s, the statue of Eros – the Greek god of love – attracted hippies like a magnet, for they regarded it as a symbol of free love. This would not have amused the genteel folks of late Victorian London who paid for the installation of the statue designed as a representation of the Angel of Christian Charity.

Unveiled in 1893 as the Shaftesbury Memorial Fountain, no other London monument has undergone such a transformation in people's minds. It was erected in memory of the 7th Earl of Shaftesbury (1801–1885) who is regarded as one of the most effective social and industrial reformers of 19th-century England. Among his good works were the support of legislation to shorten working hours and an Act to prevent women and children working down the mines. For the stream of people who pass by every day, the original reason for its presence has long been forgotten.

Designed by Alfred Gilbert, Eros was the first London statue to be cast from aluminium. During World War Two it was moved to the country for protection and even today it is boarded up on New Year's Eve and other public occasions. However, despite all the loving care lavished on Eros, he developed metal fatigue. In the early 1990s he was restored so he could be admired by future generations.

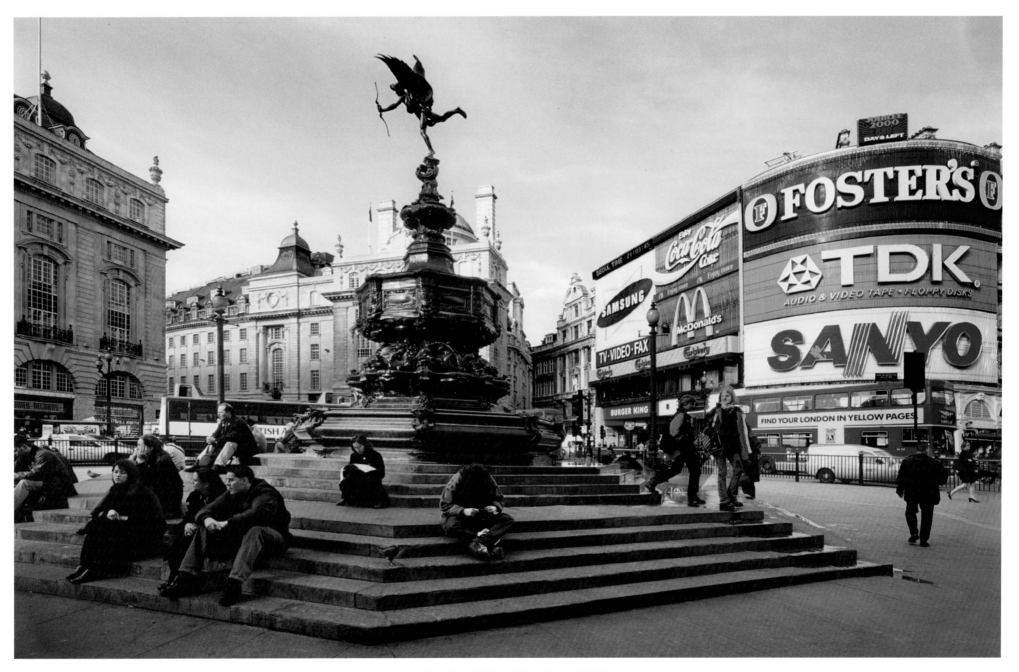

PICCADILLY CIRCUS

Piccadilly Circus is a famous entertainment and busy traffic intersection. Although originally designed by John Nash in 1819 as a circular place, alterations made in the 1880s resulted in today's ill-shaped convergence of streets. The name Piccadilly is derived from 'picadils', a stiff lace collar which was in vogue during the early 17th century. Robert Baker, a tailor who made his fortune from their sale, built a large mansion on lands in the area. It was nicknamed 'Piccadilly Hall' in derision of the source of his wealth. Although the thoroughfare which later developed was officially called Portugal Street, by the mid-18th century Piccadilly had become its accepted name.

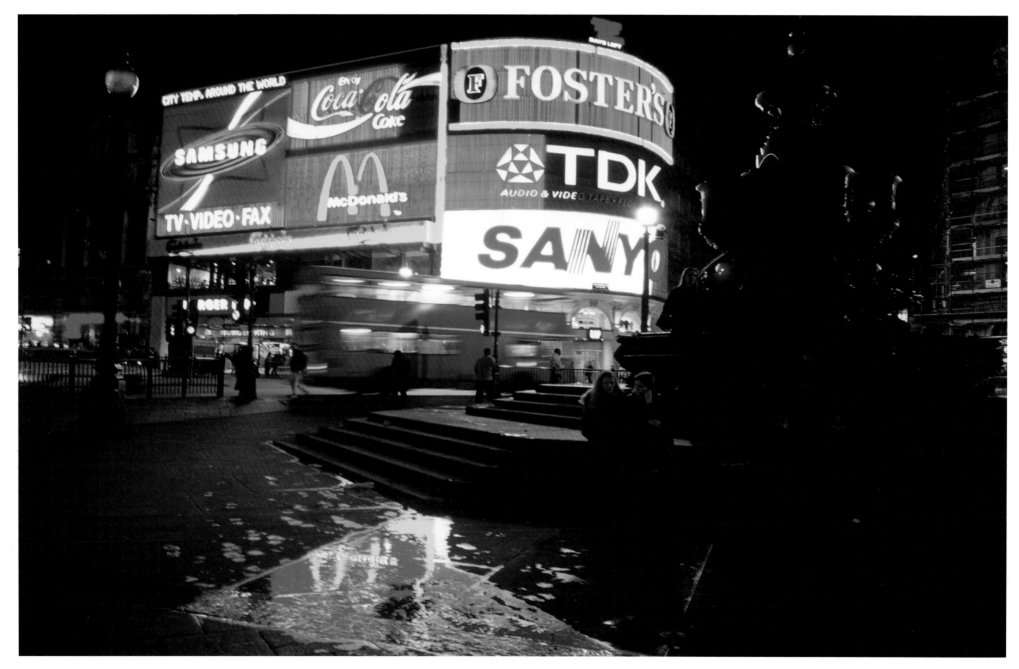

PICCADILLY CIRCUS AT NIGHT

Neon lighting was developed in the late 19th century. Its value for advertising purposes was quickly recognised and neon signs soon began to appear in the world's capitals. The shopkeepers with premises bordering Piccadilly Circus led the way in London. Initially relatively modest, the big splash came in 1923 when most of the façade of the London Pavilion became covered with neon signs. The reason why only the buildings on the northeast side are a blaze of lights at night is because the ground landlord for the rest is the Crown. When the leases were granted nearly 200 years ago, the carefully drafted wording strictly prohibited even the most modest signs.

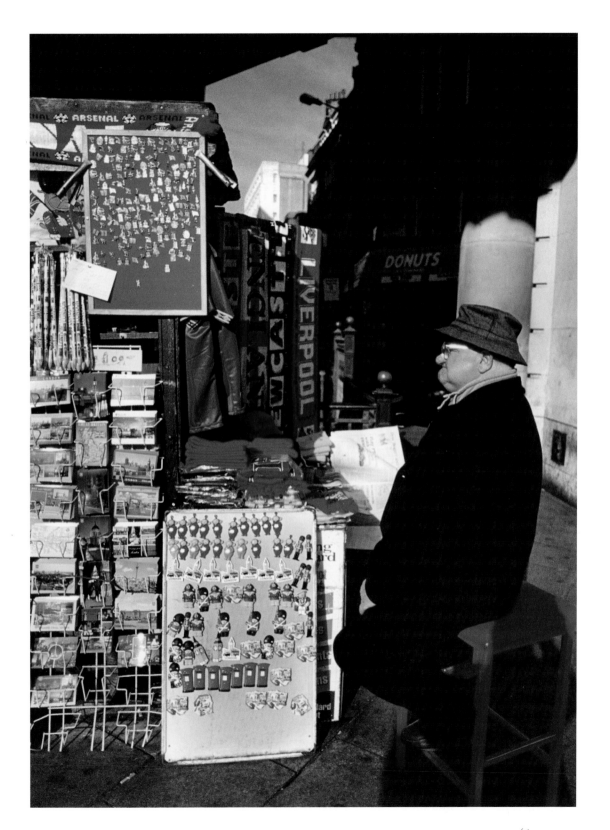

STREET TRADING

There are thousands of street traders in London, operating from market and pavement pitches. The traders have to be licensed by local authorities. At some locations, particularly those in prime tourist areas or on main thoroughfares, there are long waiting-lists.

When a pitch becomes available in the City of Westminster, the first six people on the list will be invited to apply. Occasionally applications may also be invited from other people who are associated with that pitch, such as the son of the outgoing trader.

A Licensing Hearing will then interview each applicant, taking into account his or her character and experience; the applicant's position on the waiting-list and whether any special circumstances apply; the commodities to be sold, bearing in mind the size and location of the pitch and any policy on the sale of certain goods in the area; the special arrangements for the stall after trading hours; and the ability of the applicant to personally work the pitch and to comply with street trading laws and the Council's standard conditions and policy. Successful applicants have to pay a licence fee as well as rent and take out third party insurance cover with a minimum liability of at least £2 million.

Despite precautions taken by the authorities to ensure that the traders are licensed, rogue street sellers are encountered, usually doing business from a suitcase on an upturned box. Their wares – sometimes beautifully presented in convincing packaging – are often counterfeit. *Caveat emptor* – buyer beware.

THE WEST END

For years it was a part of modern folklore: stand outside Swan and Edgars in Piccadilly Circus long enough and you will meet everyone you know. The shop closed in 1982 and the site is now occupied by other retailers. Although to many tourists Piccadilly Circus represents the heart of London, it is in fact only a busy intersection. However, there is always the chance – wherever your true home – that if you wait there for a sufficient period of time you will eventually meet someone you know.

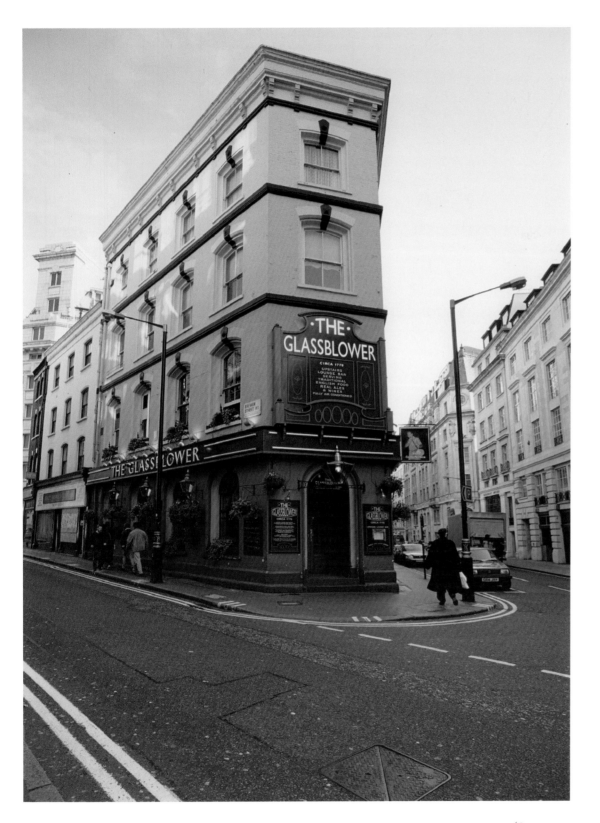

THE GLASSBLOWER

This public house, located where Brewer and Glasshouse Streets meet, is an everyday hostelry just five minutes' walk from Piccadilly Circus. Called the Bodega for years, it had a short spell as the Kilt & Celt before its present name was adopted, inspired no doubt by the thoroughfare in which it stands.

Thanks to the Campaign for Real Ale (CAMRA), England still enjoys its traditional alcoholic beverages. Founded in 1971 with the aim of saving the nation's traditional real ales from being replaced by processed beers, CAMRA has achieved a great deal in the last quarter century. It has persuaded drinkers to insist on real ale, publicans to go back to stocking it and brewers to continue producing it.

Beer is made from malted barley, hops, yeast and water. Yeast turns the fermented sugars in the malt to alcohol, while hops provide the flavouring. The basic difference between the ale and the lager family is the way they are fermented, though obviously different malts and hops contribute to the flavour differences. Ales are top-fermented at a warm temperature. The ale yeast rises to the top of the fermenting vessel during a vigorous fermentation which produces its distinctive fruity flavour. Lagers are fermented at a lower temperature, resulting in the yeast sinking to the bottom of the vessel. The different fermentation processes produce a significant difference in the final flavour.

Real ale should not be warm, cloudy or flat, but should be served at cellar temperature.

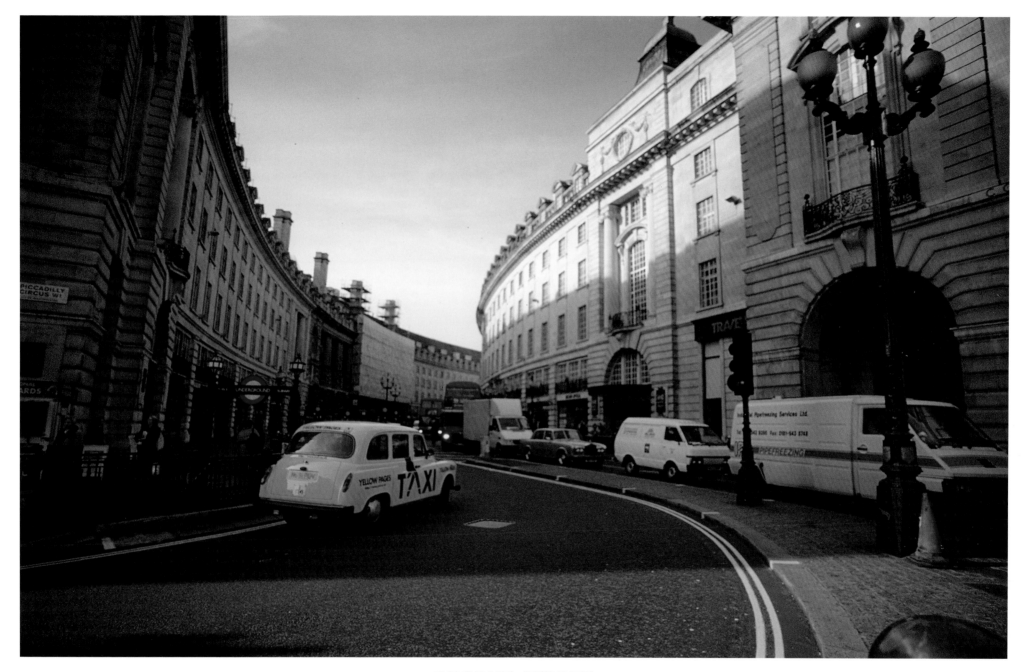

REGENT STREET

A stream once ran where London's most graceful thoroughfare stands today. Regent Street is now a continuous stream of traffic and pedestrians. Here you will find shops established in a different era: Royal Doulton whose origins date from 1815; Liberty's which opened in 1875; and Dickens & Jones, one of London's oldest department stores. There are also newcomers such as the Disney Store, Warner Bros. and the Original Levi's Flagship which will make jeans to measure. The Café Royal opened in 1865 and from the 1890s to the 1920s it attracted writers and artists such as Oscar Wilde, Augustus John and James Whistler, who always signed his bills with a butterfly.

AIR STREET,
TOWARDS REGENT STREET

If John Nash's original plans had been approved in 1811, Air Street would have vanished during the reign of George III. Regent Street was part of Nash's scheme to link Regent's Park with Carlton House, the London home of the Prince Regent, later to become George IV. His vision was for a large public building at the Piccadilly Circus end of his new thoroughfare which, if constructed, would have swallowed Air Street. However, his original ideas did not entirely come to fruition. Although Nash was responsible for co-ordinating the project, his hopes for a perfectly balanced street came into conflict with the architectural plans of those who built on individual plots.

Nash's main display piece was the Quadrant, the curved portion at the southern end of Regent Street. Shops were at ground level with lodging houses above. Pedestrians were protected from inclement weather by a covered walkway on both sides of the street. The covers were later torn down by the Victorians who considered the sidewalks 'a haunt for vice and immorality'. To break away from 18th-century traditions, the façades of the buildings that formed the original Quadrant were not uniform and the skyline was irregular. Towards the end of the Victorian era, retailing had much changed. Larger shops were the order of the day, whereas Regent Street had been designed for small outlets. In 1916 it was decided to remove Nash's Quadrant and to entirely rebuild the street. The project was completed in the 1920s. The famous curve was retained and Air Street yet again survived.

A CITY OF FLOWERS

The City of London and the 32 boroughs surrounding it form Greater London, which has an area of 609 square miles (1579km²). Although it is blessed with many parks, buildings and roads nevertheless predominate. To relieve the feeling of a concrete jungle, many areas feature flowerbeds which add a splash of colour to the surroundings. The City of London has 173 planted areas, the City of Westminster 101, while the Royal Borough of Kensington and Chelsea has 85. Residents and businesses add to the show with window-boxes and other floral displays.

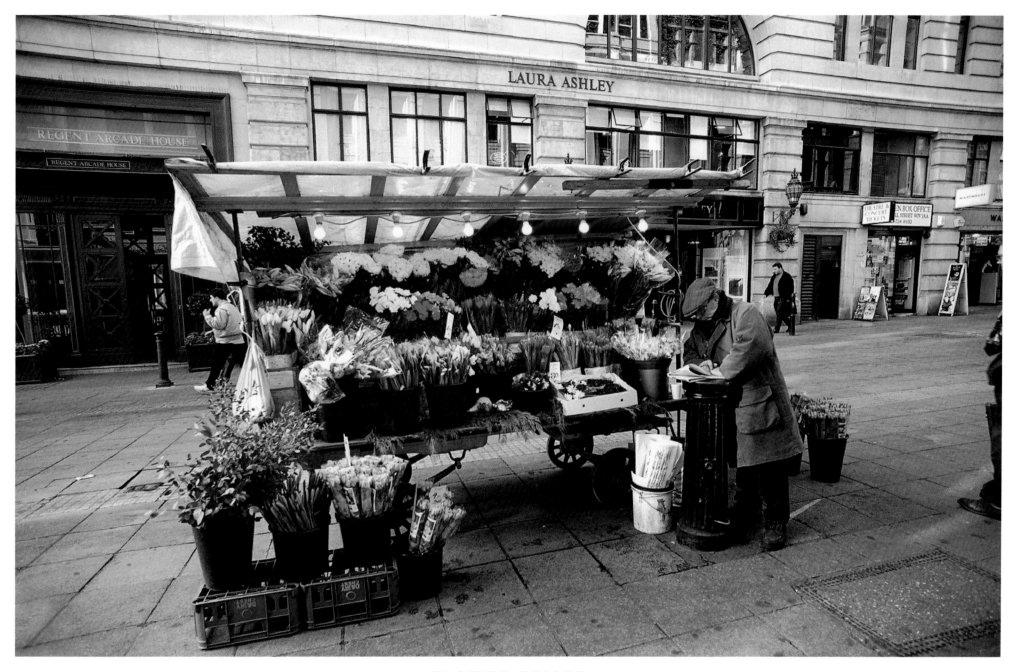

FLOWER SELLER

The 'flower girls' of old London were generally married women of a certain age. Usually wearing a feathered hat with their shoulders draped with a shawl, many could be seen early in the morning, sitting in the doorways of Covent Garden making buttonholes for selling later in the day. Apart from gypsies who periodically haunt tourist spots selling small bunches of 'lucky' heather, flower girls have long since gone. However, there are scores of flower stalls in central London offering a wide variety of fresh blooms. Although many of the flowers are now grown overseas, traditional English blooms are sold in season, including primroses and violets in the spring.

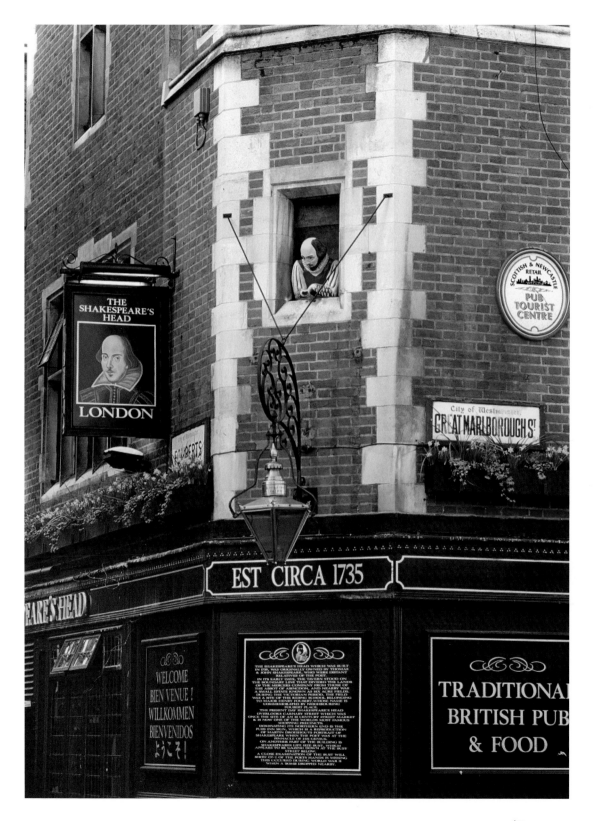

THE SHAKESPEARE'S HEAD

Just a stone's throw from Oxford Circus at the corner of Great Marlborough Street and Foubert's Place stands The Shakespeare's Head, a typical London public house. Originally owned by Thomas and John Shakespeare – distant relatives of the Bard – it is not surprising that it was named after their famous kinsman. Indeed, this was a popular name for a pub in any town or city which had a theatre. In 1864 London alone boasted eight hostelries of this name – now there are only three.

The splendid signboard is a reproduction of Martin Droeshout's engraving of William Shakespeare which appeared as the first folio of the Bard's plays published in 1623, seven years after the playwright's death. The life-size bust in the first-floor window looks along Carnaby Street. If you are wondering why one of its hands is missing, it was damaged during World War Two when a bomb fell nearby.

A great deal of England's social history can be gleaned from the names of pubs. Many, of course, compliment great men, whereas others are more subtle. The Bell is an allusion to horse-racing, a silver bell having been the winner's prize in the past. The Coach and Horses signifies that it was a stage-coach house and the Green Man alludes to the fact that a former owner was once a game-keeper. The Cat and Fiddle indicates that cat – a ball game – and dancing were provided, while the Globe signified that Portuguese wines were available, the globe being the emblem of the King of Portugal.

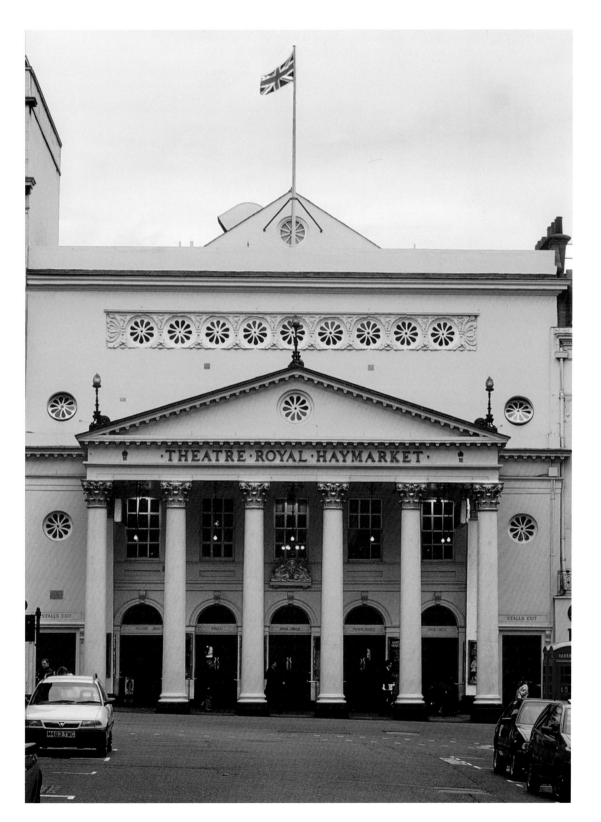

THEATRE ROYAL, HAYMARKET

There are some 40 theatres in London which each evening collectively stage a broad cross-section of productions ranging from classical to modern plays to traditional and modern musicals. While some performances only survive a matter of weeks, others appear to be immortal. Agatha Christie's *The Mousetrap* opened on 25 November 1952 when Sir Winston Churchill was Prime Minister, Everest had not yet been conquered and sweets in Britain were still rationed. Today, it is the world's longest-running play.

Perhaps the theatre with the most colourful past is the Theatre Royal, Haymarket. It was granted its royal patent in 1766 as 'compensation' after the Duke of York and others encouraged its manager to ride an unmanageable horse, which resulted in the rider losing his leg. In 1794, at its first command performance, 15 people were crushed to death, while in 1805 hundreds of the city's tailors, incensed by a run of the satire *The Tailors*, barracked the performance and had to be dispersed by troops.

The present theatre was designed by John Nash in 1820. The site was chosen so that the classical and graceful portico could be viewed from St James's Square. When lit in the evenings and framed by the great trees in the square, it still is one of the most charming views in London.

One of the city's oldest theatres is Theatre Royal, Drury Lane where Charles II first set eyes on Nell Gwynne and in the 18th century David Garrick revived Shakespeare's plays. Today, Cameron Mackintosh's production of *Miss Saigon* is staged in a theatre which was reconstructed in 1812. Unscheduled appearances are made here by the 'Man in Grey', perhaps the best-known of theatre ghosts.

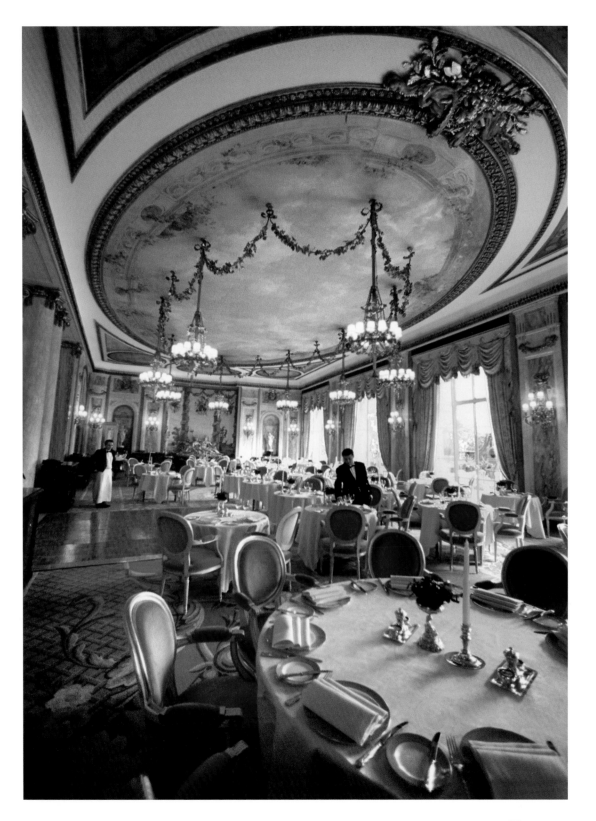

THE RITZ RESTAURANT

The word 'ritzy' is a colloquial expression for anything that is luxurious and high class. It is derived from the surname of César Ritz, the Swiss hotelier. The son of an Alpine shepherd, he devoted his life to shaping the de luxe hotel business as we know it today.

His career began in 1866 when the hotel industry was only just beginning. Having gained experience working with some of the greatest pioneers in the business, such as the chef Auguste Escoffier, he worked to make hotels a fashionable and acceptable part of society. A Ritz hotel syndicate was formed and the Ritz in Paris opened in 1898, followed by the Ritz in London in 1906. London's Ritz has a prime location in Piccadilly and this, combined with the hotel's gracious interior, ensured its popularity with royalty, aristocrats, celebrities and statesmen from the day it opened.

The Ritz restaurant – a perfect example of Louis XVI boiserie – is considered one of the most beautiful dining rooms in the world. It was restored as part of a meticulous refurbishment programme after the hotel returned to private ownership in 1995. Its rich, heavy curtains were designed exclusively for the room. As in the under-curtains, they exude a shade of pink that maximises the colour of the room and complements the rare marbles – Brèche d'Alep, Rosé de Norvège and Verte de Suède – used in the walls and pillars.

The carpet was carefully designed by Zebec in London to reflect the patterns of the oval *trompe-l'oeil* ceiling above. Rich in colour, it was made from pure wool in Northern Ireland.

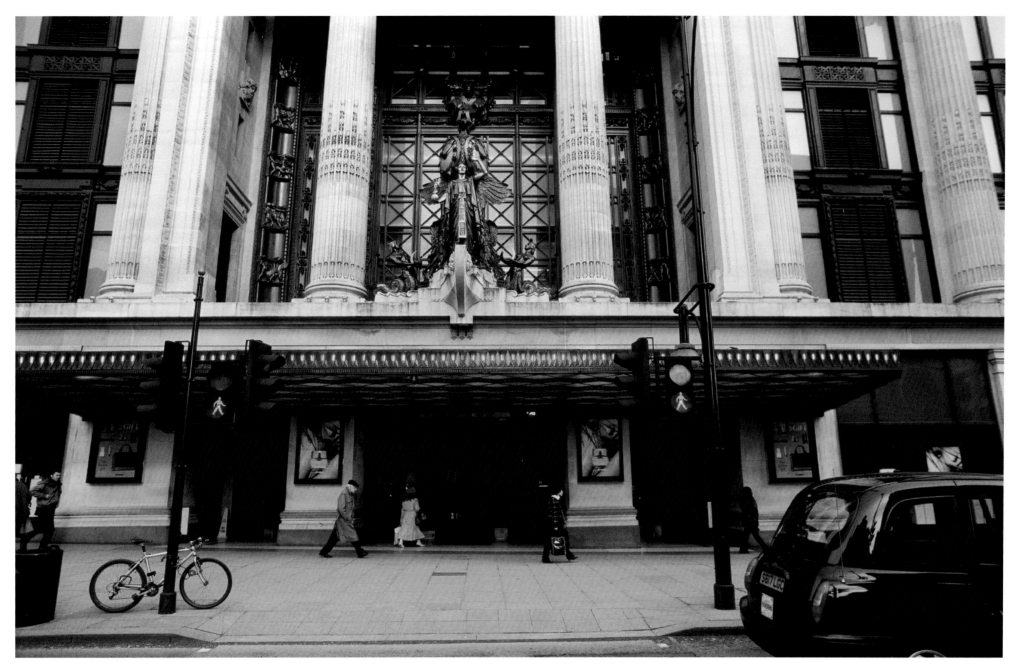

SELFRIDGES, OXFORD STREET

Gordon Selfridge, a retired partner in Marshall Field of Chicago, moved to London in 1907. Feeling too young to retire, he decided to open a London store. Strangely, it featured a Silence Room where a sign read, 'Ladies will refrain from conversation'. The first sale on 15 March 1909 was a six-pence handkerchief to Madame Barry of Bond Street. The same day a shoplifter was apprehended attempting to steal an umbrella and a walking stick. The store's imposing building, with tall Ionic columns and a huge art deco clock, was finally completed in 1928. During the 1990s the interior was completely transformed. Today, more than 17 million people enter its portals each year.

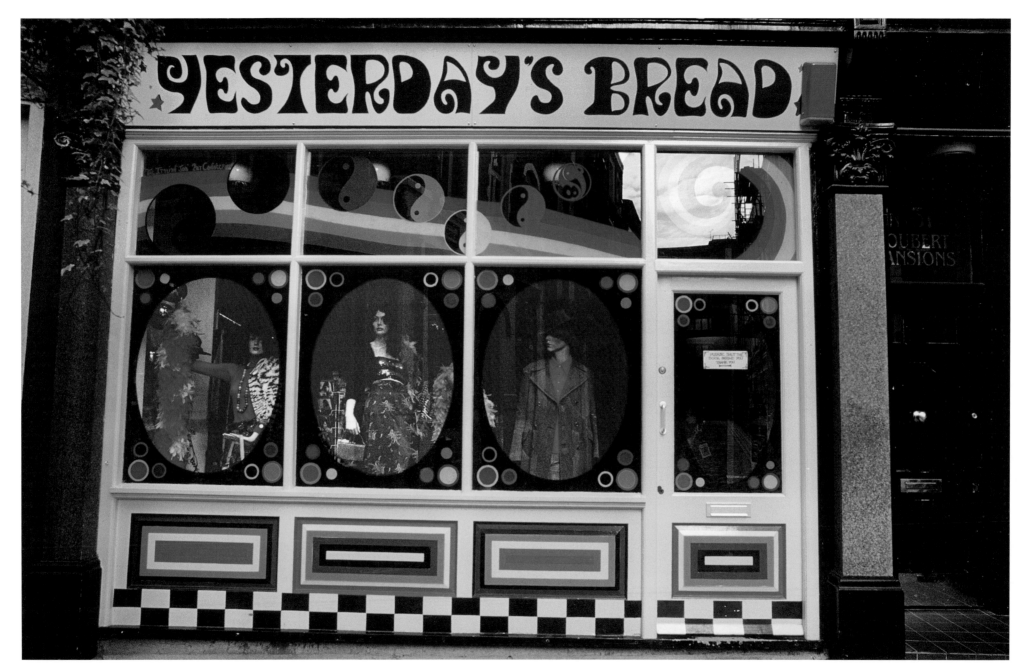

CARNABY ZONE

Carnaby Street and the thoroughfares close by are experiencing an influx of talented designers and unusual shops, reinforcing its reputation as a shopping quarter where the unexpected can be expected. There are jewellery and footwear shops as well as fashion boutiques for both men and women. Nostalgia oozes from Yesterday's Bread, for here only original and unworn 1960s and 1970s clothing, shoes and accessories such as wigs and coloured eyelashes are sold. Opened in 1996, its name is a play on words – Yes to day's bread – bread being a colloquial expression for money. Yesterday's clothes, of course, are worth a lot of bread.

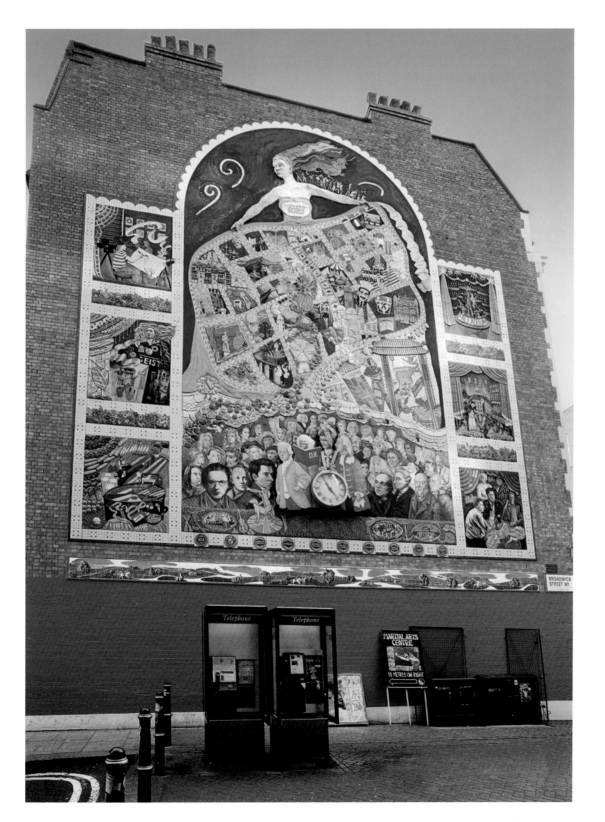

'SPIRIT OF SOHO' MURAL

The cosmopolitan area of Soho has a colourful history and today its atmosphere is that of a vibrant village with good pubs, excellent restaurants and interesting shops. Strollers heading south along Carnaby Street are greeted by a large mural depicting the past and present life of the quarter, which takes its name from the ancient hunting cry 'So-ho!' – a reminder that in the distant past the area was a park frequented by hunters and their hounds.

The creators of the mural faced no difficulty in finding inspiration for their work. In Soho of old Canaletto had a studio; Mozart lived with his family; Casanova wooed the city's women; and John Logie Baird invented television.

Designed and executed by Free Form Arts Trust in collaboration with Alternative Arts, the mural was conceived as a work of art against which the Soho Street Theatre would perform. From its inception in 1989 through to its completion in 1991, hundreds of people worked on the project. The professionals genuinely involved the local community, with mosaics being made in homes and community centres, at the school and in the library.

A mix of ceramics, tiles, mosaics, concrete relief and paint, the central section of the mural features the 'Spirit of Soho', her hair flowing with a celebratory dragon, a street parade dancing along her arm, and upon her skirt a map of Soho. Framed underneath are many of Soho's famous historic figures. The side panels depict contemporary Soho. At the bottom right, George Melly, Brendan Behan, Dylan Thomas, Jeffrey Barnard and Jessie Mathews gather round a table while Ronnie Scott plays his sax.

BURLINGTON ARCADE BEADLE

From Piccadilly through to Burlington Gardens, parallel with Bond Street, is an elegant Regency shopping mall. It was designed in 1819 by Samuel Ware for Lord George Cavendish who lived next door at Burlington House. Now the home for the Royal Academy of Arts, it is the only survivor of six 17th-century mansions which once stood in Piccadilly.

Lord Cavendish, the younger son of William, 4th Duke of Devonshire, purchased the house in 1817. It appeared that the building of the adjacent arcade was not primarily motivated by commerce, but by the need to prevent a nuisance. The story goes that Lord Cavendish ordered the construction of the shopping mall to stop the bawdy Londoners of the time from throwing oyster shells and other rubbish into his garden.

In the early 1800s, London's West End was somewhat wild. To protect the customers who patronised the 38 shops and to keep out ruffians, Lord Cavendish founded the corps of Burlington Arcade Beadles. Recruits came from his regiment of the 10th Hussars. In those days veteran soldiers were demobilised with only their uniforms. Lord Cavendish therefore gave some of his men a civilian career. Their task was to patrol the long pavement. The Beadles enforced the Regency laws which prohibited singing, humming, hurrying, making merry and staggering around with too many parcels – unless, of course, they were carried by a servant.

The Beadles still insist on the Regency laws of courtesy, quiet and decorum. Although not dressed in Regency attire, they are nevertheless instantly recognisable by their Edwardian frock-coats with star-bright buttons and gold-braided top hats.

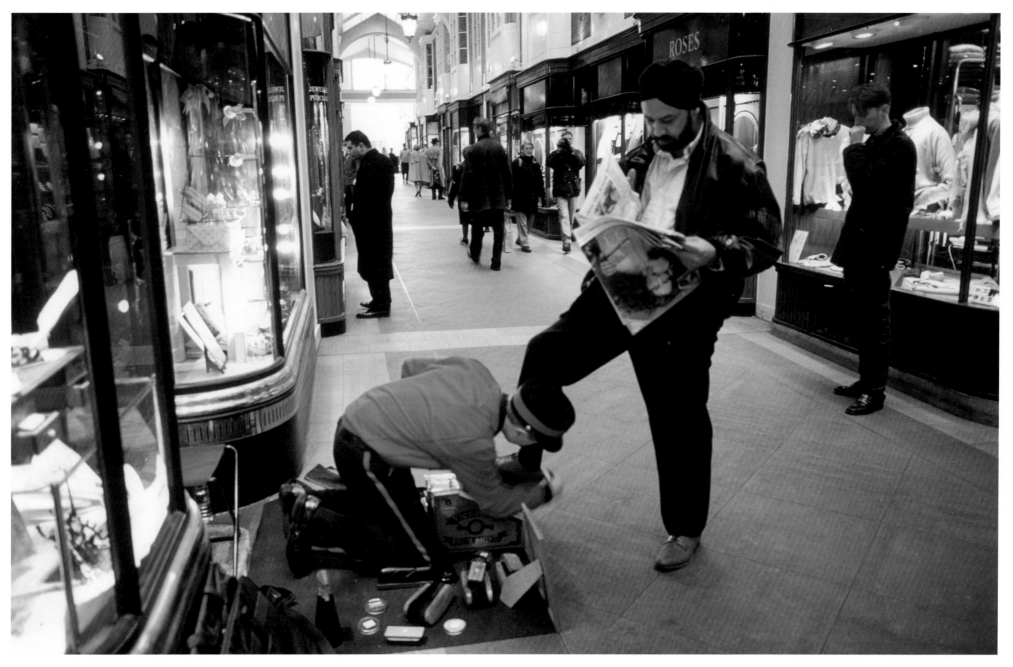

A TRADITIONAL SHOESHINE IN BURLINGTON ARCADE

Wearing their smart uniforms, the shoeshiners from the Traditional Victorian Shoeshine Company are encountered daily at prime sites in central London and at major events like Royal Ascot. Their uniforms are inspired by the 'City Reds' Shoeblacks Brigade established by the Victorian philanthropist, Lord Shaftesbury. Recruits came from the ragged schools which educated destitute children. The brigade was formed to provide a shoeshine service at the Great Exhibition of 1851. It proved so popular that it continued some years after the event. Michael Willis, shown here, regularly polishes the shoes of the rich and famous. He is something of a celebrity himself: he appeared in the remake of Disney's *101 Dalmatians*.

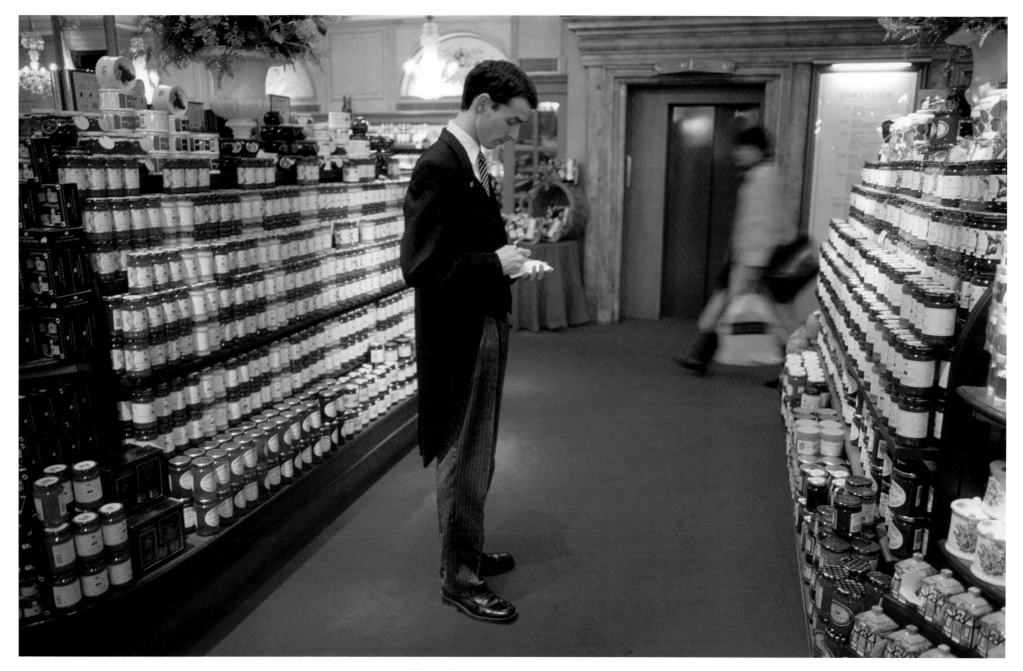

FORTNUM & MASON'S

While some people eat to live, others live to eat. The clientele of Fortnum & Mason's certainly fall into the latter category, for here is a gourmet's paradise. When William Fortnum was employed as a footman in the royal household of Queen Anne, one of the perks of his employment was to be allowed to take the used candles which he then sold to the household's ladies. Encouraged by the success of his used-candle business, William persuaded Hugh Mason to join him in establishing a grocery business. The rest is history. While the shop has seen many changes over the years, its ground-floor staff continue to carry out their duties in morning coats.

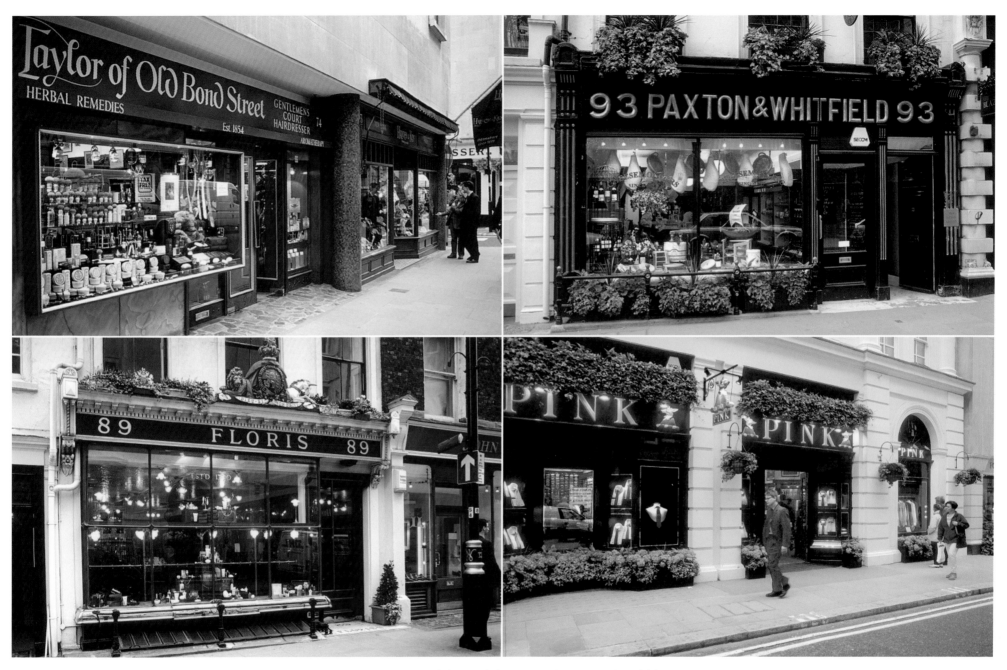

JERMYN STREET'S SHOP FRONTS

London is a paradise for the discerning shopper and Jermyn Street is a good starting place. Taylor of Old Bond Street was established in 1854 and manufactures personal products for both men and women with as pure and natural ingredients as is practicable. Paxton & Whitfield has been a cheesemonger since 1797. Connoisseurs have 200 cheeses from which to choose. Floris, founded in 1720, has been making and selling perfumes for eight generations. Thomas Pink may only have opened for business in 1984, but in a relatively short space of time it has established itself as the United Kingdom's top luxury shirt brand.

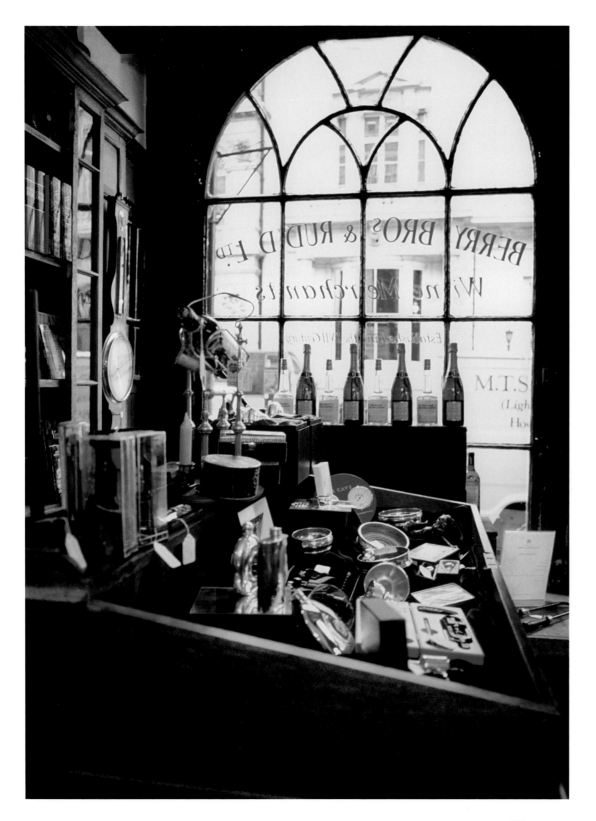

BERRY BROS. & RUDD LTD

Pedestrians strolling along St James's Street will notice that the wine merchants at No. 3 have a sign featuring a coffee mill suspended outside their premises. Britain is steeped in tradition and many long-established firms, such as Berry Bros. & Rudd, maintain their links with the past while running their businesses in the modern world.

Since the 1690s a single family and its close associates have been selling wine and spirits from the same premises here in St James's. No other family anywhere in the world has been a wine merchant in the same building for so long. Established as a grocer at 'the sign of the coffee mill', the company still remembers its origins today. Though it has not sold groceries since 1896, it does still sell tea and coffee.

Its large grocer's scales are still used today – for weighing customers! As to why this custom started is lost in the mists of time, but the nine volumes of records reveal that the first occasion was in 1765. Lord Byron, Beau Brummel, Nellie Melba, John Nash, Laurence Olivier and the Aga Khan are just some who have had their weights recorded for posterity. One Japanese Sumo wrestler recently weighed in at around 300lbs (136kg), a record for the firm.

The interior of the premises has not changed much over the years. The floor is uneven and the wooden panelled walls are dark with the patina of the ages. The oval table with three original wheelback Windsor chairs where former generations deliberated the choice of fine wines, remain for the use of today's clientele.

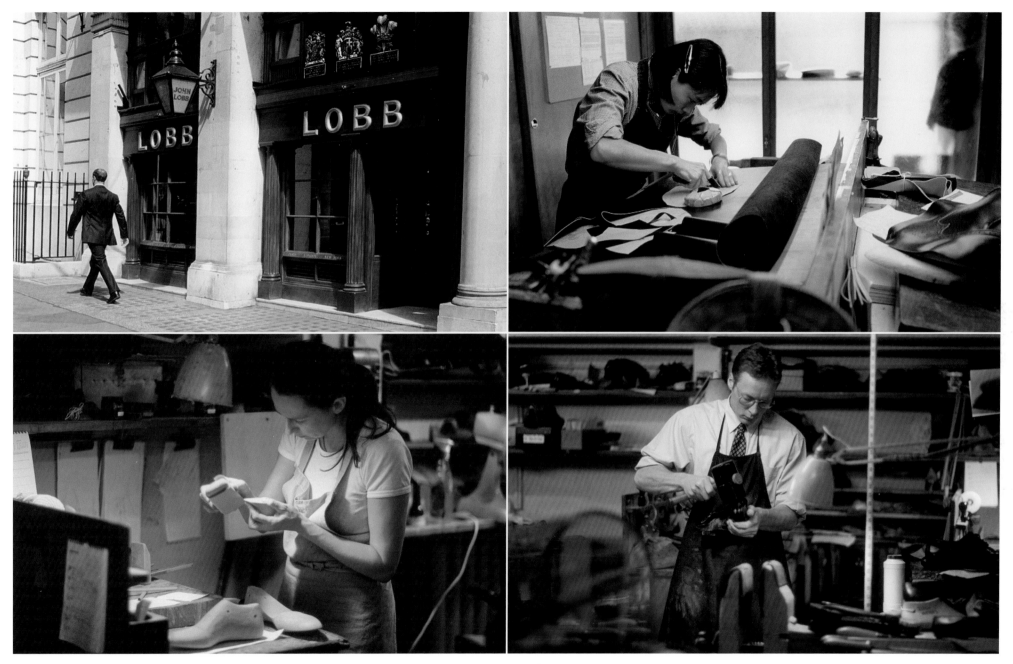

JOHN LOBB, BOOTMAKER OF ST JAMES'S STREET

Established in the mid-19th century, here shoes are still handcrafted with love, care and attention. The fitter precisely measures the client's feet. The last-maker uses these statistics to carve solid pieces of well-grained wood into exact contoured models of each foot. The clicker chooses and cuts the eight pieces of leather used for the uppers, while the closer does the sewing, stiffening, lining and shaping. The maker adds the sole and layered, riveted heel and the polisher brings the shoes to their final pristine glory. The whole process takes months and the result is a unique, individually made masterpiece.

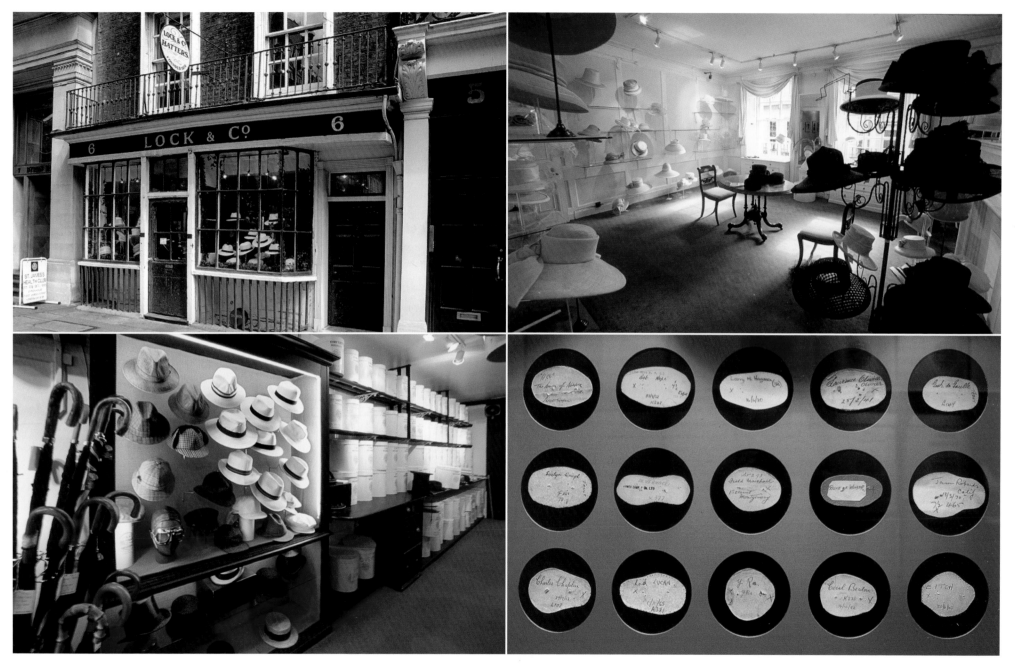

JAMES LOCK & CO., HATTERS

Many women like the opportunity to wear a hat as there is no easier or quicker way of adding instant glamour. While a hat can add charm and beauty, it can also create an air of eccentricity. Each June there is certainly a host of flamboyant and downright bizarre ladies headgear at Royal Ascot. In 1998 one creation incorporated a World Cup trophy while another contained so many yellow feathers, its wearer resembled a chicken. However, for every outlandish hat there are hundreds of traditional examples of the milliner's art. Gentlemen, of course, always wear a top hat.

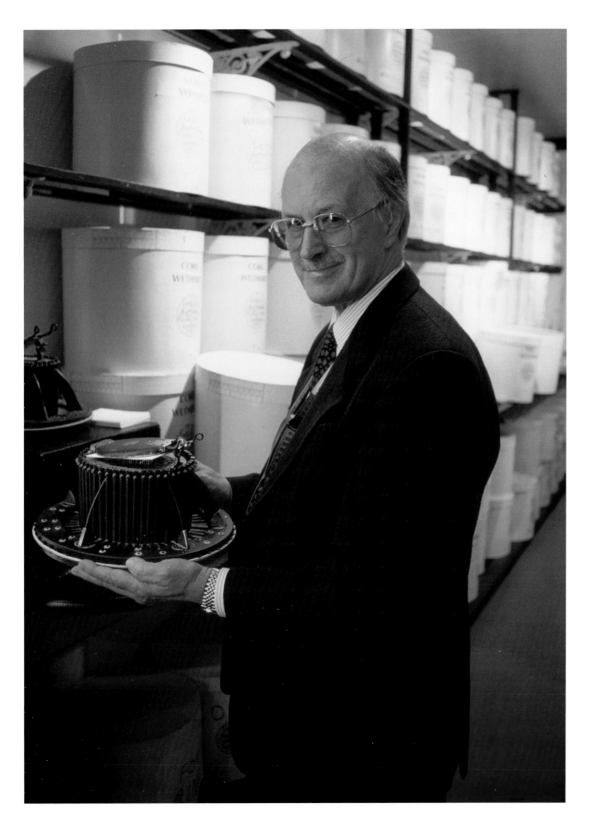

Ray Parker, manager of James Lock & Co., the famous hatters established in St James's in 1676, holds a *conformateur*, a French invention which simplified the making of hard hats. The device, when applied to the client's head, exactly maps the head's contours. The shape is recorded in reduced scale upon a small card. This, together with careful measuring, ensures that the hatter produces an exact replica of the head upon which the hat is moulded, thereby ensuring an absolutely perfect fit.

The cards are retained for future reference. A few relating to Lock's more famous past clients have been framed and are displayed at its St James's Street premises.

In keeping with Lock's tradition to name their hat styles after the wearers who first ordered them, the 'Coke' – one of the firm's most famous designs – was named after a Norfolk farmer. In 1850, William Coke requested a close-fitting hat which would not blow off in the wind and which was hard enough to protect the heads of his gamekeepers from over-hanging branches. The hatters, Thomas and William Bowler, produced a domed hat with a top hardened with shellac. Mr Coke tested the new design by jumping on it – the hat withstood the shock. When production of the hat reached 60,000 a year, it generally became known in Britain as a 'bowler'.

Lock's famous past customers include Lord Nelson and the Duke of Wellington. The company holds royal warrants from both HRH the Prince of Wales and HRH the Duke of Edinburgh.

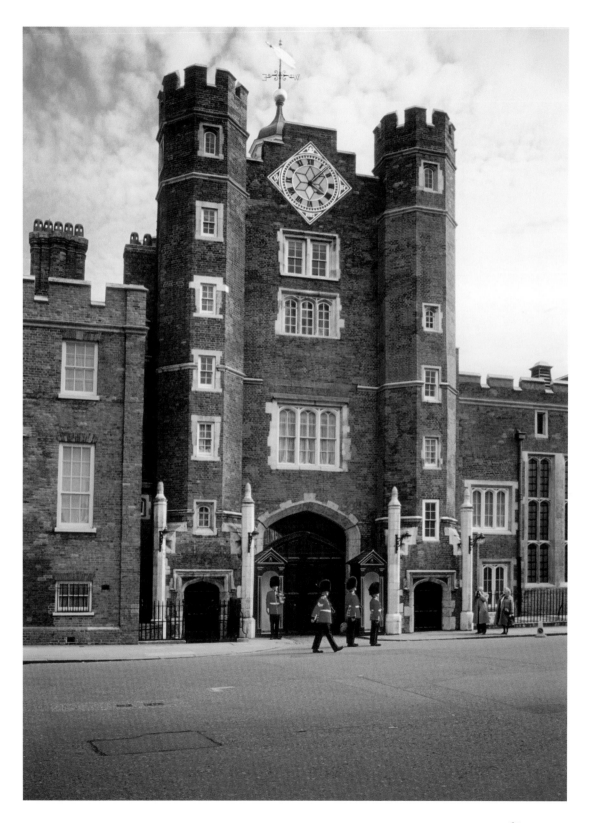

Built in 1532, St James's Palace stands on the former site of a hospital founded in 1100 for the specific care of 'fourteen leprous maidens'. The palace was built on the orders of Henry VIII as a love-nest for Anne Boleyn. Both Elizabeth I and James I held court here. Charles II was often seen in the grounds, now St James's Park, playing bowls and feeding the ducks with his mistresses. However, it was not until 1698, when Whitehall Palace was destroyed by fire, that it became the principal royal residence in London.

A large part of the palace was destroyed by fire in 1809, but it was restored by 1814. The largest surviving part of the original structure is the gatehouse with its flanking octagonal turrets.

The building has had a colourful history. In the 18th century both George I and George II banished their sons and heirs from the building. Prince George, later to become George IV, was married here in 1795. According to his wife he became so drunk that he collapsed into the fireplace of the bridal chamber where he remained until morning. The Duke of Cumberland, Queen Victoria's unpopular uncle, was nearly murdered here by his Corsican valet. The attack was provoked by the duke's continuous taunts regarding the servant being a Roman Catholic.

St James's is the sovereign's senior palace and it is still the 'Court' to which ambassadors and high commissioners are accredited. Although it is the monarch's official residence, no sovereign has lived here since the death of William IV. However, the palace is the London home of HRH the Prince of Wales and Princess Alexandra and Sir Angus Ogilvy.

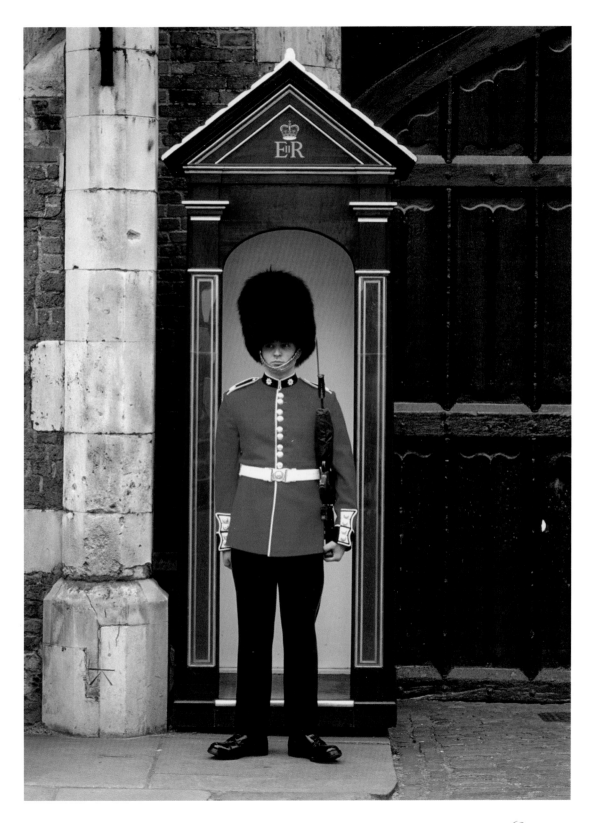

A GUARDSMAN,
ST JAMES'S PALACE

Preparations for duty begin the previous day when tunics and trousers are pressed, bearskins are groomed, and the metal on the uniforms and boots are polished – a procedure that can take three to four hours to complete. A newer recruit will take five to six hours to prepare, taking up to 90 minutes to polish boots compared to the 30–45 minutes it takes an 'old-hand'.

At 7.30 the next morning there is a complete rehearsal of the mounting and dismounting ceremony. This can take up to 90 minutes if newer recruits are present, but an hour if the Guard is experienced. After 9am the final preparations are made and the equipment required for the period of duty is placed on vehicles headed for the Guard's destination.

At 11.20am the Guardsmen gather to form up in battalion format at Wellington Barracks and orders are confirmed. Thereafter, with the order, 'To your duties quick march', they are off to either Buckingham Palace or St James's for their period of duty – 24 hours in the summer, 48 hours in the winter. Each Guardsman spends two hours on duty and four off.

The Guardsmen also have a security function to fulfil. From 10pm through to 8am combat dress replaces the ceremonial uniform, during which time the Guardsmen patrol in pairs.

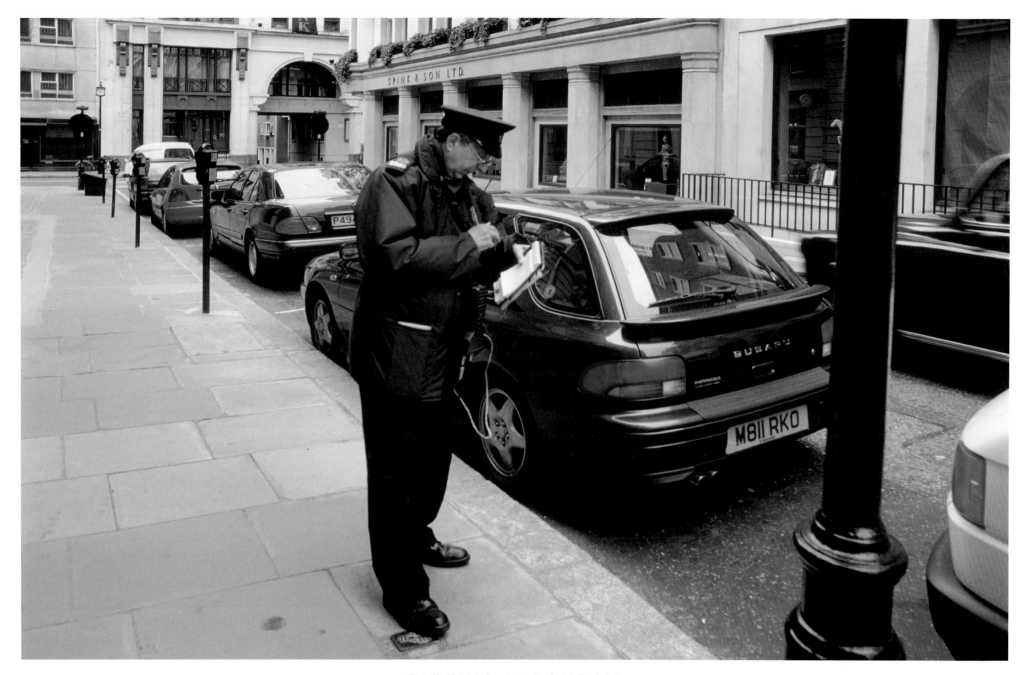

PARKING IN LONDON

Parking spaces are scarce in many parts of London: when available they are often expensive. This is particularly so of street parking. When it is permitted, it is generally upon the payment of a meter fee or by purchasing and displaying a voucher. Even then, parking is usually subject to a maximum of two hours. Around 5 million parking fines are issued in London each year. These can be for as much as £80. Should the vehicle be towed away, the release fee can be up to £125. There are approximately 40,000 appeals against the fines each year. Car parks are usually cheaper and have more generous parking periods.

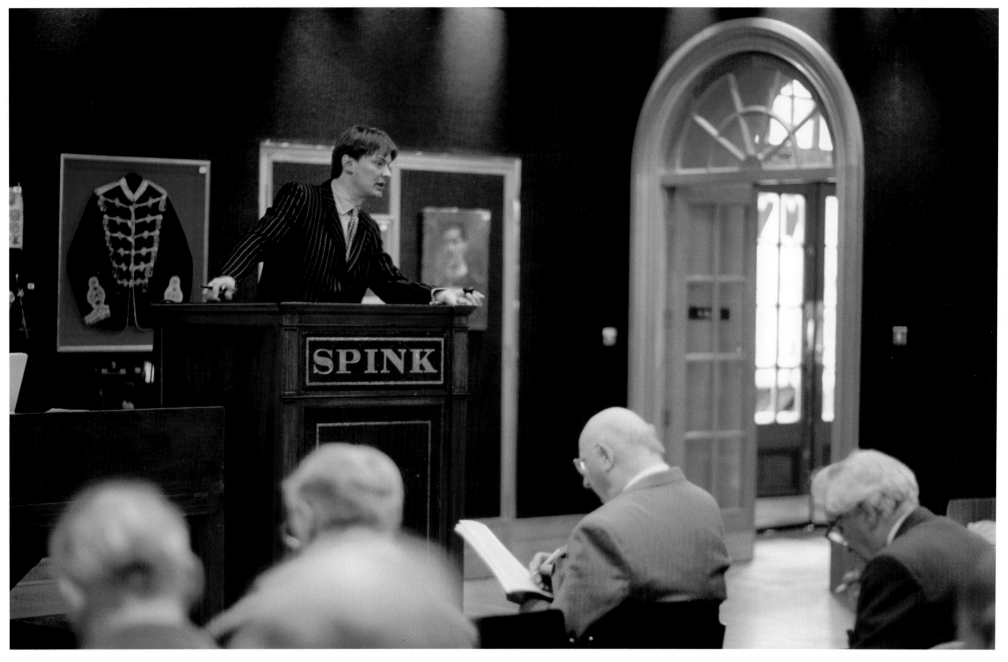

AN AUCTION IN PROGRESS

London's auction houses are among the oldest in the world. The four main ones were established in the 18th century: Sotheby's in 1744; Christie's in 1766; Bonhams in 1793; and Phillips in 1796. In addition to the auction houses, London has thousands of fine art and antique dealers. Spink & Son, established in 1666, is not only the world's largest and oldest antique dealer, but is also the world's oldest and largest coin dealer. It has been a numismatic auctioneer since 1978 and a member of the Christie's Group from 1993. At the auction shown here a new record price was established for a Victoria Cross. It sold for £138,000 in May 1998.

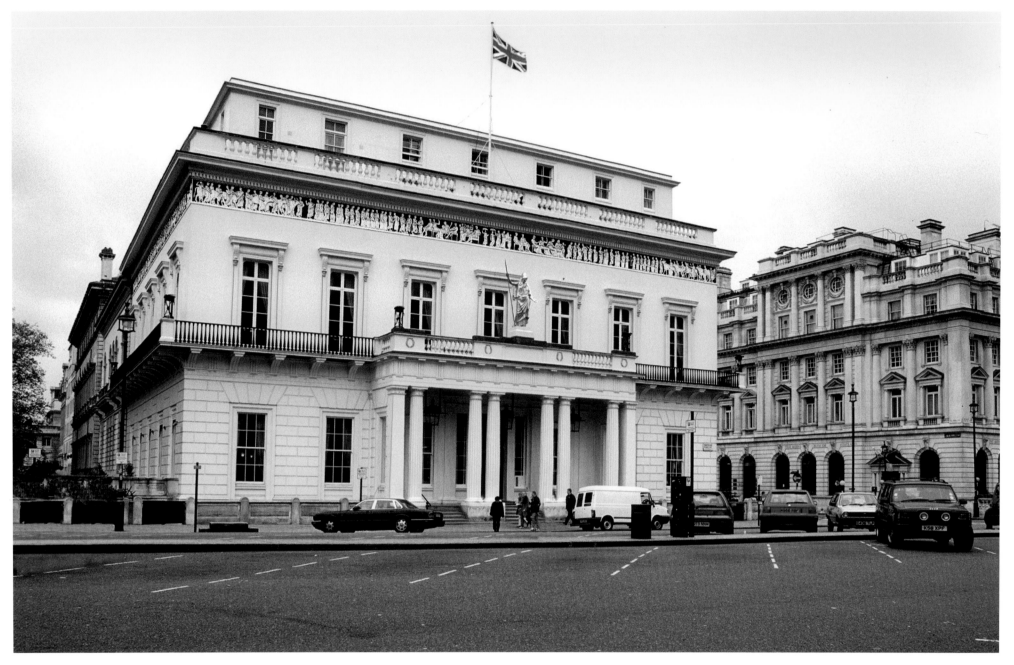

THE ATHENAEUM

Founded in 1824 by John Wilson Croker, the politician and writer, the Athenaeum is the most intellectually élite of all the London clubs. Originally known as 'The Society', it took its present name when it moved to Pall Mall in 1830. Athenaeum was the name of a university in Rome founded by Emperor Hadrian for the study of science and literature. The frieze above the first-floor windows is a reconstruction of the one on the Parthenon in Athens, while the large gilt statue above the entrance porch is Athena, goddess of war, personification of wisdom and patroness of the arts and crafts. Club members include senior politicians, archbishops, literary figures and scientists.

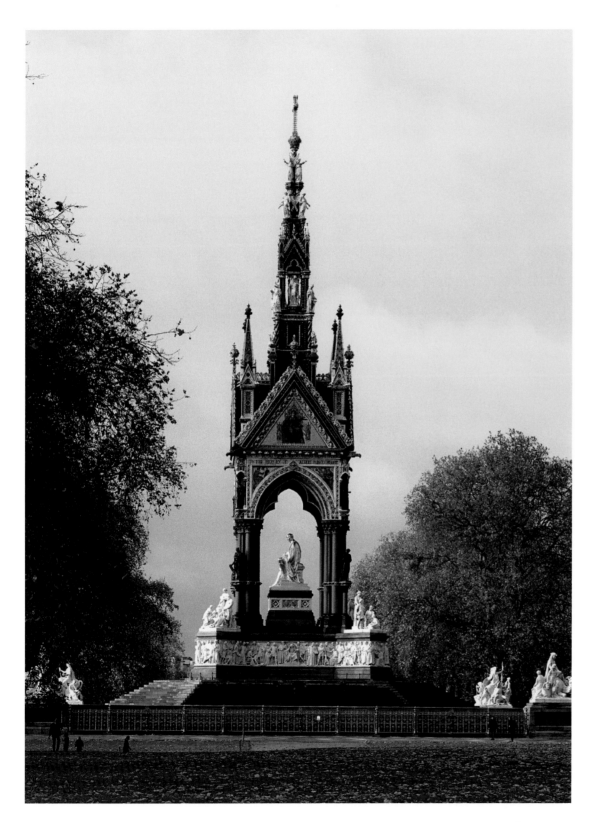

ALBERT MEMORIAL

In 1839 Queen Victoria proposed to her first cousin, Albert of Saxe-Coburg-Gotha. The couple were married the following year. Their domestic bliss helped to assure the continuation of the monarchy, which was by no means certain upon Victoria's accession in 1837.

During his lifetime Prince Albert was undeservedly regarded as an enemy alien by the public. In 1861 he contracted typhoid from the poor sanitation at Windsor Castle and died. Grief-stricken, Victoria remained in mourning for almost forty years. The public, contrite about its failure to acknowledge Albert's commitment to public duties, raised money for a memorial. A committee was formed to advise the Queen and several leading architects were asked to submit proposals.

Victoria chose the elaborate Gothic design of George Gilbert Scott. The canopy of the memorial is inlaid with mosaics, enamels and polished stone and the elaborate white marble frieze features 169 life-size figures. When Victoria inspected the near-completed monument in 1872, she expressed no opinion, but Scott was knighted. Four years later the central figure of the Prince was added.

A combination of poor maintenance and design led to the gradual deterioration of the memorial. The roof leaked and the inner iron structure rusted and then cracked. In 1915 the gilding was removed to prevent it glistening at night and attracting the attention of German Zeppelins. Declared unsafe in 1983, the memorial was painstakingly restored from 1990–1998.

The nearby Royal Albert Hall was officially opened in 1871. Events as diverse as concerts and tennis tournaments, circuses and motor shows have been held there.

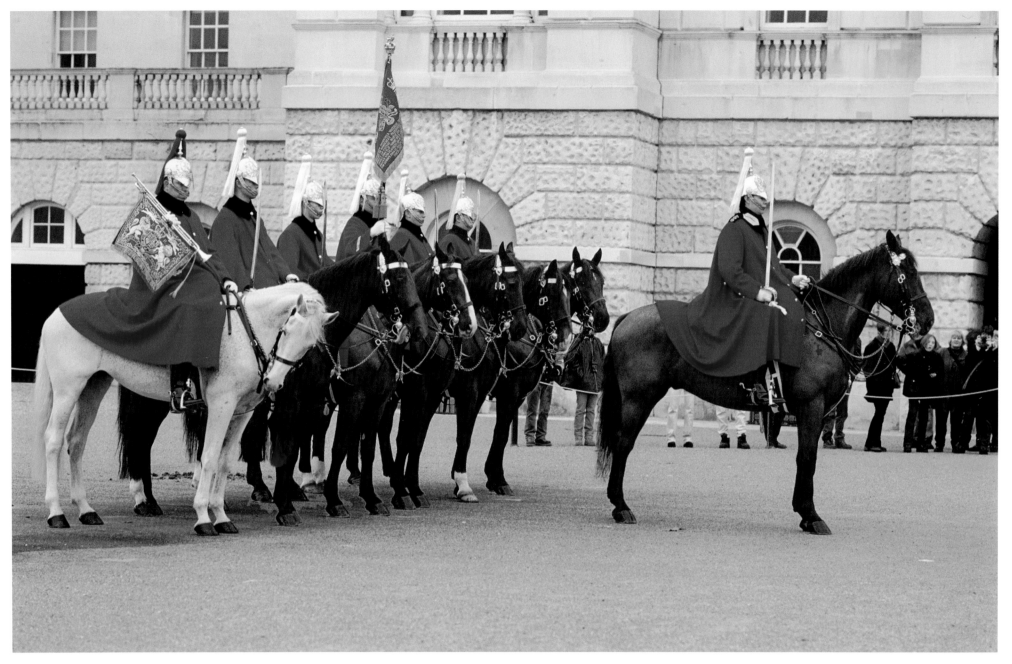

CHANGING THE GUARD AT WHITEHALL

Until 1841 the only access to both St James's Palace and Buckingham Palace was through the Horse Guards complex. This is why for centuries the Household Cavalry has provided the Queen's Life Guard in Whitehall at Horse Guards' Arch. When the Queen is in London, the Guard comprises one officer, one corporal major (who carries the standard), two non-commissioned officers, one trumpeter and 10 troopers. This is known as Long Guard. When Her Majesty is not resident, the Guard is reduced to two non-commissioned officers and 10 troopers. This is known as Short Guard. The Guard Changing Ceremony takes place daily at 11am, except Sundays when it is at 10am.

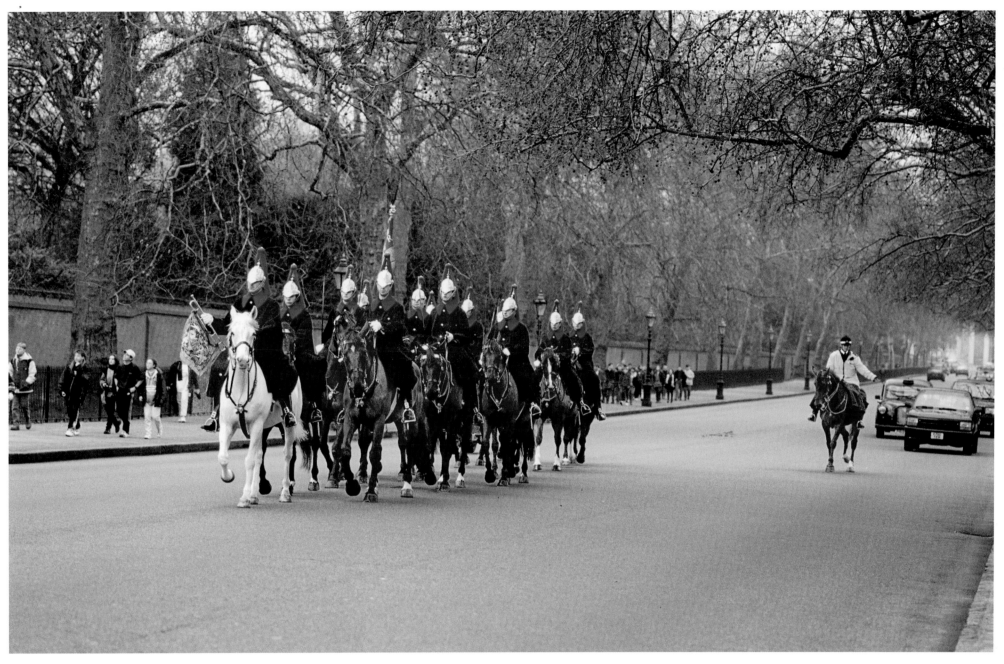

THE HOUSEHOLD CAVALRY

The Queen's Life Guard is provided by the Household Cavalry regiment which is stationed at Hyde Park Barracks. The regiment also provides the sovereign's escort for Her Majesty on all state occasions and various other mounted escorts and dismounted lining parties. Traffic in central London moves slowly at the best of times, but Londoners never complain about pageantry hindering their progress. Indeed, traffic flow in the City is becoming slower. The average speed during the daytime off-peak periods fell from 11.9mph (19km/h) in 1983 to 10mph (16km/h) in 1997.

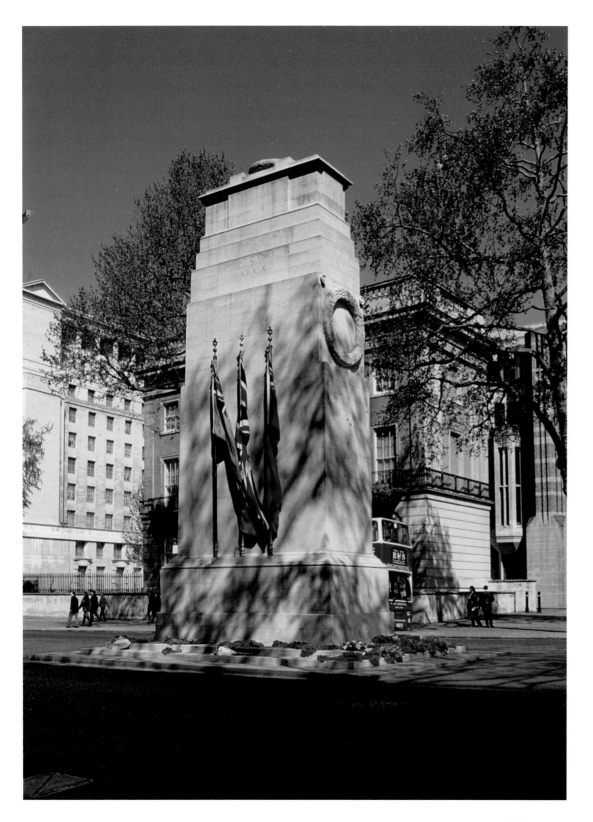

CENOTAPH, WHITEHALL

Each year on the Sunday nearest the eleventh day of the eleventh month at 11am, a service attended by the sovereign, members of the royal family, politicians, service personnel and their families is held at the Cenotaph in Whitehall. This is the national memorial to the 'Glorious Dead' of both world wars. Built in 1919–1920 from Portland stone, its lines are slightly convex and concave to represent infinity. It is adorned with the flags of the three services and the Merchant Navy.

During an earlier era, York Place, the official London residence of the then Archbishop of York, was located in this area. It was greatly extended by Cardinal Wolsey, Archbishop of York from 1514–1529. After Wolsey's fall from favour, Henry VIII took over the residence. He carried out an extensive rebuilding programme. The residence was then renamed Whitehall Palace, either as an acknowledgement of the white stone used in its construction or to follow the then tradition of naming any festive-hall a 'white-hall'.

The only remaining complete part of the palace is the Banqueting House. Designed by Inigo Jones, the building was completed in 1622 and was intended for occasions of state, plays and masques. Charles I commissioned Sir Peter Rubens to add the magnificent ceiling paintings. The King was beheaded on a scaffold outside the Banqueting House on 30 January 1649. It is said that on the morning he wore two vests for fear that any shivers of cold should be thought to be trembles of fear. The Banqueting House is used for a variety of royal and society occasions, charity events and corporate functions.

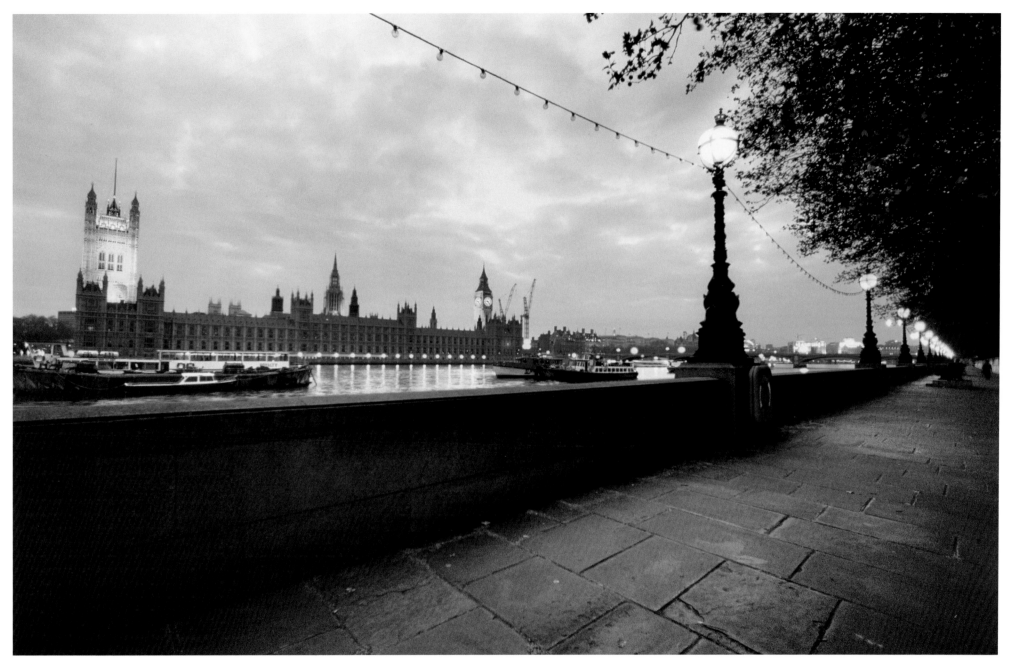

TRADITIONS AT THE PALACE OF WESTMINSTER

The Houses of Parliament are steeped in traditions and customs. In the House of Lords, the Lord Chancellor sits upon the Woolsack, a tradition said to date from the time of Edward III (1327–1377) when a woolsack was regarded as a symbol of the realm's prosperity. In the House of Commons, the facing government and opposition benches are separated by a green expanse of carpet into which two parallel red lines are woven. Members of Parliament may not overstep these, which by tradition are two sword lengths apart. This symbolises non-violent solutions to differences.

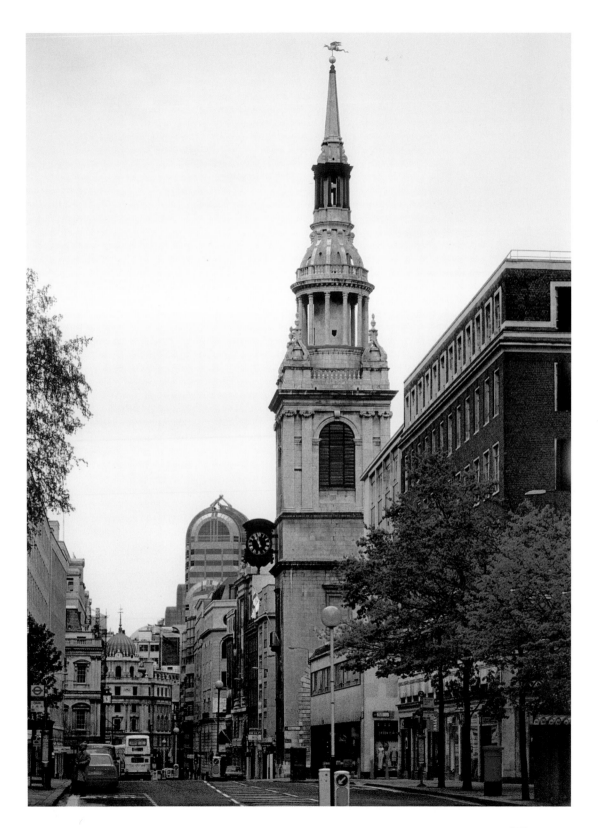

ST MARY-LE-BOW

The church of St Mary-le-Bow in Cheapside is more often than not referred to as 'Bow Bells'. It is said that true Cockneys have to be born within hearing distance of its famous peal of bells. This idea probably originated from the time when the curfew was rung on the bells in the 14th century.

The popular legend that Bow Bells uttered the words, 'Turn again, Whittington, thrice Lord Mayor of London', is but a fable. What we do know as a fact is that in 1472 a merchant called John Dun gave a bell and lands to maintain its ringing at nine o'clock each night to direct travellers on the road to London. In 1520 William Copland gave a larger bell for 'sounding the retreat from work'. During World War Two, the British Broadcasting Corporation (BBC) regularly broadcast Bow Bells to enemy-occupied countries.

The original church was destroyed during the Great Fire of London and was rebuilt by Sir Christopher Wren during 1670–1673. The spire and steeple are considered amongst his finest achievements. Unfortunately the church was bombed during World War Two, but was rebuilt during 1956–1962.

Its history is certainly colourful. In 1196 William Fitz Osbert escaped up the tower, having protested at uneven taxes. After killing one of the Archbishop of Canterbury's guards, he was smoked out and later hanged. The tower collapsed in 1271, killing 20 people. Thirteen years later a goldsmith was murdered. In 1331 a wooden balcony collapsed during a joust to celebrate the birth of the Black Prince, throwing Queen Philippa and her ladies to the ground.

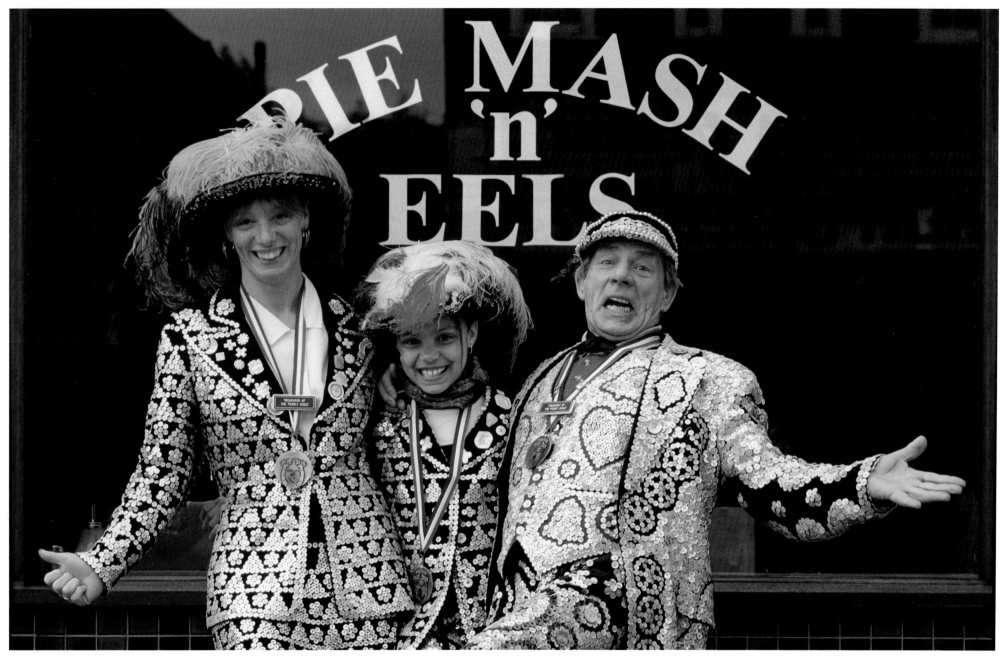

PEARLY KING, QUEEN AND PRINCESS OF PECKHAM

The 'aristocracy' of the costermongers (street sellers), coster kings were originally elected in each borough to protect the rights of traders. Children inherit their parents' titles. In the early 19th century they began to liven up their everyday dress by adding a few pearl buttons. In the 1880s Henry Croft, a road-sweeper and rat-catcher, decided to completely cover his clothes with pearl buttons, incorporating patterns and symbols. The coster kings and queens liked the idea and followed his lead. Today they are known as the Pearly Kings and Queens, and they undertake charity work and spread Cockney cheer.

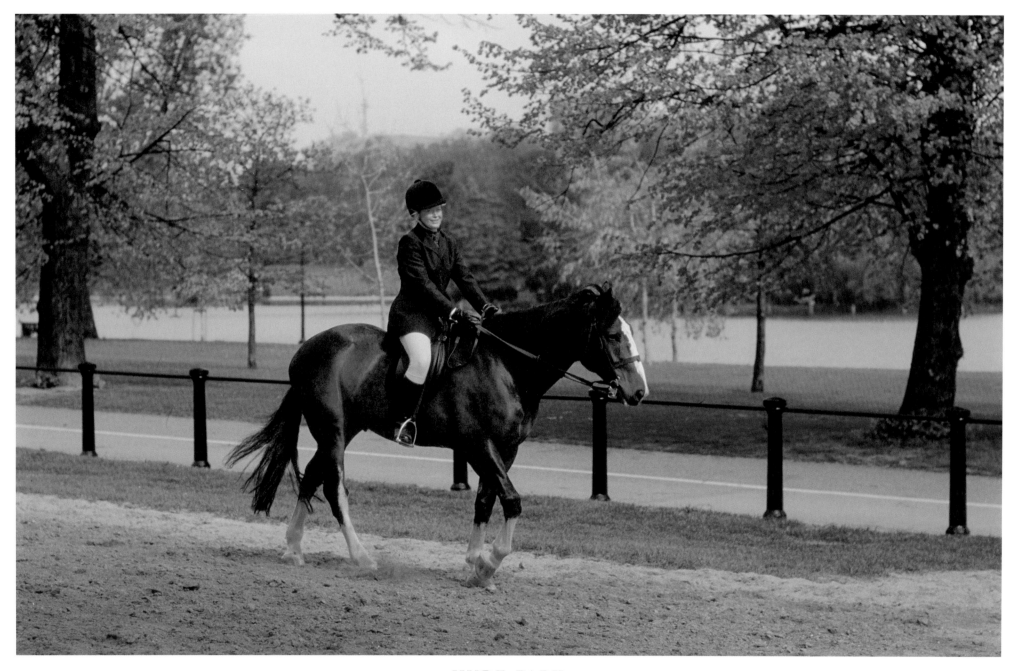

HYDE PARK

Hyde Park was acquired by Henry VIII, upon the Dissolution of the Monasteries, as a hunting ground. Of all the London parks, the 65-acre (26.3ha) Hyde Park is the city's most informal. One of its famous features is the Serpentine, an artificial lake covering nearly five acres (2ha), which was constructed on the orders of Queen Caroline in 1730. Today the lake is used both for boating and public bathing. Traditionally the regular bathers always take a dip on Christmas morning, whatever the weather – even if the ice has to be broken before they can enter the water.

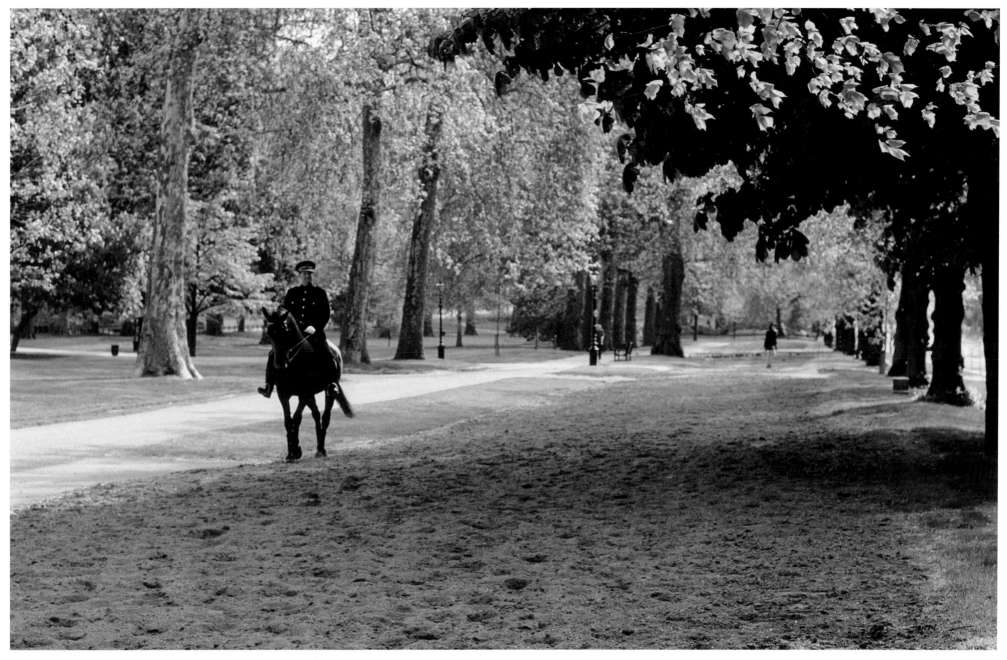

ROTTEN ROW, HYDE PARK

There are some five miles (8km) of bridle-ways in Hyde Park – the most beautiful setting for horse riding in any of the world's capital cities. Rotten Row has attracted riders for over 300 years and it is still regularly used by the Horse Guards and civilians. Its somewhat strange name is a corruption for *route du roi*, the French for King's Way. It links Kensington and St James's Palaces and was the first lighted roadway in England. In 1690 William III ordered 300 oil lamps to be hung from the trees to deter highwaymen and robbers, but to no effect. The writer Horace Walpole was relieved of his watch and money here in 1749.

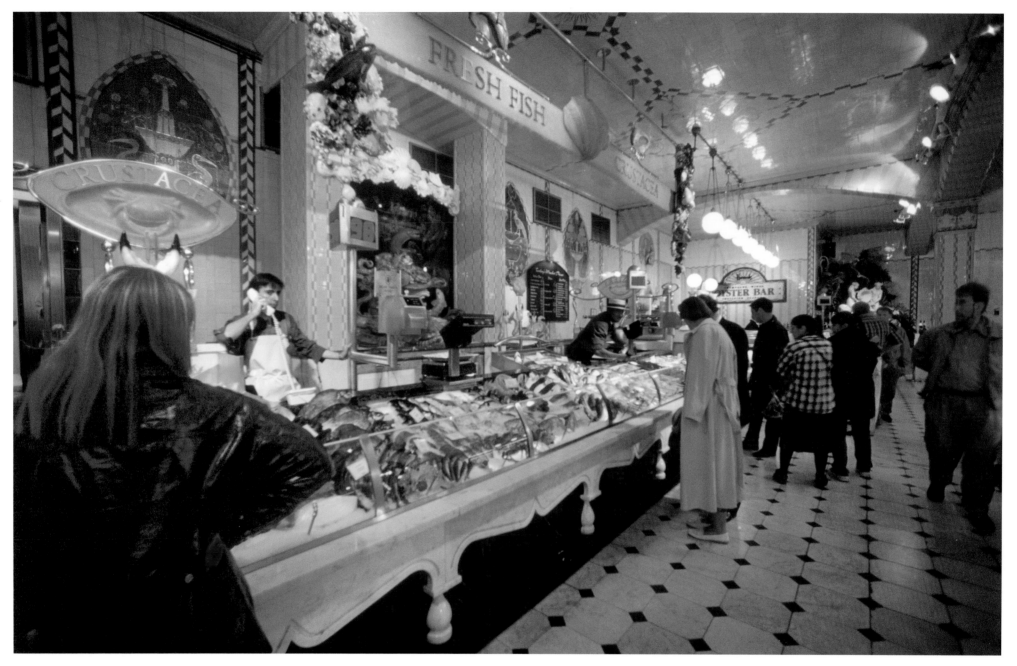

FOOD HALLS, HARRODS

As Harrods's roots lie in the grocery trade, it is not surprising that its food halls are still the heart and soul of the business today. While most impressive at Christmas time, the halls continue to offer a great variety of stock throughout the year. As a matter of routine the choice is: 350 types of cheese; 150 types of bread; 1200 different wines and spirits; 151 varieties of tea; 27 types of coffee; 45 home-made pâtés; up to 50 types of wet fish; three types of caviar; and three types of oyster. The gourmet's lust is not only satisfied here. There are 19 bars and restaurants throughout the store.

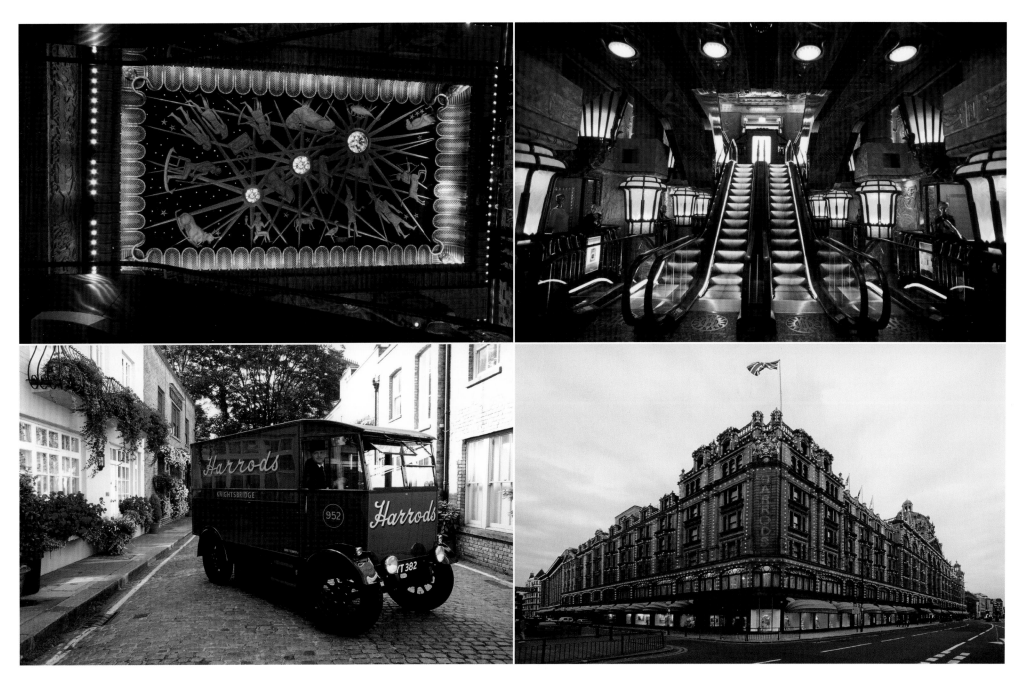

HARRODS

Its motto is *Omnia Omnibus Ubique* – all things for all people, everywhere. From its origins as a wholesale grocer in 1834, Harrods has grown into one of the world's most celebrated stores. In 1898 it was the first London store to install an escalator. Nervous customers were given free smelling salts or even brandy at the top of its moving staircase. From the mid-1980s it underwent a lavish refurbishment that included a new Egyptian Hall for retailing luxury gifts from around the globe. However, not even Harrods can satisfy everyone. One outraged customer complained that one of the store's drivers had the audacity to park outside a neighbour's home while delivering her order!

ROYAL BOTANIC GARDENS, KEW

Located on the banks of the Thames River, between Richmond and Kew, the Royal Botanic Gardens comprise mainly the Richmond and Kew estates, which once belonged to the royal family. The present-day gardens owe their origin to Augusta, dowager Princess of Wales and mother of George III. In 1759 she transformed part of the Kew estate into a botanic garden. The ordered collection of plants was assembled primarily for scientific and educational purposes. Her gardener was William Aiton and her botanical adviser, Lord Bute. The Chinese Pagoda, which still towers nearly 164 feet (50m) above the gardens, was among several buildings contributed by the architect Sir William Chambers.

George III inherited the Richmond estate from George II, his grandfather. On the death of his mother in 1772, he also acquired the Kew estate. The two properties were subsequently combined.

Sir Joseph Banks became the unofficial director and it is mainly due to him that the gardens are so famous today. On his orders, collectors searched the world for plants of economic, horticultural and scientific interest.

The gardens were acquired by the state in 1840, and the royal family donated additional land then and in later years. The gardens now cover an area of about 300 acres (121.5ha).

Although a visual delight for visitors, Kew is first and foremost a scientific institution, making significant contributions to increasing our understanding of the plant kingdom. Kew has a dried-plants collection with six million specimens, while its vast collection of living plants represents about 10 per cent of the world's flora.

WOODLAND, ROYAL BOTANIC GARDENS

In 1761 when Queen Charlotte married George III, she received a small single-storey cottage in the grounds of Richmond Lodge as a wedding gift. It was used as a summer house. To celebrate her Diamond Jubilee of 1897, Queen Victoria gave Queen Charlotte's cottage and the surrounding land to the nation. The area behind the cottage is now managed as a native woodland. Bluebells flourish here in the spring and among the birds that can be seen are tawny owls, blue and great tits, sparrowhawks and green woodpeckers. This conservation area also supports many insects, including rare hover-flies.

PRINCESS OF WALES CONSERVATORY, ROYAL BOTANIC GARDENS

Built in the mid-1980s, this conservatory replaced 26 individual houses which were showing considerable signs of structural deterioration. With a floor space of 48,330 square feet (4490m²) under a single multi-span roof, the house has 10 different environmental zones. The major two encompass the wet and dry tropics, while smaller areas are devoted to species with specialised environmental requirements. Each zone is continually monitored by a computer, which adjusts the heating, misting, ventilation and lighting systems as required. Approximately 450 tonnes of rock and 1000 tonnes of compost were used for the internal landscaping. The conservatory was opened by HRH the Princess of Wales on 28 July 1987.

KEW PALACE

This is the smallest and most intimate of the royal palaces. Formerly known as the Dutch House, it was built in 1631 by a prosperous London merchant with Dutch parentage. Queen Caroline, the wife of George II, acquired a 99-year lease on the property in 1728 at an annual rent of £100 and a fat doe. From 1781 it was primarily used as an annexe to the White House, George III's nearby residence which he had demolished in 1802. It was in the garden here that the older children of George III were instructed in 'practical gardening and agriculture'. The palace remained in royal occupation until 1818.

SPRING AT THE ROYAL BOTANIC GARDENS, KEW

Each autumn Kew's horticultural staff spend up to five weeks planting bulbs. The fresh colours of their blooms announce the coming demise of winter and herald the beginning of a new gardening year. In 2004 an estimated 2.4 million bulbs burst into flower. It started in February with a brilliantly coloured carpet of 1.6 million crocuses. A host of golden daffodils followed in March. Are they giving a hint of sunnier days ahead? Lift your eyes from the ground and there is more to see. The white and pink blossoms of Kew's cherry trees and magnolia abound. Visiting Kew in spring is an inspiring experience: it is a feast for the eyes to behold.

EMBANKMENT PLACE, CHARING CROSS

Viewing London from any tall building provides an opportunity of seeing familiar landmarks from a different perspective. In the late 1980s a new landmark began to emerge beside the Thames River above Charing Cross Station. It is a nine-storey office block designed by Terry Farrell, considered a master of spatial planning.

The idea of constructing an 'air rights' building above Charing Cross Station was born in 1985 when the developer Greycoat bought Law Land, a 19th-century property company which owned land adjacent to the station. Greycoat had a good relationship with British Rail, then owners of the station, and the plans advanced.

From the outset, Greycoat wanted a 'building of drama'. It wished to have a design that was distinct, but which could take its place among the existing range of noble buildings on the banks of the Thames. Additionally, because of the huge costs of building over a railway terminus, it had to be sufficiently large to make it a viable economic proposition.

The building, with its stunning arched roof, is supported by columns sunk deep into the London clay through the platforms of the station below. The result is a much-admired piece of modern architecture.

Charing Cross, opened in 1864, is a busy main line station. Its six platforms and 742 trains serve an average of 97,000 passengers a day.

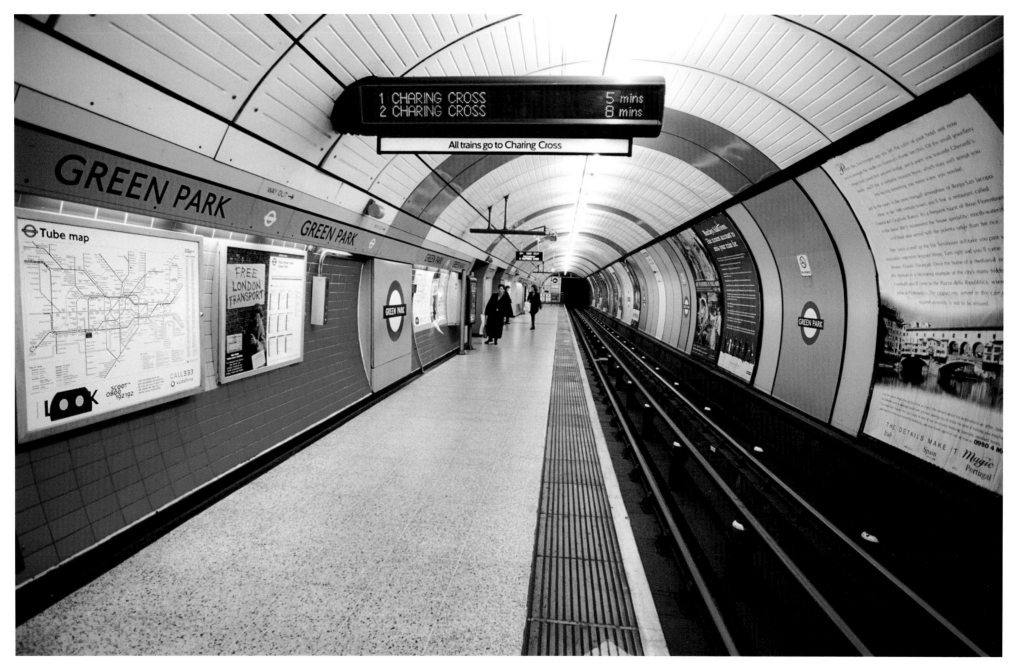

THE WORLD'S OLDEST UNDERGROUND RAILWAY

It surprises many Londoners and amazes all visitors that the London Underground runs to a timetable. The first section was opened in 1863 and ran from Paddington to Farringdon, a distance of 3.73 miles (6km). Today, it stretches westwards to Amersham and eastwards to Upminster – respectively 26.71 miles (43km) and 18 miles (29km) from central London. Serving 275 stations, the system carries 942 million passengers some 4578 million miles (7367 million km) a year at an average speed, including station stops, of 20.5mph (33km/h). At peak times 514 trains are required for its operation. Following the extension of the Jubilee line to Stratford in November 1999, trains on this line no longer go to Charing Cross.

LONDON UNDERGROUND

Of the 244 miles (391 km) of track, 46 per cent of London's Underground runs below ground level. Hampstead boasts the deepest station at 192 feet (58.5m), while the maximum depth the system runs below the surface is at Holly Bush Hill, Hampstead, where 221 feet (67.4m) of earth separates passengers from a view of the sky. A total of 398 escalators and 102 lifts service the railway. Angel Station's escalator is the longest at 197 feet (60m), while the shortest is a mere 30 feet (9.1m) at Chancery Lane. The station with the most escalators – a total of 25 – is Waterloo, which also has two passenger-conveyors.

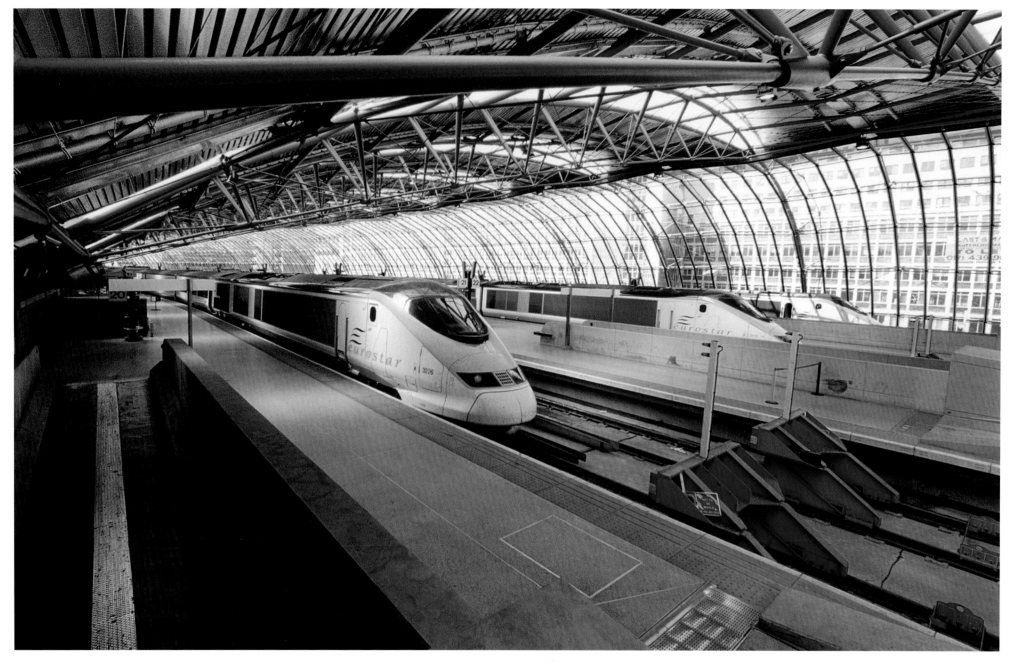

WATERLOO INTERNATIONAL

It is now possible to travel by Eurostar from the centre of London via the Channel Tunnel to Paris or Brussels without changing trains. Waterloo International covers 7.5 acres (3ha). Its dramatic, tapering roof was constructed from 2.5 acres (1ha) of glass and 2 acres (0.81ha) of stainless steel sheeting. The 1312-feet (400m) long Eurostar trains travel smoothly up to 186.4mph (300km/h) and seat up to 766 passengers – the equivalent of two fully loaded Boeing 747 'Jumbo' jets. When the high-speed line in Britain is completed during the first decade of the millennium, the travel time from London's St Pancras Station to Brussels and Paris will be 120 and 140 minutes respectively, reducing the current journey time by 40 minutes.

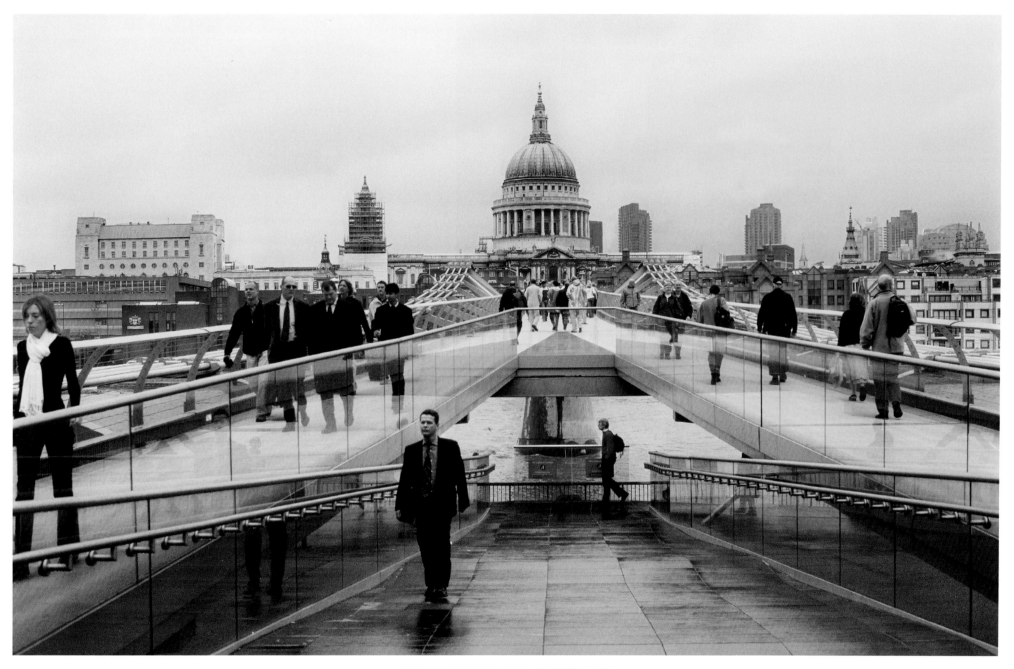

MILLENNIUM BRIDGE

This is the first pedestrian river crossing over the Thames in central London for more than a century. Technically it is a shallow suspension bridge designed to give unrivalled and unimpeded views of London free from traffic high above the river. Its 325-metre span links St Paul's Cathedral with the Tate Modern Gallery and incorporates an innovative light pipe system at deck level, creating a 'blade of light' across the water. Opened by Queen Elizabeth II in June 2000, it immediately became known as the Wobbly Bridge as it moved wildly as people flocked across. Closed within days of its opening, it took 18 months and £5 million to correct the fault.

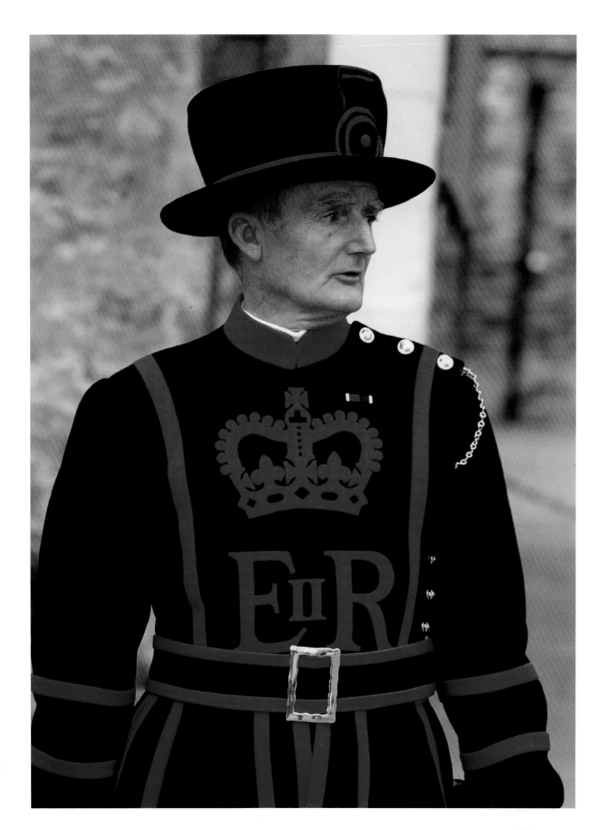

YEOMAN WARDER

Visit the Tower of London and the Yeoman Warders will be wearing their everyday blue undress uniform. Their resplendent predominantly red-and-gold ceremonial uniform with red stockings, white ruff and black patent shoes is reserved for state occasions. These include visits to the Tower by the reigning monarch, coronations and lyings in state. They will also wear their ceremonial uniforms at the Lord Mayor's Show each November and at charity functions. Additionally, there are State Parades within the Tower at Easter, Whitsunday and on the Sunday before Christmas Day. On these occasions the Yeoman Warders escort the Governor from Queen's House to a service in the Chapel of St Peter ad Vincula and back again.

The Yeoman Warders are responsible for the Tower's security as well as looking after the three million tourists who visit the fortress each year. In addition to posing for photographs and answering questions, they also conduct guided tours. Each evening the Chief Yeoman Warder, or his deputy, the Yeoman Gaoler, takes part in the Ceremony of the Keys. Dating back some 700 years, this is one of the oldest traditions at the Tower. Just before 10pm, the warder, with military escort, proceeds to lock the Tower's outer gates. As he returns, a sentry challenges him at the Bloody Tower. Once the keys have been identified as the sovereign's, the warder proceeds to the Governor to whom the keys are handed for safekeeping overnight.

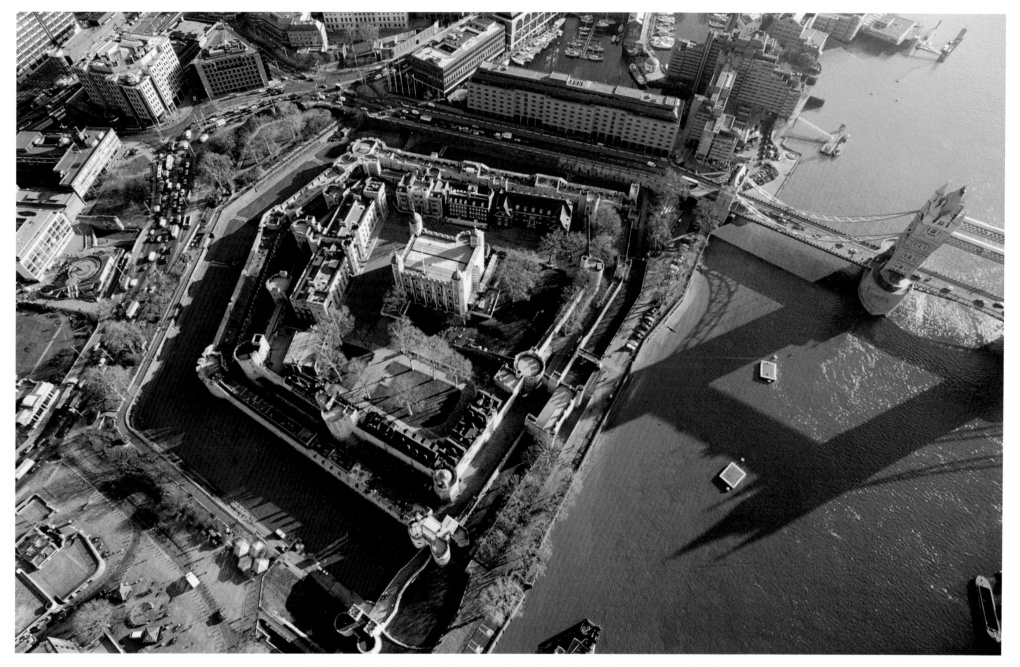

THE RAVENS OF THE TOWER OF LONDON

Although there are no dungeons at the Tower of London, it has housed plenty of prisoners. The first was the Bishop of Durham who in 1100 escaped from the White Tower by shinning down a rope. There are no prisoners today, but great care is taken to ensure six 'guests' never leave. They are the ravens, traditionally birds of ill omen. Legend has it that if the ravens left, the White Tower would fall and a great disaster befall the kingdom. Charles II decreed that six should always be kept there – today, two are even held in reserve. Their daily diet is raw meat and bird biscuits soaked in blood.

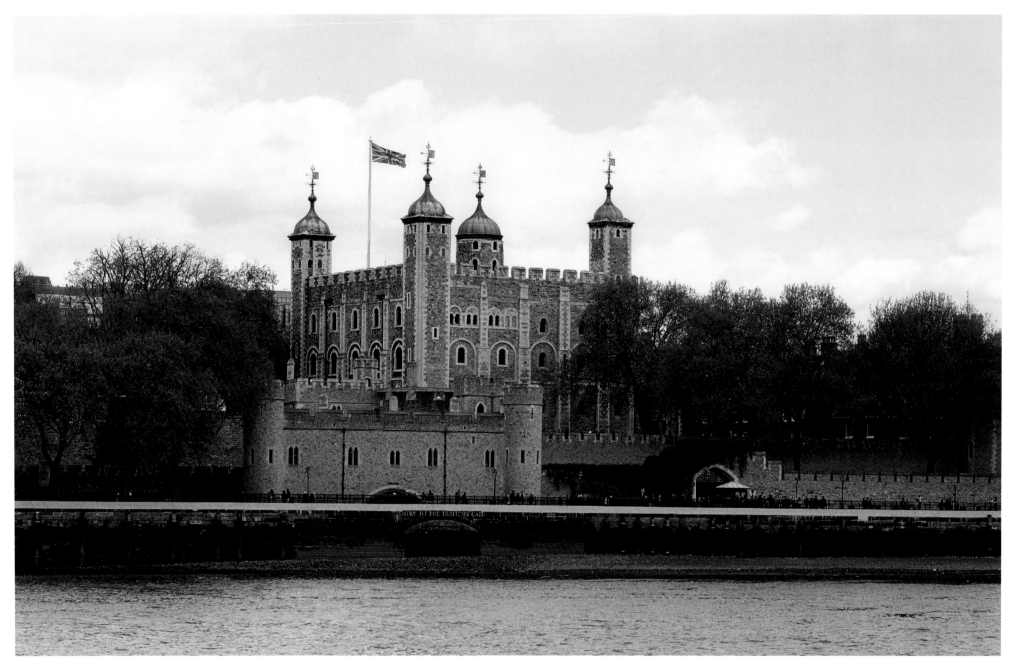

TOWER OF LONDON

Charles I inadvertently lay the foundations for England's banks here in 1640. Up until then wealthy citizens kept their valuables at the Tower. To help finance his skirmishes with Cromwell, Charles purloined the lot. When he repaid all, the good citizens then entrusted their wealth to the stout safes of their goldsmiths. The written instructions to hand money to third parties developed into cheques and banking began. The private treasures have long gone, but the Tower has been a depository for the Crown Jewels for centuries. The 530-carat First Star of Africa is set in the Sceptre with Cross, while the 109-carat Koh-i-Noor diamond sparkles in the late Queen Mother's crown.

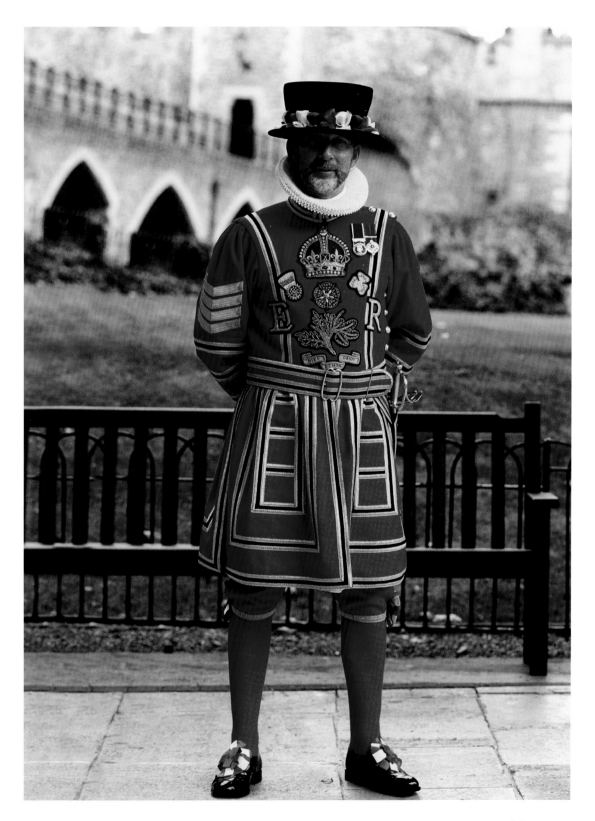

YEOMAN WARDER
IN CEREMONIAL DRESS

There are 36 Yeoman Warders at the Tower plus the Chief Yeoman Warder and the Yeoman Gaoler. Popularly known as 'Beefeaters', the Yeoman Warders are all former long-serving Senior Non-Commissioned Officers from the British Army, Royal Air Force, Royal Marines and Royal Navy.

New Yeoman Warders are sworn in on Tower Green. The oath of allegiance dates back to 1337. After the ceremony the new recruit joins the other Yeoman Warders and his health is toasted by the Chief Yeoman Warder from the ceremonial pewter punch bowl. The bowl dates back to 1722 and was a gift from Yeoman Warder Wilkins who was found to be earning a living as an innkeeper while he should have been on duty. The Chief Yeoman Warder toasts newcomers with the words, 'May you never die a Yeoman Warder'. Originally the post of Yeoman Warder was sold for 250 guineas (£262.50). Upon the warder's retirement, £250 was returned and the remainder was retained by the constable who recruited him. Should the warder die in his post, the constable retained the whole sum.

So, why are they called Beefeaters? In the past, those on duty were given a daily meat ration. In 1813, 30 men received 24lbs (10.9kg) of beef, 18lbs (8.2kg) of mutton and 16lbs (7.3kg) of veal.

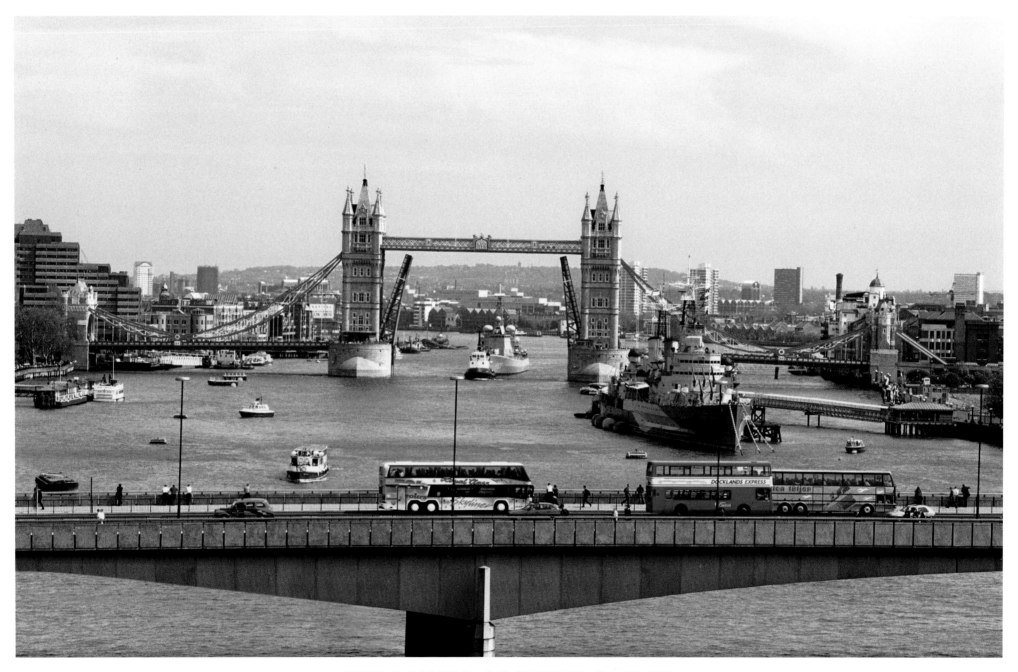

THE RAISING OF TOWER BRIDGE

A warship passes through Tower Bridge to berth alongside HMS Belfast, the cruiser built for the British Royal Navy in 1939 which is now permanently moored at Symon's Wharf. The bridge is raised about 500 times a year. In 1997 United States President Bill Clinton unexpectedly witnessed the bridge in operation. Half of his large motorcade had crossed from the south to the north bank when the traffic was halted and the bridge raised to allow a humble barge pass. The President and First Lady sat in their stretch limousine for 10 minutes and viewed the proceedings, while the frantic security men on the other bank watched helplessly.

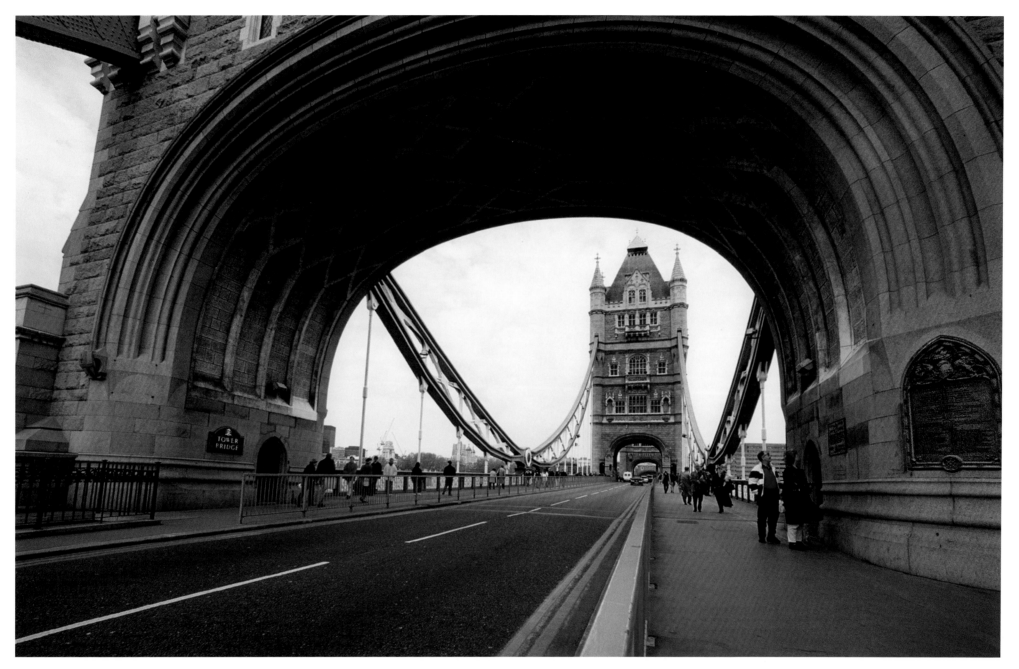

THE ROAD ACROSS TOWER BRIDGE

River traffic has the right of way along the Thames as opposed to vehicles crossing Tower Bridge. When the bridge is opened, a carefully synchronised plan comes into operation. As a vessel approaches, the bridge's lookout advises the duty policeman who halts the vehicles using traffic lights. In addition, a tugboat is on permanent standby to assist the passage of vessels through the bridge. Despite these precautions, numerous incidents have occurred here. One bus driver – to the great alarm of his passengers – inadvertently proceeded through the red light, sped along the rising roadway and 'flew' his vehicle across a gap of several feet.

CLEOPATRA'S NEEDLE

This 186-tonne obelisk, standing on the Victoria Embankment, is certainly well-travelled. Cut from the granite quarried in Aswan in about 1475 BC, it was ferried down the Nile to be erected at Heliopolis, an ancient Egyptian city about 15 miles (25km) northwest of Giza. It was later moved to Alexandria and erected there, but at some point in the following centuries it toppled over and lay in the sand.

The obelisk was presented to Britain in 1819 by Mohamed Ali, the Turkish Viceroy of Egypt. It was initially considered too large to transport to England. However, on the basis that the French had managed a similar achievement, the English engineer John Dixon was asked to do likewise. Erasmus Wilson, a surgeon, gave £10,000 to finance the project and Dixon spent £5,000 building a cylindrical iron pontoon in which to transport the gift. The obelisk – nearly lost at sea when the crew encountered a gale in the Bay of Biscay – eventually reached London in 1878.

Although the obelisk bears hieroglyphics relating to Thutmose III and Ramses II, it has no direct association with Cleopatra. The plaque at its base probably explains why it is called Cleopatra's Needle, for one phrase reads, 'Alexandria, the Royal City of Cleopatra'. When erected in 1879, the morning's newspaper, Bradshaw's Railway Guide, a razor, a box of pins, a set of coins, four bibles in different languages, and the photographs of 12 beautiful women were placed in the foundations.

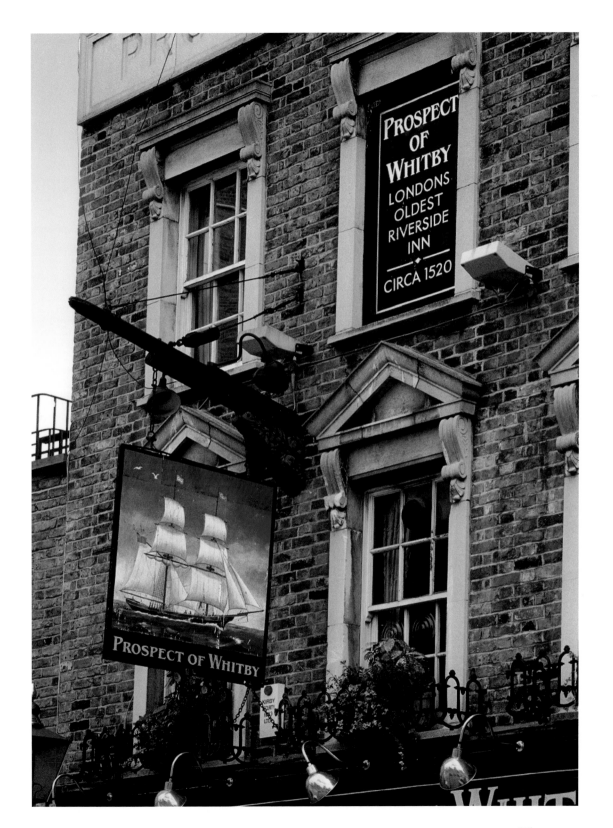

PROSPECT OF WHITBY, WAPPING

Originally built in 1520 as a timber-framed country house, the Prospect of Whitby soon afterwards opened as a tavern. At one time it was known locally as the Devil's Tavern, for it was the haunt of river thieves and smugglers. Before the opening of London's docks in 1802, ships had to berth in the middle of the Thames, the cargo being transported to the quayside by flat-bottomed boats. The opportunities for pilfering were immense. It was at the tavern that many a plan was hatched and many an illegal transaction took place.

In 1777 the tavern was renamed. A collier from Whitby, called the Prospect, regularly moored off the tavern in the 1770s, and locals began to refer to it as 'the one by the Prospect of Whitby'. Possibly eager to shake off the hostelry's reputation, the then landlord officially adopted the name. Wapping certainly had a reputation. Samuel Pepys often made references to the disturbances caused by sailors, many of whom lived in the area. Pepys regularly visited the tavern on official Royal Navy business. Today, the Ancient Society of Pepys still holds luncheons and dinners in the diarist's honour in the tavern's Ye Pepys Room.

However, its past is not just connected with smuggling. In 1780 a sailor returning from Japan sold an unidentified plant later known as the fuchsia to a local market gardener at the tavern. In the 19th century it became a haunt of writers and artists, including Charles Dickens, Joseph Turner, Gustave Doré and James Whistler. In more recent times, Paul Newman, Glenn Ford and Rod Steiger have soaked up the unique atmosphere of the Prospect of Whitby.

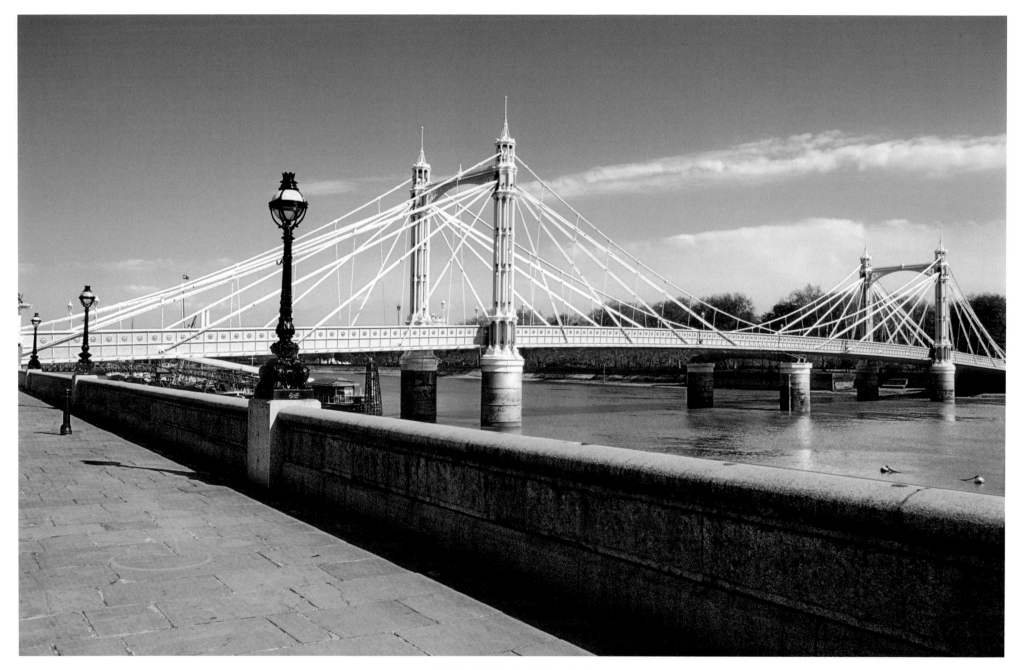

ALBERT BRIDGE

It may look modern, but it was built during the period 1871–1873. The work of R.M. Ordish, this three-span bridge was constructed using his 'straight-link suspension' system. The result is a design that utilises elements of both the cantilever and suspension methods of bridge construction. Built as a cantilever structure, each half is supported by 16 straight wrought-iron bars which radiate from the top of the two ornamental cast-iron towers. However, it was not built with today's heavy traffic in mind. In the early 1970s, a central support had to be added to strengthen the bridge.

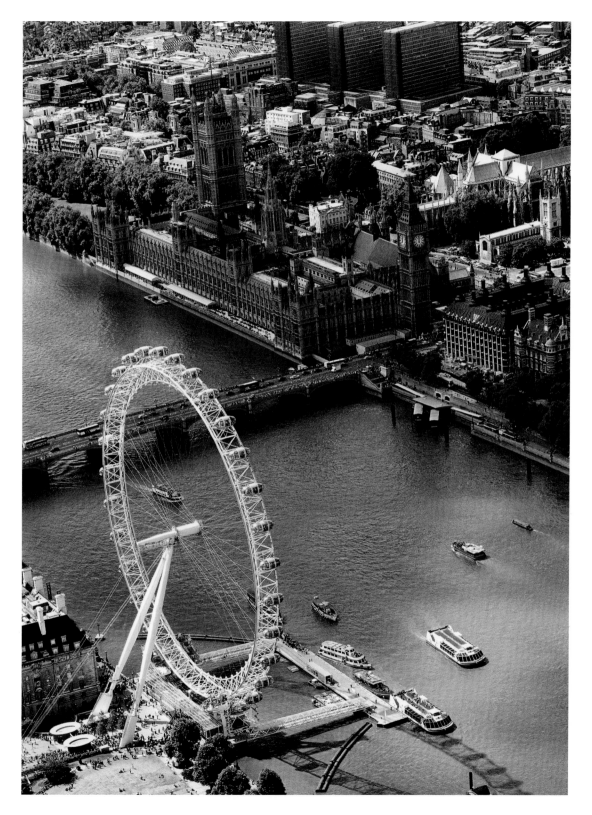

BRITISH AIRWAYS LONDON EYE, SOUTH BANK

When ideas were sought for ways in which London could celebrate the dawn of the third millennium, many landmarks and monuments were proposed. However, none has been more popular than the one suggested by the architects Davis Marks and Julia Barfield: a large observation wheel to be built on the bank of the Thames. In 2003 it was voted the best attraction in Britain by overseas visitors, receiving more than double the votes of its nearest rival. It is estimated that the Eye accounts for 1.5 per cent of London's tourist revenue.

Although its inaugural flight was in 2000, work began seven years earlier. Because there was no single place that it could be constructed, its components were built at different locations throughout Europe. The main structure was built in Holland with tubular steel provided by British Steel; the hub and spindle were cast in the Czech Republic; the bearings came from Germany; the cables were made in Italy; and the capsules were created in France. The different parts of the structure were sailed up the river by barge. Its rim was assembled horizontally on temporary platforms built up from the riverbed and then lifted into place by cranes.

The wheel has a diameter of 450 feet (135m). It weighs 1900 tonnes in total with each capsule weighing 1.5 tonnes. It travels at 10.24 inches (0.26m) per second and takes 30 minutes to complete a revolution. On a clear day, the viewing distance is 25 miles (40km). Offering unrivalled views of London, it is a beautiful landmark in its own right.

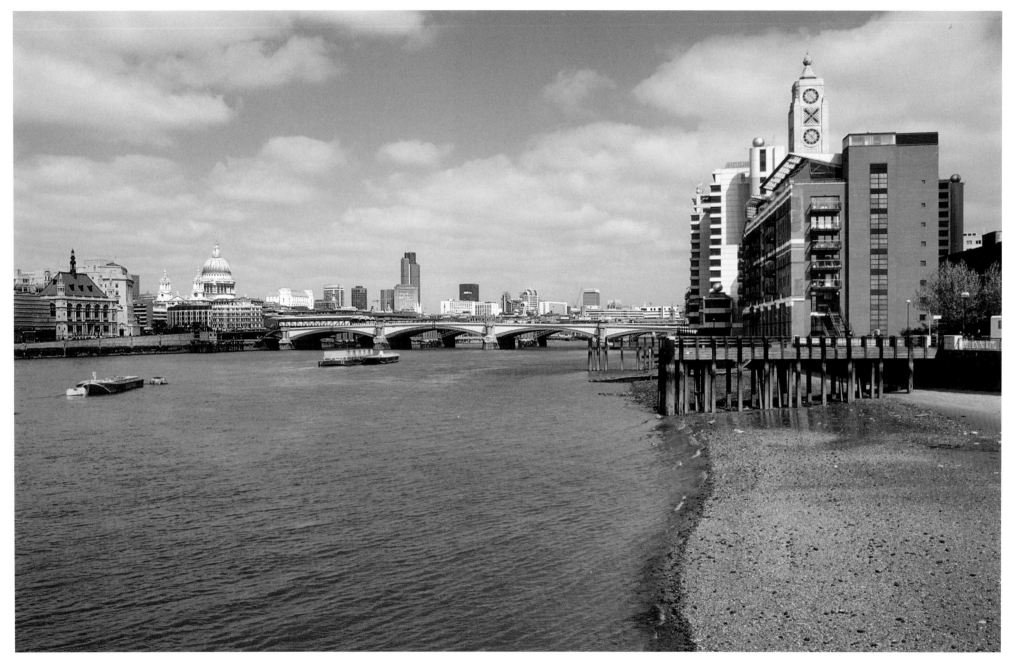

OXO TOWER WHARF

The royal barge was once moored here, but in the late 18th century the area was taken over by slum housing and industry. In 1905 the Post Office built a power station here. In the late 1920s it was acquired by the company that owned the Oxo brand for use as a coldstore and meat-packing warehouse. The tower was added, and the word 'oxo' was incorporated into the design of its Art Deco windows. By 1970 it was yet another empty warehouse, but in the mid-1980s regeneration of the area led to the provision of housing, shops and studios for designers. Harvey Nichols now operates a restaurant on the top floor of the tower which enjoys stunning views over London.

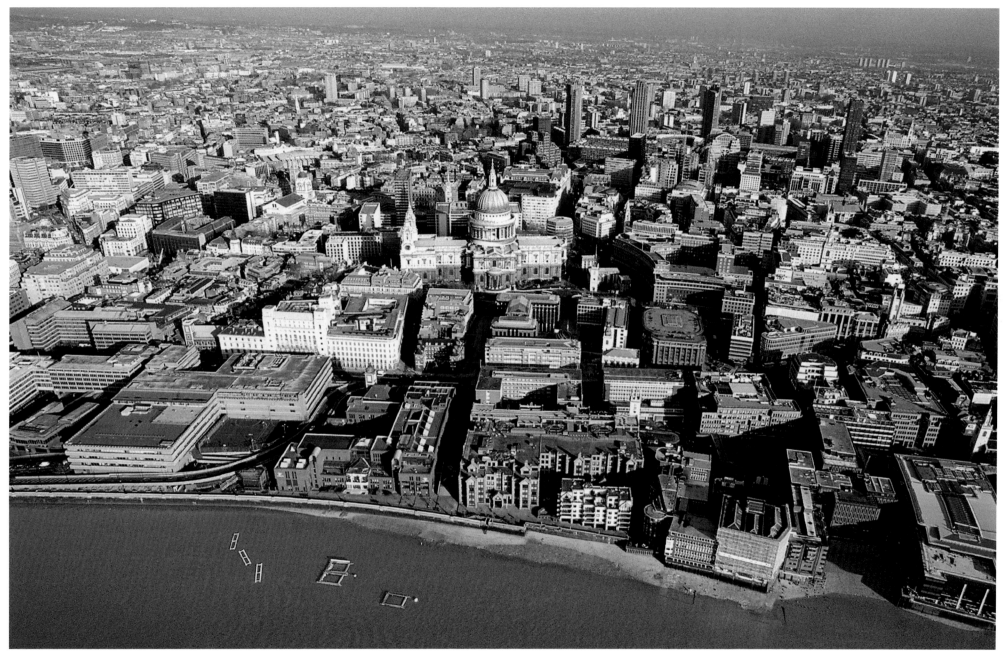

CITY OF LONDON

One of the most famous and ancient traditions of the Corporation of London is that of granting the Freedom of the City. Although today this confers no special privileges, many myths have been created over the centuries. The most famous is the right of freemen to drive sheep over London Bridge. The myth is based on the fact that freemen were exempt from bridge and other tolls. The last freeman to herd his sheep over the bridge – at four in the morning in order to avoid traffic and for the safety of the animals – suffered the embarrassment of three sheep bolting. It eventually took seven hours to round them up.

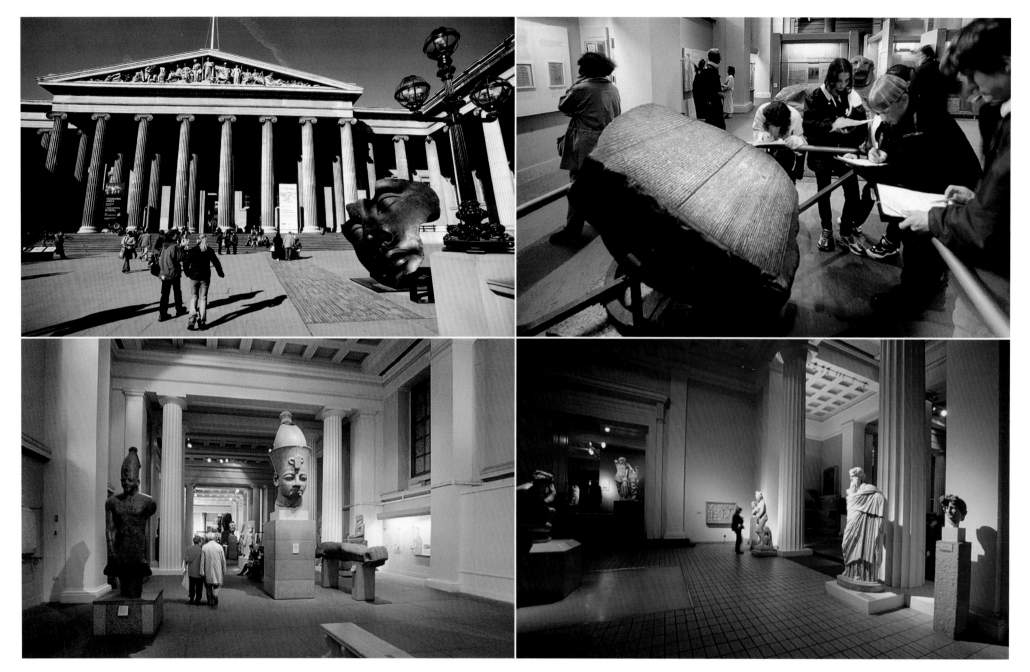

BRITISH MUSEUM

It is the most magnificent treasure house in the world, with a wealth and range of collections unequalled by any other national museum. The Rosetta Stone, the Elgin Marbles, Egyptian mummies, Botticelli and Michelangelo drawings, Assyrian reliefs, the Lewis Chessmen and the Sutton Hoo Treasure are all to be found here, together with some seven million other objects. Founded in 1753, with the acquisition of the collection of Sir Hans Sloane, today the museum attracts some six million visitors a year. Its present building dates from 1823. In recent years it has undergone extensive refurbishment as part of the British Museum's 250th Anniversary Programme of Development.

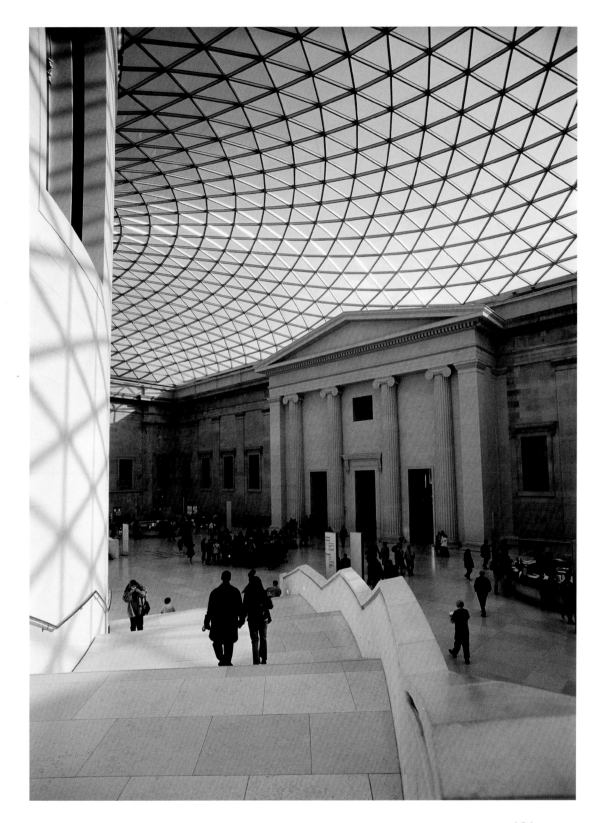

QUEEN ELIZABETH II GREAT COURT, BRITISH MUSEUM

The courtyard at the heart of the British Museum was one of London's long-lost spaces. When Sir Robert Smirke designed the building in 1823, it featured an elegant quadrangle with an imposing portico on each side. Even before construction was completed in 1850, it was apparent that there was insufficient space for the museum's fast-growing library. To solve this problem, the circular Reading Room was built in the quad. It opened in 1857 and soon became surrounded with storage buildings. The area intended as a garden was lost and forgotten.

The library's departure in 1998 to its new home in London's St Pancras, offered the opportunity to recapture the hidden space. The Reading Room has been restored to its original 19th-century splendour, and all the other buildings have been removed. The southern portico, which was demolished to enlarge the museum's entrance hall in the 1870s, has been reinstated, but with a new design. A glass and steel roof that has no visible supports covers the area that is now known as the Great Court. It is the largest covered square in Europe. The stunning roof has a complex geometric form, resulting in each of the 3312 triangular glass panels being a different size and shape.

The court is now the hub of the museum, allowing access to all parts of the building. It is equipped with a range of new facilities, including galleries, exhibition spaces, state-of-the-art auditoria, education and study rooms, shops and restaurants.

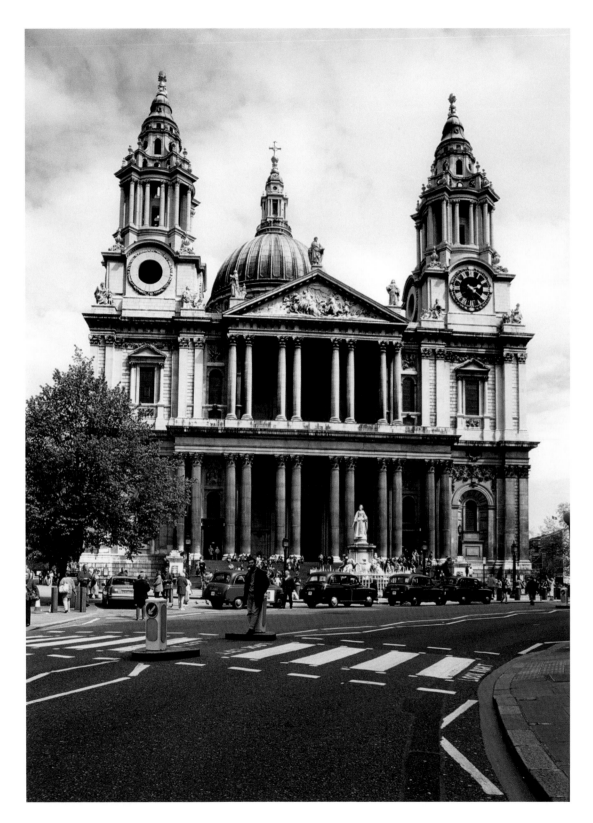

ST PAUL'S CATHEDRAL

In 1663 Sir Christopher Wren was asked to renovate the old St Paul's Cathedral – a magnificent example of 12th-century Norman architecture. Instead of restoration, Wren strongly recommended demolition and rebuilding, a proposal that was adamantly rejected by the authorities. Ironically, the architect submitted his renovation plans just six days before the cathedral was destroyed by the Great Fire of London.

Although Wren was unexpectedly granted his wish to rebuild, matters did not progress smoothly. He submitted three plans for the new cathedral. When Charles II rejected his favourite design, it is said Wren burst into tears. The final royal warrant approving the plans gave Wren permission to modify the design. Changes made during construction included shortening the nave and replacing the planned steeple with a dome.

In 1696, 21 years after construction began, an earthquake in Dorset slowed supply of the Portland stone. This was but one of Wren's problems. More importantly, he feared the authorities would insist on economies being made. He abandoned the traditional construction method of building from east to west and, instead, worked on the entire structure simultaneously. As no one section of the building was being completed, as it would have if he had worked traditionally, the Parliamentary Committee protested against the 'slow progress' and Wren's salary was halved. The arrears were paid in 1711, a year after the building was completed, but only after the 80-year-old Wren appealed personally to Queen Anne.

Today, St Paul's is an important feature of the London skyline. Its dome is the third largest in the world and the cross which surmounts it is some 366 feet (111m) above street level.

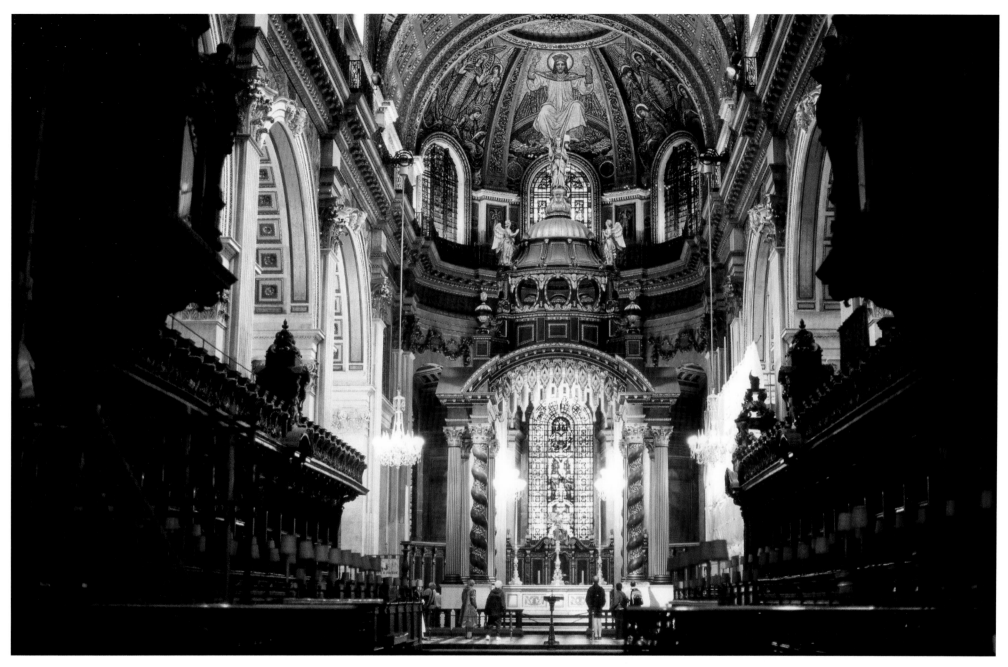

THE CHANCEL, ST PAUL'S CATHEDRAL

During World War Two, a bomb crashed into the north transept of St Paul's Cathedral while another destroyed the Victorian high altar and damaged its marble screen. The present altar, with its canopy based on a sketch by Wren, dates from 1958. Made of marble and gilded oak, it commemorates the Commonwealth dead of both world wars. The choir stalls and organ casing, featuring delicate carvings by Grinling Gibbons, were not damaged. The organ was installed in 1695 and has been rebuilt on several occasions. With 7189 pipes, five keyboards and 138 organ stops, it is the third largest organ in the United Kingdom. Prince Charles married Lady Diana Spencer at St Paul's in 1981.

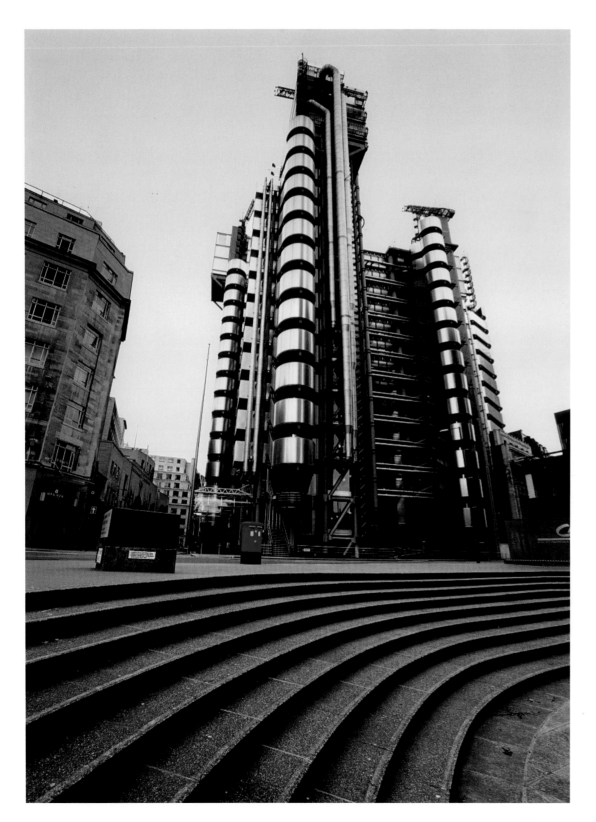

The business started in a coffee shop in the late 17th century. Today the company, whose messengers are still called waiters, has an income of £20 million each working day. Lloyd's is not an insurance company, but a society of individual and corporate members, each of whom accepts insurance risks as a member of one or more underwriting syndicates. Individual members are liable to the full extent of their private wealth to meet their commitments.

Between 1988 and 1992, in common with other insurers worldwide, Lloyd's was faced with claims arising from an unprecedented volume of natural and man-made catastrophes. Additional claims arose from events which happened years ago, such as the latent health risks associated with the use of asbestos. The Lloyd's syndicates suffered losses totalling nearly £8 billion. Many members have consequently been involved in litigation to try to recoup their personal losses.

Throughout its long history, Lloyd's has had several homes. Its present one was designed by the leading architect Richard Rogers. With a total possible underwriting area of 204,515 square feet (19,000m²), this modernistic edifice with its external lifts opened for business in May 1986. Although equipped with the very latest technology, tradition is not forgotten at Lloyd's. The Lutine bell has not been discarded. Salvaged in 1859 from HMS *Lutine*, which went down in 1799 with a loss to Lloyd's of £1 million, it was traditionally rung to herald both good and bad news – one stroke for bad news, two for good. It was last rung for an overdue ship in 1979 and for a safe arrival in 1981. Now its use is restricted to ceremonial occasions.

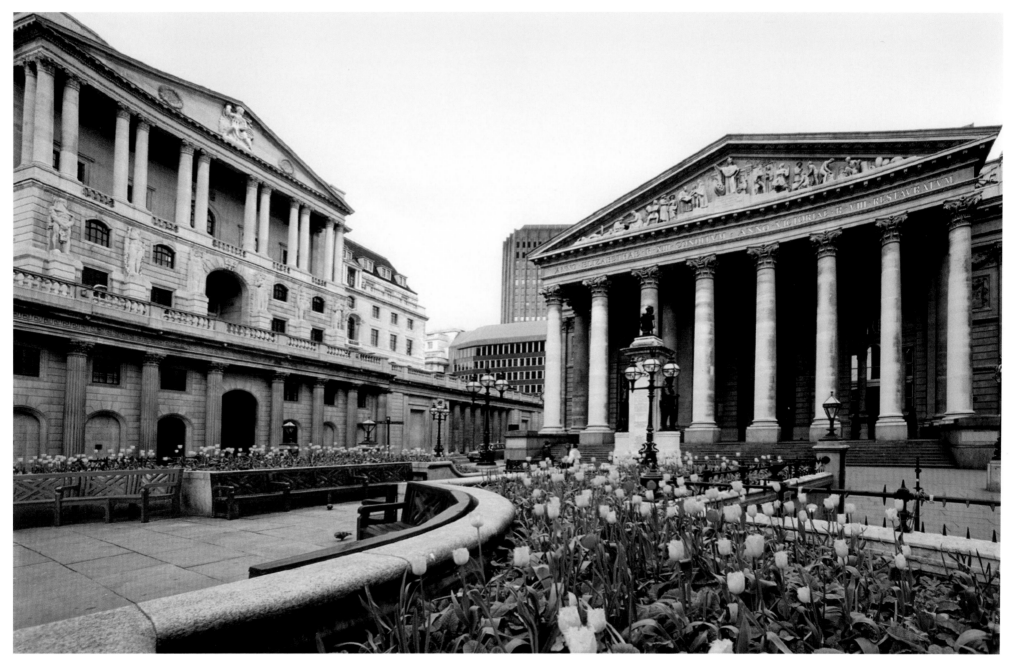

THE BANK OF ENGLAND AND THE ROYAL EXCHANGE

Known affectionately as 'The Old Lady of Threadneedle Street', the Bank of England stands literally and figuratively at the financial centre of the City of London. Founded by Royal Charter in 1694, it is the nation's central bank. Entirely rebuilt in the late 1920s, it is screened from outside gaze by a windowless wall. Its name appears nowhere externally, which results in tourists confusing the bank with the neighbouring Royal Exchange, shown here to the right. Founded in 1566 as a place for merchants to conduct business, the present building was opened in 1844, but ceased its original function in 1839. It is now a shopping complex.

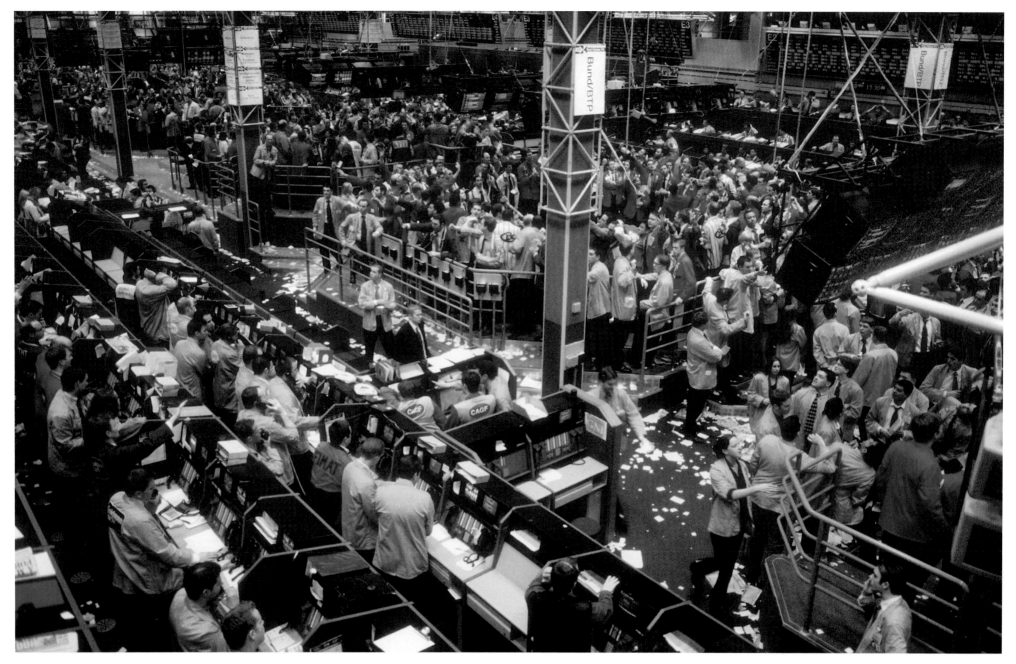

LONDON INTERNATIONAL FINANCIAL FUTURES AND OPTIONS EXCHANGE (LIFFE)

Founded in 1982, LIFFE is one of the leading futures and options exchanges in Europe. The Exchange trades derivatives, instruments that most people had not heard of until a rogue trader in Singapore managed to bring down Barings, Britain's oldest merchant bank. Exchange-traded futures and options allow users to trade on an asset's expected price at a given date in the future. They are indispensable tools for participants in the financial markets who want to manage risk in an efficient and cost-effective way. LIFFE provides a market for trading interest rate, equity (company shares) and commodity derivatives.

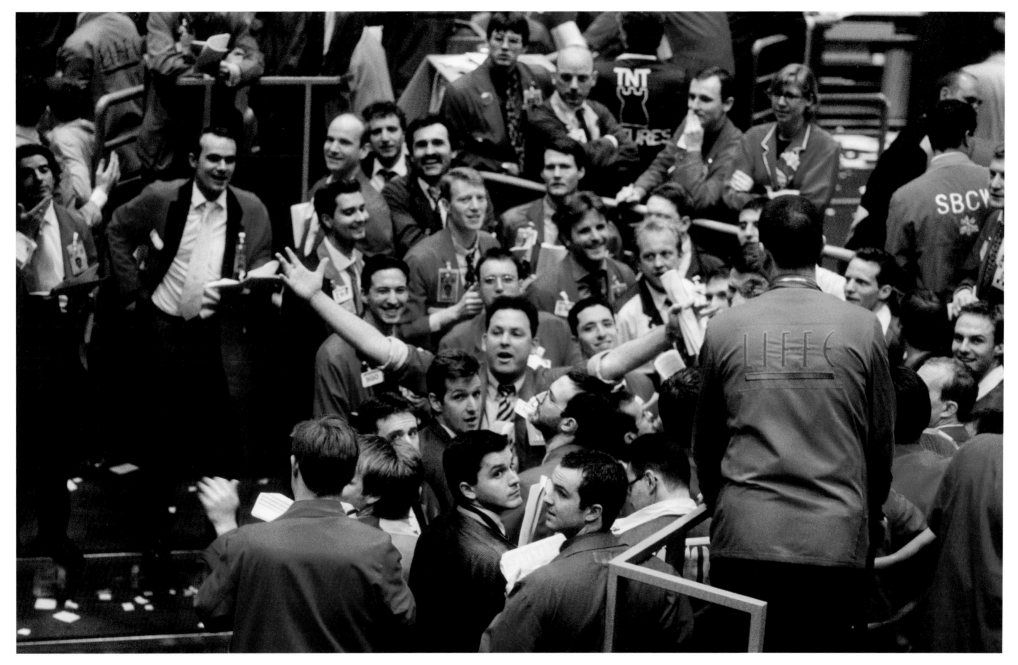

ON THE TRADING FLOOR

The City of London has long had a tradition of innovation. In recent times the most dramatic visible effect of change has been at LIFFE. For 18 years traders undertook their business face-to-face by a system called 'open cry' which combined the use of voice and hand signals. From November 1998 trading has been gradually migrated from the floor of the Exchange to one of the world's most sophisticated electronic systems: LIFFE CONNECT™. The average daily nominal value of LIFFE's trades is £223 billion, which totals many trillions each year.

THE MONUMENT AND
THE OLD BAILEY

The Act of Parliament that provided for the rebuilding of the City after the Great Fire of London in 1666 also provided for the event to be commemorated by a monument (left). Constructed during the period 1671–1677, it stands some 201.7 feet (61.5m) high, which is the exact distance to the east that the fire broke out. Designed by Sir Christopher Wren and his friend, Thomas Hooke, it takes the form of a Doric column surmounted by a flaming urn of gilt bronze. It is the tallest isolated stone column in the world. A spiral staircase of 311 steps within the structure leads to the enclosed balcony.

London's Central Criminal Court is the world's most famous criminal court. It is more familiarly known as The Old Bailey after the street in which it is located. Its figure of Justice (right) is an image familiar to millions, standing commandingly upon its dome 197 feet (60m) above the street. Cast in bronze and covered in gold leaf, the figure is 12.14 feet (3.7m) high and the span of her outstretched arms is 7.8 feet (2.4m). In her right hand she holds the sword of retribution, while in her left she holds the perfectly balanced scale of justice. Unlike other statues which symbolise justice, the figure at the Old Bailey is not blindfolded. It was sculpted by Frederick William Pomeroy for the building which was opened in 1907.

WILDY & SONS, LAW BOOKSELLERS, LINCOLN'S INN

The decision in 1830 to ban horse-drawn carriages from Lincoln's Inn resulted in two archways for pedestrians becoming redundant. Appropriately for the Inn's students and barristers, Wildy & Sons established a bookshop in the subsequently enclosed former thoroughfares. Today the internationally renowned shop extends into the adjacent No. 3 New Square and has a stock of 20,000 new, secondhand and antiquarian books. All but one is for sale. The firm's most treasured possession is a volume of John Manwood's *Lawes of the Forests*, privately published in 1592. Found discarded in a rubbish bin after World War Two, it is one of three known copies.

ROYAL COURTS OF JUSTICE

More commonly referred to as the Law Courts, the building was constructed in the 19th century to provide one location for all the superior courts concerned with civil cases. Before the Law Courts were operational, cases were heard in Westminster Hall during the legal term time and at sundry locations on other occasions. This was an inconvenient state of affairs, but centralisation nevertheless progressed slowly.

The site was acquired in 1865 and G.E. Street was appointed architect for the project. The foundations were laid in 1871, but work did not begin on the actual building until 1874. Although six years were scheduled for its completion, a combination of financial difficulties, inclement weather and problems with the workforce delayed its opening until the end of December 1882. The architect died from a stroke the year before the building was completed and many people believed that his demise was a result of the frustrations he encountered with the project.

The large Victorian building is constructed of bricks – some 35 million in number – which are faced with Portland stone. It contains 1000 rooms and has some 3.5 miles (5.63km) of corridors. Originally containing 19 courts, four more were added in 1911 and a further 12 in 1968. A modern 11-storey building behind the Law Courts accommodates the Companies and Bankruptcy Courts. The entire complex has 60 courts.

THE WIG & PEN CLUB, STRAND

Located in two adjoining timber-framed and stuccoed houses, this members-only dining club, founded in 1951, is for lawyers, journalists and others in professional life. The older of the two houses was constructed in 1625 and is the only building in the Strand to have survived the Great Fire. This was formerly the home of a gatekeeper of Temple Bar. He supplemented his income by selling portions of 'a pennorth of meat and bread' to crowds who gathered to see the heads of traitors on the spikes of Temple Gate. The walls of the club are smothered with memorabilia which give it the atmosphere of a bygone age.

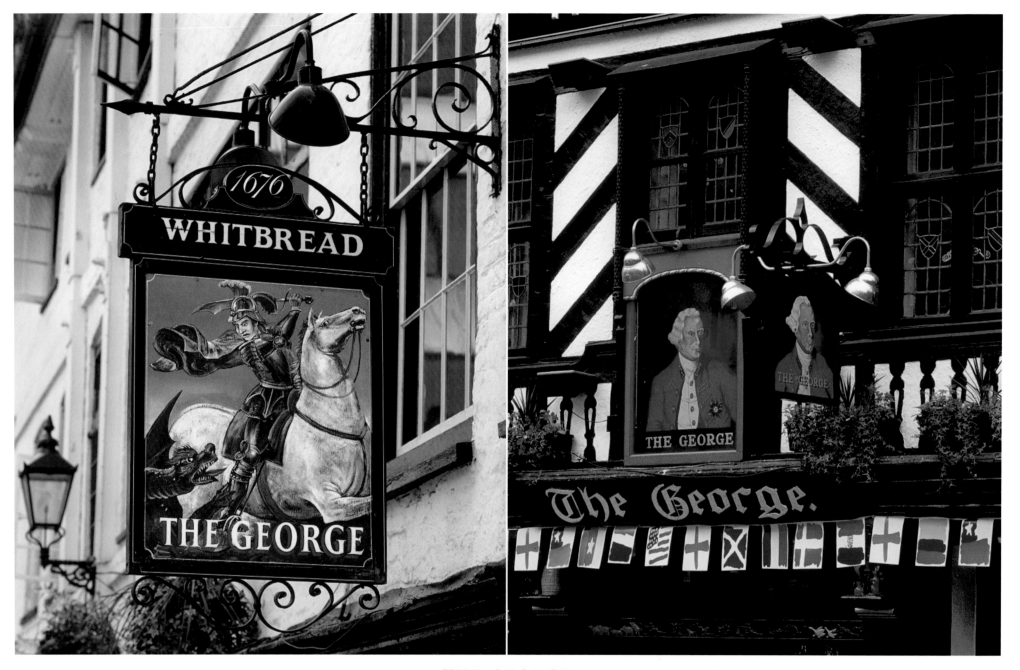

THE GEORGE

It is not surprising that George is the name for so many public houses in England, for from 1714 to 1830 four successive monarchs were so named. In Victorian London the most frequently encountered name for a tavern was The King's Arms, with the second position being held jointly by The Coach and Horses and The George. In 1864 there were 52 houses bearing these names. Today there are 16 Coach and Horses and 17 Georges. However, the percentage fall in the number of public houses called St George and the Dragon has been more dramatic – in 1864 there were 14, now there are only two.

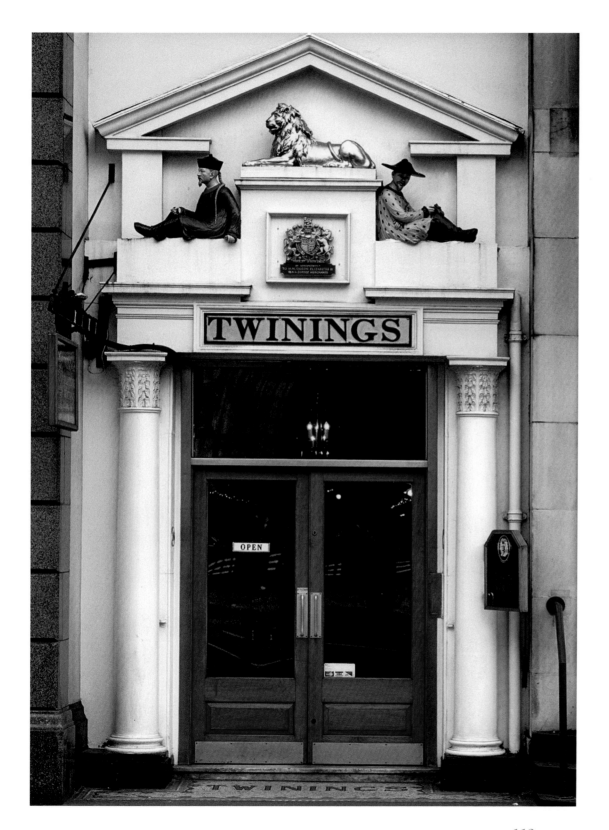

TWININGS, STRAND

In 1784, if Richard Twining had not persuaded the then Prime Minister William Pitt to reduce the tax on tea, Britain would not have been the tea-drinking nation it is today.

Founded by Thomas Twining in 1706, by the acquisition of Tom's Coffee House in Devereaux Court, the establishment was one of thousands in London at the time. To give his business a competitive edge, Twining began to sell tea as a sideline. Within a very short time, more dry tea was being sold than the beverage in liquid form. In 1716 Twining bought three adjacent houses and extended the premises to the Strand. He then opened a shop for the sale of loose tea and coffee beans under the sign of the Golden Lion.

Twining's grandson, Richard, built the famous doorway at 216 Strand. Unveiled on 10 April 1787, a golden lion was chosen for its centrepiece. As all the tea came from China in those days, two figures of Chinese men flank the King of Beasts. The three figures are the work of Coades, a famous company of the time. Made from Coade stone, the composition of which is unknown, the company claimed that the material would resist frost, rain, heat and smoke. When, in 1997, the figures were stripped to be repainted, the stone was found to still be in excellent condition.

A royal warrant holder since 1837, Twinings has the record of being the oldest British company to be in business on the same site, holding the same name and selling the same product. Twinings tea is available in 90 countries.

SHOP FRONT, CAMDEN HIGH STREET

Until the end of the 18th century the area now occupied by Camden Town in northwest London was entirely rural. From the 1820s, with the advent of the Regent's Canal, and from the 1830s, with the coming of the railways, it developed into a residential quarter of wealth and fashion. Towards the end of the 19th century it rapidly became populated by the working classes. As so often happens in London, the pendulum has swung back again and now it is a choice location for professionals.

Badly run-down areas beside the canal were revitalised in the early 1970s. There are now cafés, an array of interesting shops, craft workshops and markets, making it a fascinating area to visit. The shops of Camden High Street are open seven days a week and the weekend antique and craft market is a shopper's paradise.

An unusual feature of the street is the number of shop fronts above ground level with three-dimensional forms on their façades. It all started in the early 1980s with a large painting of the Statue of Liberty on a shop wall. The larger-than-life bust of Elvis on the wall of a shop selling mainly leather jackets and jeans dates from the mid-1990s. Further along, one army surplus shop has a three-dimensional fighter-plane zooming skywards, while another features a tank seemingly breaking through its wall.

SHOP WITH GUARDIAN ANGEL, CAMDEN TOWN

Since its founding in the early 1980s, the Chalk Farm Gallery has established itself as a north London institution. Its policy is to encourage new work and seek fresh creative talents. In the early 1990s it made a move which literally changed the face of Camden Town – it painted its shop front cerise. The gallery's proprietor wanted to brighten the Victorian brickwork and to raise spirits. Her inspiration was San Francisco. It worked, and many shops have since followed suit. The angel represents her late husband – her guardian angel – with whom she ran the gallery for nine years.

REGENT'S CANAL, CAMDEN TOWN

Once busy waterways for the transportation of goods, London's canals today provide a peaceful haven away from the hustle and bustle of city life. Whether just sitting in the sunshine with friends, walking the towing paths along which the horses once dragged the barges, or going on a pleasure cruise, the canals are now places for relaxation. There are about 50 miles (80km) of canals running through the heart of London. They provide a sanctuary for plants and animals of all kinds, from wildflowers to insects, wildfowl and birds to fish and even foxes.

TERRACE OF HOUSES, REGENT'S CANAL

A modern innovative terrace of houses designed by Nicholas Grimshaw overlooks the architect John Nash's Regent's Canal in Camden Town. Started in 1812, this 8.4-mile (13.5km) waterway was completed in 1820. It was once the busiest stretch of Britain's canal system. Along this final leg of a slow journey from all parts of the country, the ladened barges passed through 12 locks, under 40 bridges and through one tunnel to London's docks. Initially the canals were a great success, but with competition from the railways they went into decline. Today, narrow boats and other craft cruise the waterways in pursuit of leisure rather than for the purpose of transporting goods.

COVENT GARDEN

Covent Garden grew from a few temporary stalls erected in 1656 in the garden of Bedford House, the home of the Earl of Bedford, to a major fruit, vegetable and flower market. In the 18th century live hedgehogs, used by Londoners as pets to eat beetles, were regularly sold here. In the early 19th century the market was getting out of control and in 1828 an Act of Parliament was passed for its improvement and regulation. In 1830 a new market building, designed by Charles Fowler, was constructed and it became a popular place where fashionable Londoners mingled with costermongers, farmers and flower girls.

By the end of the 19th century, the market had five sections and in 1904 the Jubilee Market was added for foreign flowers. The Duke of Bedford sold the market to a private company owned by the Beecham family, which, together with other properties in the area, was acquired by the Covent Garden Market Authority in the early 1960s. Although there had been suggestions for moving the market since the 18th century, this did not happen until November 1974 when what had become London's main produce wholesale market moved to Nine Elms, Wandsworth.

The area then became the subject of major development proposals. Thanks to the Covent Garden Area Trust, which campaigned not only for the conservation of the buildings but also for the preservation of the mix of residential, business and other uses, today's Covent Garden is a charming area. Although the freehold of the area is commercially owned, the Trust has a 150-year lease and conservationist powers. It pays an annual rent of one red apple and a posy of flowers for each underlease.

STREET ENTERTAINERS, COVENT GARDEN

Jugglers and other street entertainers are a regular feature at Covent Garden's Piazza. Occasionally there is even a sword-swallower. The name juggler is derived from the Latin *joculare*, meaning to jest or joke. Although it has its origins in the ancient world, juggling became a regular feature of European fairs in the 17th and 18th centuries. Sword-swallowing is also an old art. Contrary to popular opinion, it is not an optical illusion. Neither was the incident here in August 1996, when a cast-iron manhole cover was propelled 16 feet (5m) into the air by an orange fireball. An electrical fault caused the blast.

When Sir Arthur Conan Doyle wrote *A Study in Scarlet* in 1886, he had no idea that he was creating a character which would not only prove extremely popular, but which many people would regard as 'real'. The first story in which Sherlock Holmes appeared was published in *Beeton's Christmas Annual of 1887*. Doyle sold the manuscript outright for a mere £25.

Born in Edinburgh in 1859, he studied medicine at the city's university. Thereafter he established a medical practice on the south coast of England, but it was not successful. To boost his income and to occupy the time between patients, Doyle wrote. Holmes was based on Joseph Bell, a doctor and lecturer at Edinburgh who had amazing diagnostic powers.

Most of the Sherlock Holmes stories appeared in *Strand* magazine. Despite their great success, Doyle always considered he could do better. In the 24th story he killed off Holmes in a struggle with Moriarty at the Reichenbach Falls. No one envisaged the reaction of readers. People wore black armbands and flooded the offices of *Strand* magazine with letters of protest. Eventually Doyle was persuaded to resurrect the great detective. In 1903, to the delight of his fans, Holmes investigated the case of the *Empty House*. The detective and Doyle finally retired in 1927, having investigated no less than 60 cases.

But Sherlock Holmes lives on. The detective's fictional home at 221B Baker Street is on the site now occupied by the headquarters of the Abbey National Banking and Financial Services Organisation. On average it receives 30 letters a week addressed to Mr Holmes requesting assistance from all parts of the world.

MILLENNIUM DOME

Built on the site of a former gasworks, the Millennium Dome in Greenwich is the largest dome in the world. Officially opened on New Year's Eve 1999, the structure is covered by a vast canopy of PTFE-coated glass fibre, supported by 12 slender masts. Its roof is the world's largest, measuring some 25 acres (10.12ha). The building covers an area approximately a third larger than the Great Pyramid and has the same volume as 1100 Olympic-size swimming pools. If the dome were to be inverted under Niagara Falls, it would take more than 10 minutes to fill.

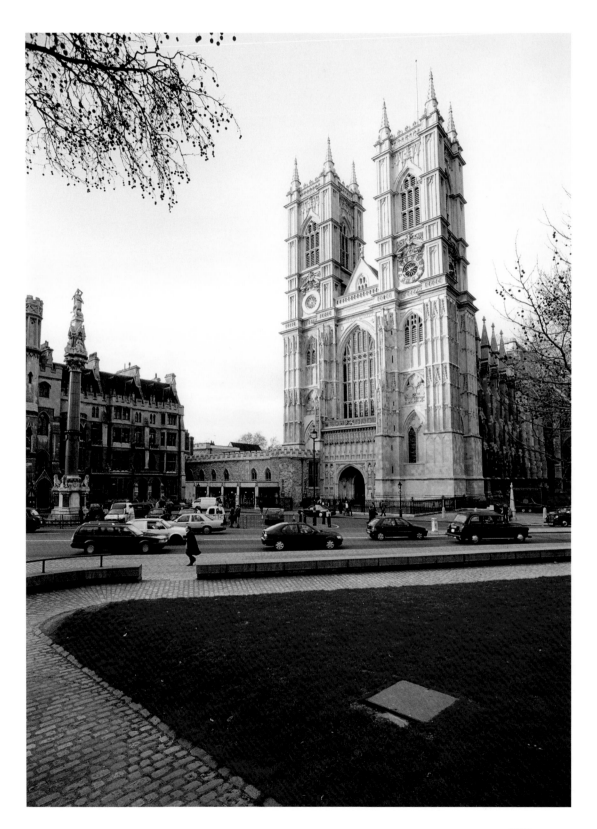

WESTERN TOWERS, WESTMINSTER ABBEY

Although most of Westminster Abbey was built by the early 1500s, two centuries were to elapse before its construction was finally finished. During the interval it was not all tranquillity. When Henry VIII dissolved the monasteries in 1540, the abbey's royal associations saved it from destruction. However, a portion of the abbey's revenues was transferred to St Paul's Cathedral and the expression was coined, 'Robbing Peter to pay Paul' – a reminder that the building of the first church upon the site had associations with St Peter.

During the Civil Wars of 1642–1649, Oliver Cromwell's army camped in the abbey and 'broke down the rails before the Table [Altar] and burnt them in the very place in the heat of July'. Cromwell was buried in the abbey along with two other leading Parliamentarians. Upon the restoration of the monarchy in 1660, their bodies were removed, hanged at Tyburn and beheaded before interment at the foot of the gallows.

Sir Christopher Wren had become Surveyor of the Abbey by the end of the 17th century. In addition to undertaking restoration work, he also put forward plans for completing the Western Towers. His successor modified the original proposals. The building work was completed in 1745. An unusual feature of the clock, installed in 1737–1738, is that it has only one hand.

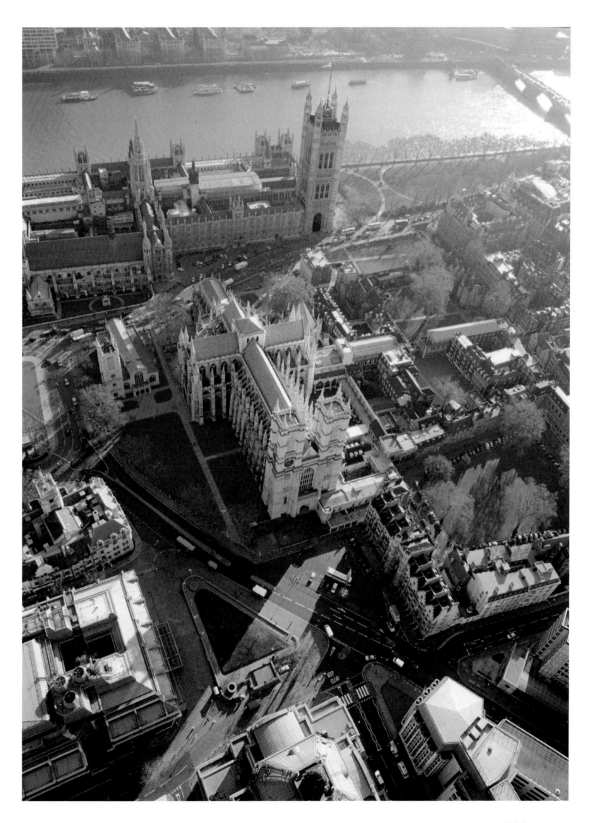

PALACE OF WESTMINSTER AND WESTMINSTER ABBEY

In ancient times, this area was known as Thorney Island (Isle of Brambles). According to legend, the 7th-century King Sebert of the East Saxons built a church here after receiving instructions from St Peter in a dream. A late 8th-century charter granted land to the church of 'St Peter and the needy people of God in Thorney in the terrible place which is called Westminster'.

Although the early history of the area is subject to much conjecture, what is certain is that the saintly Edward the Confessor, King of England from 1042 to 1066, laid the foundation for a great church for use by a Benedictine community. During its construction, Edward established a residence nearby. The abbey was consecrated on 28 December 1065 and eight days later Edward died and was buried before the high altar. After the Battle of Hastings, William the Conqueror was crowned king in the abbey on Christmas Day 1066. Ever since then the coronation of every monarch has taken place at the abbey. During later years, the abbey was richly endowed and additions were made. Then in 1245, Henry III decided that he could do better for the glory of God and a rebuilding project began. It lasted nearly 300 years.

The abbey is not the only great building in Westminster. The Palace of Westminster was built by the early Norman kings. William II started the project in 1097. Still a royal palace, though no monarch has lived there since 1512, it is now also known as the Houses of Parliament.

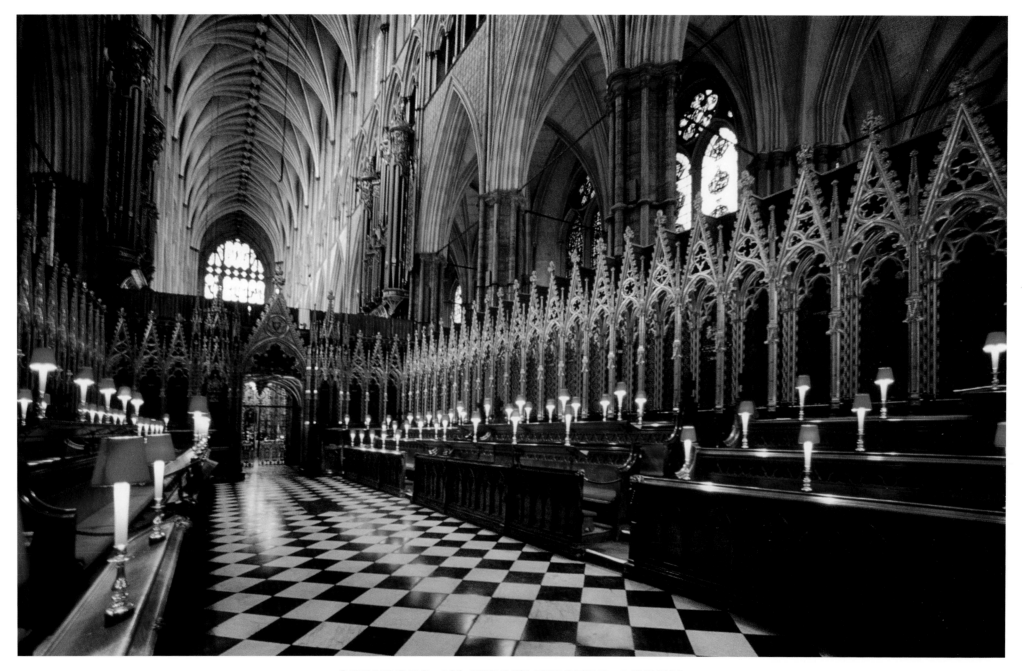

SERVICES AT WESTMINSTER ABBEY

There have been many joyous occasions in the abbey: coronations, baptisms and weddings, as well as services of thanksgiving. One of its saddest, though, was the funeral service of Diana, Princess of Wales, which took place here on Saturday 6 September 1997. Millions of mourners worldwide were able to follow the proceedings which were televised live from the abbey. However, the serenity of this marvellous building is perhaps best experienced by attending one of the regular services. To hear the choristers accompanied on the very organ at which Henry Purcell played in the second half of the 17th century, is an experience which will not be forgotten.

CORONATION CHAIR, WESTMINSTER ABBEY

Constructed around 1300, the Coronation Chair has been the seat upon which 38 monarchs were crowned. The Stone of Scone, which was the coronation seat of the kings of Scotland, was captured by the English in 1296, and incorporated as an integral part of the chair's design. In 1950, a group of Scottish Nationalists stole the stone as a publicity stunt. Discovered in Scotland a few months later, it was immediately returned to Westminster. However, during 1996 the government decreed its repatriation and today it is displayed at Edinburgh Castle.

HENRY VII'S CHAPEL, WESTMINSTER ABBEY

Also known as the Lady Chapel, the glory of this Tudor masterpiece is its fine fan-vaulted ceiling. American writer Washington Irvine described it as a place 'where stone is robbed of its weight and density, and suspended aloft as if by magic, and the fretted roof achieved with the wonderful minuteness and airy security of a cobweb'. John Leland, an historian at the time the chapel was constructed, stated simply but no less admiringly that it was 'a wonder of the world'. Although there is no record of the architect responsible for this gem, it is believed to be the work of Robert Vertue, one of Henry VII's masons.

INNOCENTIA
QVALIS PER INVIDIAM EMERSIT:
NEC METAM, NEC TERMINVM RECEPIT.
ITA DEMVM, POSTERITATIS CERTVS,
PER CONSCIENTIAM (DVM VIATOR ERAT)
ET FAMA IAM FRVITVR DEFÆCATISSIMÁ
ET EA, POST VITÆ ÆRVMNAS, REQVIE,
CVIVS SE PARTICIPEM IN HORAS EXOPTAT
MOESTISSIMA CONIVX
IANA
CVTHBERTI BARONIS OGLE HÆREDVM
PRIMOGENITA
QVÆ LACHRYMIS IMMERSA
PIE MONVMENTVM HOC
. P .
OBIIT DIE VIII. FEBRVARII. cIↃ. IↃ c xv
ANNO ÆTATIS. LVII.

THE TOMBS OF WESTMINSTER ABBEY

There is far more to Westminster Abbey than carved stone, for it is a national shrine where many English monarchs and notables, such as Edward Talbot, 8th Earl of Shrewsbury (died 1618) and Jane, his wife (died 1626) (above), are buried. When Ben Jonson requested to be laid to rest here he stated, 'Six foot long by two feet wide is too much for me; two feet by two feet will do for all I want.' He was buried upright. Undoubtedly the most poignant of all the tombs is the Unknown Warrior's, for this single grave is representative of thousands of dead.

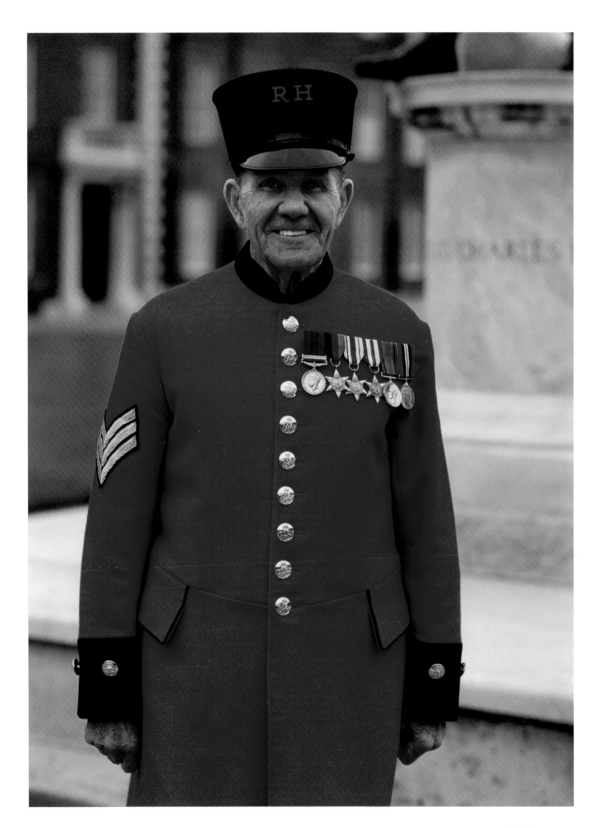

THE ROYAL HOSPITAL, CHELSEA

Inspired by the Hôtel des Invalides in Paris, in 1681 Sir Stephen Fox, the army's Paymaster General, suggested to Charles II that a similar home for veteran soldiers should be established in London. Clearly the monarch warmed to the idea, for the following year Sir Christopher Wren was appointed architect of the hospital and the King laid the foundation stone. Completed in 1692, the Royal Hospital is constructed around three courtyards. Apart from some minor alterations made by Robert Adam between 1765 and 1782 and the addition of stables in 1814, the hospital has changed little over the centuries.

A bronze statue of Charles II by Grinling Gibbons can be seen in the central courtyard. Each year on 29 May the Chelsea Pensioners honour the birthday of their founder. On the day, known as Oak Apple Day, a parade is held, the King's statue is decorated with oak foliage and pensioners and their guests carry sprigs of oak. The significance is that Charles II escaped capture after the 1651 Battle of Worcester by hiding in an oak tree on the Boscobel estate.

A large painting by Antonio Verrio of Charles II on horseback hangs in the Hall. It was in this room, from 10–17 November, that the Duke of Wellington lay in state after his death in 1852.

Each May crowds of gardening enthusiasts descend on the hospital's grounds for the Chelsea Flower Show. Staged here by the Royal Horticultural Society since 1913, this event is regarded as the highlight of the horticultural year. The country's top growers display their prize blooms and complete gardens are constructed for the few days of the show.

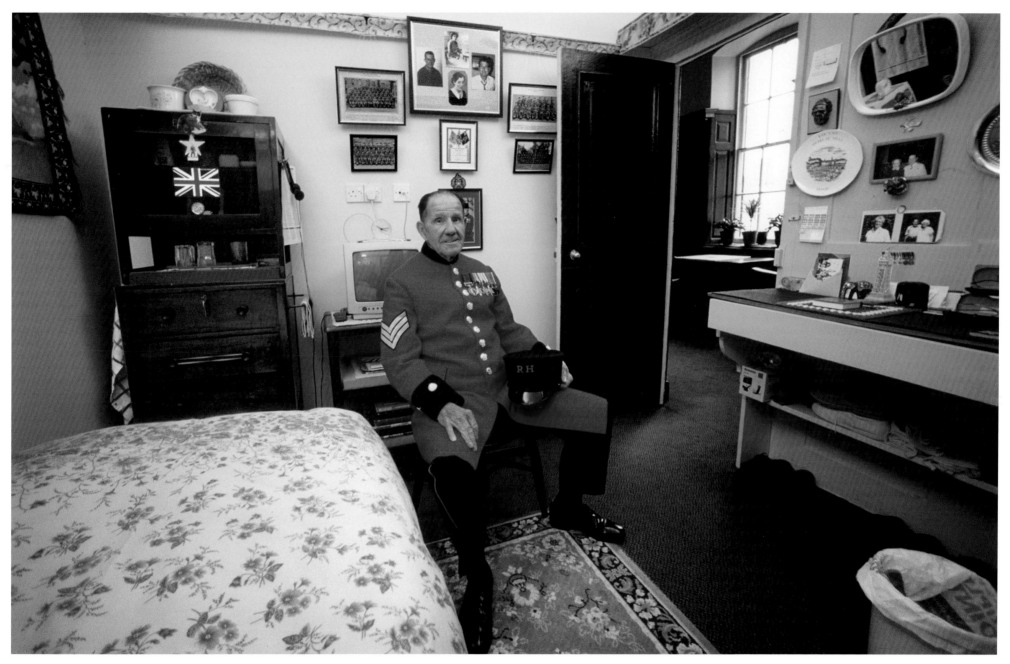

CHELSEA PENSIONER, THE ROYAL HOSPITAL

Chips Jaggard is one of the 385 veteran soldiers who are resident at the Royal Hospital in Chelsea. Pensioners apply for a place at the hospital where they are lodged, fed, clothed and nursed when ill. Applicants must have volunteered for the armed forces; be in receipt of a military pension; and must have no dependants. Also, they must be over the age of 65, or, if unable to earn a living, over 55 years of age. While their ceremonial dress is scarlet, their everyday uniform is navy blue with a peaked cap bearing the initials RH in red.

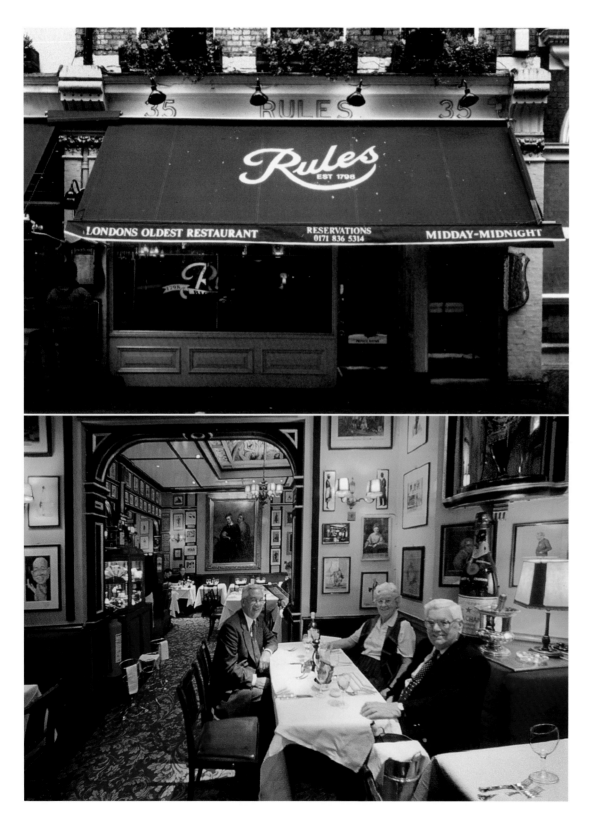

RULES,
LONDON'S OLDEST RESTAURANT

Founded by Thomas Rule at Maiden Lane in 1798, London's oldest restaurant still thrives. In a period spanning the reign of nine monarchs, the business has been owned by only three families. Today it seats 200 people on three floors, employs 80 staff and serves an average of 450 people a day. In the 18th century it was famed for its 'porter, pies and oysters'. Specialising in classic game cuisine, oysters, pies and puddings, its fare remains traditional. The game is supplied from the restaurant's own estate located in 'England's last wilderness' high in the Pennines in northern England.

Soon after its opening, it was noted that 'rakes, dandies and superior intelligences' were its clientele. The late John Betjeman described the ground floor of Rules as 'unique and irreplaceable and part of literary and theatrical London'. Throughout its long history, Rules has attracted writers, artists, lawyers, journalists, actors and royalty. It was here, in an upper floor private dining room, that the Prince of Wales – later Edward VII – frequently entertained the beautiful actress Lily Langtry. They visited so often that a private entrance was made.

The quintessential British surroundings of the restaurant have poignant associations with Charles Dickens. When working at a blacking factory and earning meagre wages, he frequently wandered the alleys of Covent Garden, sniffing the aromas rising from the kitchens. He never forgot those hard times, even when later in life he could afford to, and did, dine at Rules. There are also strong associations with the great 20th-century writer Graham Greene, who sometimes celebrated his birthdays here.

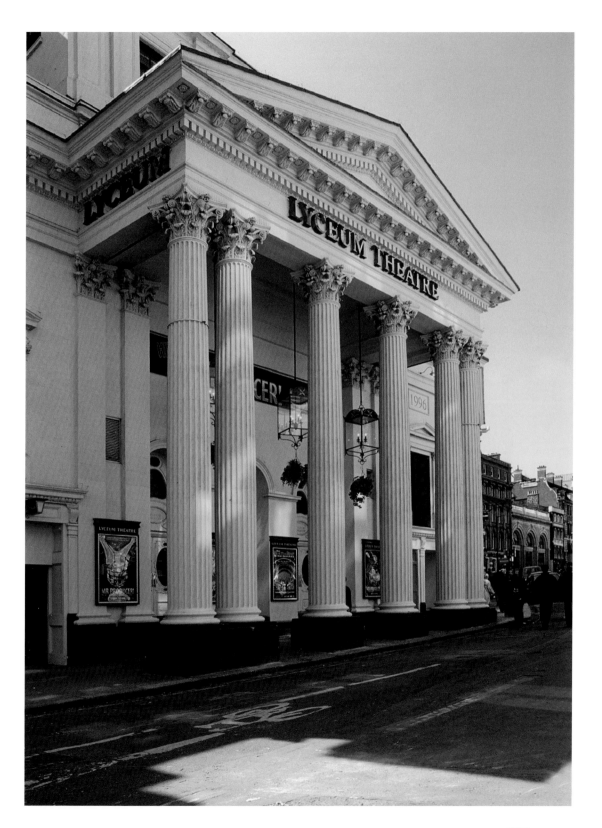

LYCEUM THEATRE

London has some of the best theatres in the world. Most of them are old and those which have been well-preserved or painstakingly restored exude an intimate atmosphere reminiscent of Victorian or Edwardian England. While many tragedies have been performed upon their stages, some of the theatres have also suffered their own dramas.

The Lyceum Theatre was established in 1771 as a concert and exhibition room, but was converted into a theatre in 1794. It was not immediately granted a theatre licence, so was initially let as a circus. Rebuilt in 1834, it operated as a theatre for the remainder of the 19th century. Its heyday was in the last quarter of the century, when Henry Irving was its actor-manager and Ellen Terry, one of the great beauties of her day, his leading lady for over 20 years. Bram Stoker, better known as the author of *Dracula*, was the theatre's administration manager.

In 1902 the Lyceum closed because the owners could not afford the extensive alterations required by the authorities. The building, apart from its façade, was demolished during this time. Rebuilt in 1904 as a music hall, it reverted back to a theatre in 1909. In 1939 the site was acquired for road improvements, but these never transpired. After World War Two it operated as a dance hall, but closed again in 1991. After extensive renovations in the 1990s, the Lyceum Theatre reopened on 31 October 1996 with a production of Lord Andrew Lloyd Webber's *Jesus Christ Superstar*.

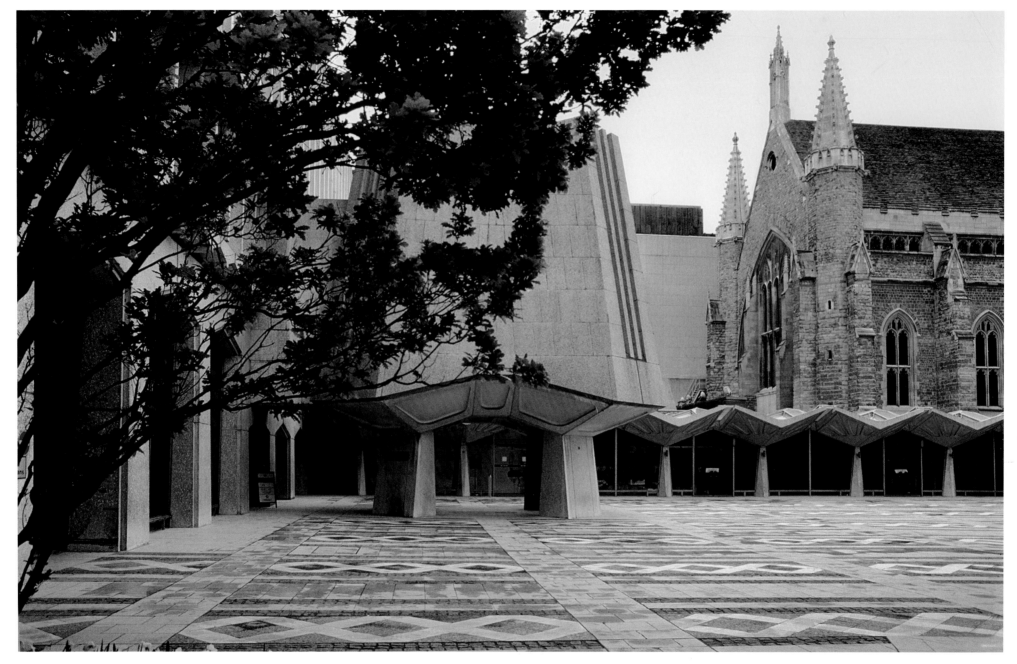

GUILDHALL, CITY OF LONDON

For centuries the Guildhall in the City of London has been the seat of government for the Square Mile. The word 'guildhall' is derived from the Anglo-Saxon *'gild'*, meaning payment, so it is where citizens probably would have paid their taxes. Archaeological excavations in Guildhall Yard in 1987 revealed that a Roman amphitheatre once stood on this site. The present hall was begun in 1411 and completed around 1439, while sections of its crypt are believed to have been part of a late 13th-century building. The imposing medieval hall is a splendid setting for state and civic banquets in honour of royalty and world leaders, while the adjoining complex, added in 1974, houses offices.

DYERS' COMPANY ARMORIALS

It is appropriate that the armorials of the Dyers' Company are colourful. The supporters are two leopards spotted with various colours, and fire issuing from their mouths and ears. They were authorised in 1577, though the arms are much older.

The dyers were first mentioned as a guild in 1188. The first Dyers' Hall was destroyed in the Great Fire of London in 1666. Its replacement suffered the same fate 15 years later. In 1731 two houses on the company's Dowgate Hill Estate were adapted for use as a hall. Unfortunately these fell down in 1768 and a new hall was erected on the site two years later. Regrettably, its structure proved to be defective and the building had to be demolished in 1838. The present hall was built in 1842 and withstood the bombing of World War Two.

The Dyers' Company undertakes a considerable amount of charity work. One of its more unusual roles relates to the protection and health of swans on the Thames River. It is believed that this involvement dates back to 1483 when both the Dyers' and Vintners' Companies were given the privilege of keeping swans on the river. Since time immemorial the swan has been a royal bird in Britain. Each July the Queen's swan master and the swan masters of the Dyers' and Vintners' Companies undertake the Swan Upping Voyage during which the birds are counted. General care of the birds is an ongoing task.

The earliest evidence that the cutlers of the City of London occupied a regular meeting place is found in an old document of 1285–1286. However, it was not until 1416 that the Cutlers' Company was granted the first of several charters.

From the mid-18th century much of the trade had moved to Sheffield, but surgical instrument-making remained in London. It is therefore appropriate that the present Cutlers' Hall, opened in 1887, is built on the site occupied by the Royal College of Surgeons from 1674–1825.

The company has had several halls over the years. By 1660 its second medieval premises, which had been its home for some 250 years, were considered too inconvenient. The new hall took four years to build. The final accounts had just been paid when it was completely destroyed by the Great Fire of London. Rebuilding took place immediately and the building was occupied in 1670. In 1882 the site was compulsorily purchased for the building of Cannon Street Station.

The cutlers' fifth and present home opened in 1887. A splendid sign featuring an elephant and castle hangs near the entrance. An elephant's head was incorporated into the company's crest when the cutlers were given a grant of arms in 1476. It was no doubt incorporated as a reference to the ivory used in the handles of swords and knives. The elephant and castle was granted as its crest in 1622.

The Cutlers' Company maintains its interest in cutlery by fostering apprenticeships in the surgical instrument-making industry. It also funds university and music scholarships.

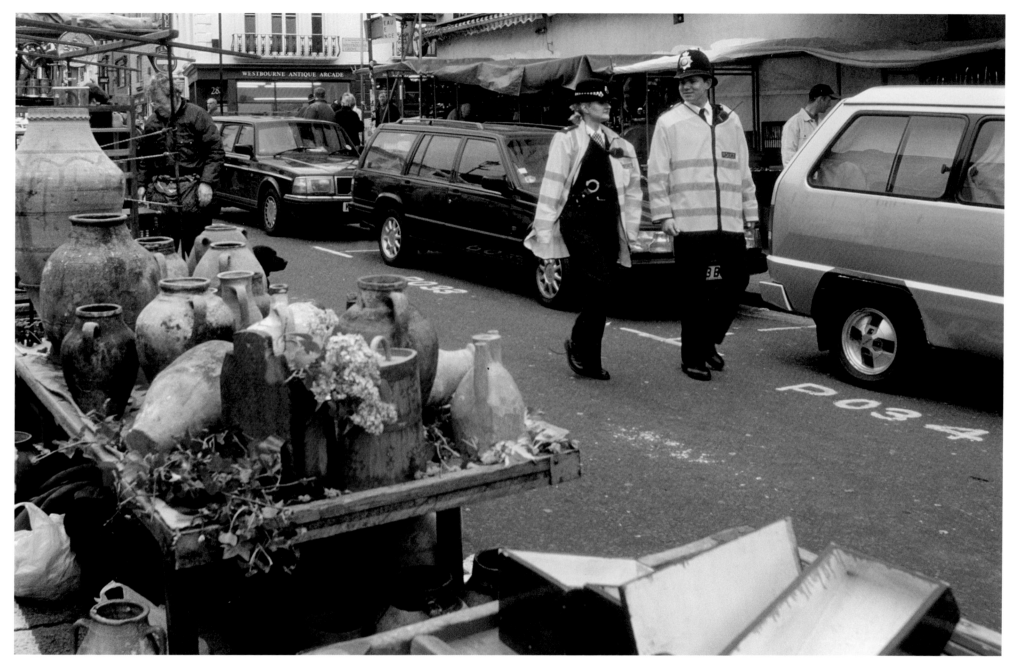

THE LONG ARM OF THE LAW

The author Henry Fielding sowed the seeds for the nation's police force. Appointed magistrate of Westminster in 1748, he established a group which eventually became known as the Bow Street Runners. Their principal task was to bring criminals to justice. Meanwhile, night foot patrols were established in 1782 and horse patrols on the main roads around London in 1805. Daytime crime prevention patrols started in 1822. The Metropolitan Police was established in 1829 with 1000 officers. In the first year of its operation, many of the officers were dismissed for being drunk on duty. The Bow Street Runners were integrated into the police force in 1839. Today it employs over 35,000 personnel.

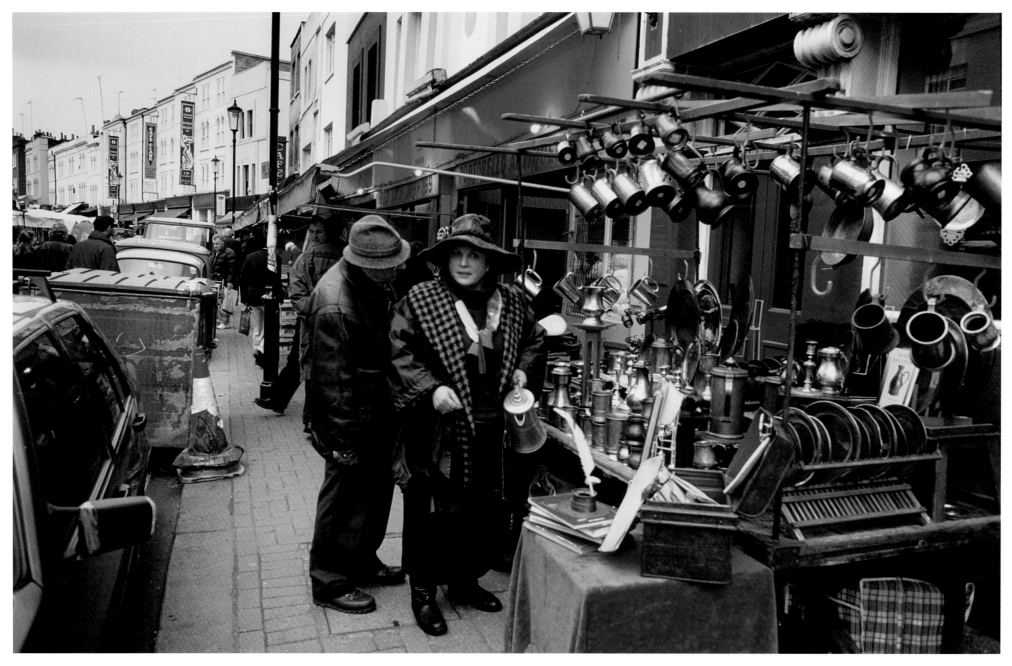

THE RELATIVE AGE OF COLLECTIBLES

By strict definition, an object must be 100 years old to be an antique. One observer remarked in the late 1960s that 'antiques are rapidly disappearing from the market', and added that people were *even* collecting Art Deco of the 1920s! Antiques are still available, but in the early 1990s the London sale rooms launched auctions of 20th-century objects. Today, quality designer objects of the second half of the 20th century are keenly sought by collectors, for these will be antiques of the future. As a new millennium gets under way, it is a little like looking the wrong way down a telescope – even the 1960s seem an age away.

ANTIQUES MARKET, PORTOBELLO ROAD

The world's largest antiques market takes place each Saturday in Portobello Road and the surrounding streets. Proceedings officially begin at 5.30am, though some dealers are there even earlier. Some travel hundreds of miles for the event. Numbering some 1500, they trade from shops, fitted stands in arcades or from outside market stalls. It is not unusual for an item to change hands several times during the day. By 10am the area is crowded as both Londoners and tourists scour the area for bargains. Serious hunting should begin by at least 7am. Leave it much later and the better buys will have been snapped up by members of the trade.

NATURAL HISTORY MUSEUM

Only the most unobservant of passers-by could fail to glean the purpose of this building, for the entire length of its 676-feet (206m) façade incorporates relief mouldings of mammals, birds, fish and insects. Closer examination will reveal that living species are featured on the left of the main entrance, while those which have long since been extinct appear to the right. Francis Fowke won the competition for the design, but unfortunately he died before the work was started. Alfred Waterhouse was appointed executive architect. Empowered to revise the plans, he effectively designed a new building, but retained sufficient elements of Fowke's proposal to silence possible criticism.

CENTRAL HALL, NATURAL HISTORY MUSEUM

Britain's best-loved dinosaur is *Diplodocus carnegii*. With a length of 85.3 feet (26m) it dominates the Central Hall of the Natural History Museum. Although only a plaster cast of the 150-million-year-old skeleton found at Wyoming, encountering this life-size model of one of the largest land animals to have roamed our planet is a dramatic and awe-inspiring experience. The museum's collection comprises 68 million specimens and one million books and manuscripts. The exhibition galleries cover three acres (1.2ha) while behind the scenes 300 scientists and librarians undertake research work. This is used to resolve a diverse range of international problems and assists conservationists, doctors, farmers and industrialists.

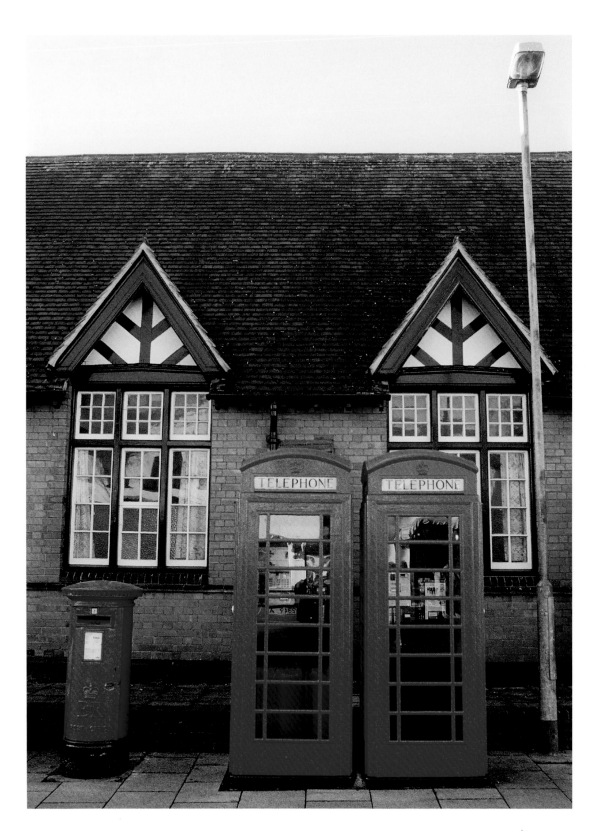

TELEPHONE KIOSKS AND PILLAR BOX

They are not only London's, but also the nation's most famous items of street furniture. Both the pillar box and the telephone kiosk are icons of Britain. Despite the increasing use of e-mails and mobile phones, neither is threatened by extinction. The first roadside letter boxes appeared in 1852 and since then there have been hundreds of different varieties: free-standing pillar boxes, ones inserted into walls and others attached to lamp-posts or telegraph poles. There are 13,427 of them in London alone.

Britain's first public telephones appeared in 1876. The early ones took a variety of forms. While there were ornate cast-iron ones, others were rustic wooden huts and arbours. Coin-operated boxes made their debut in London in 1906. Six years later, when the Post Office took over the telephone system, it was decided to introduce a standard design, but the initiative was temporarily halted when World War One broke out. Matters only progressed in 1927 when Sir Giles Gilbert Scott's design for a telephone kiosk was introduced. He was asked to update the design in 1935 to commemorate George V's Silver Jubilee. It is these distinctive red kiosks that are seen today.

The replacement of many telephone kiosks in the 1980s brought a public outcry. Although many were lost, thousands remain – 2000 of them as 'listed buildings'. From 1993 many were reinstalled in sensitive heritage sites, starting with 60 in London's Westminster. Four were even installed in Parliament Square where there had been none before. The average length of a payphone call is one minute and 15 seconds.

THE PRIORY HOUSE OF
ST BARTHOLOMEW THE GREAT

In 1916 a bomb from a Zeppelin raid fell nearby this gatehouse, displacing the tiles on its façade. Under the tiles was revealed a charming half-timbered 16th-century building. The house is built over the top of all that remains of the original west door of St Bartholomew's – an archway constructed in the 13th and 14th centuries.

The church is all that survives today of the priory founded by Thomas Rahere, who, according to legend, was a jester and musician, though it is more probable he was a clerk in holy orders. While on a pilgrimage to Rome, he contracted malaria. Rahere repented his sins and promised the Lord that if he was allowed to recover he would build a hospital in London and administer to the necessities of the poor.

The result was St Bartholomew's Hospital and the priory, both of which were founded in 1123. With Henry VIII's Dissolution of the Monasteries, the demolition of the priory began. However, the local residents protested that the choir of the complex was their parish church and it was saved. The remaining monastic buildings were sold in 1544 and were put to many uses over the years. The early 14th-century Lady Chapel was transformed into private houses and later a printer's office where in 1725 Benjamin Franklin worked. The crypt became a coal store, the cloisters a stables and a blacksmith established a smithy in the north transept. By the mid-19th century the church and what remained of the priory were in a deplorable state. After a series of restorations we may now enjoy the beauty of London's oldest parish church.

KENSINGTON PALACE

After purchasing Kensington Palace in 1689, William III commissioned Sir Christopher Wren to extend and improve the original Jacobean mansion. Today Kensington Palace contains the offices and London residences of Princess Margaret, Princess Alice, the Duke and Duchess of Gloucester, the Duke and Duchess of Kent and Prince and Princess Michael of Kent. Diana, Princess of Wales, used to live in Kensington Palace, where she also had her offices. Within hours of her tragic death in 1997, the first bunch of flowers was laid at the palace's gates and within days Kensington Palace Gardens were full of bouquets, their perfume hanging heavy in the air.

DIANA, PRINCESS OF WALES MEMORIAL PLAYGROUND, KENSINGTON GARDENS

Opened in June 2000, the Princess of Wales Memorial Playground was the first official public memorial to Princess Diana's memory. The playground is constructed on an earlier recreation ground donated by the author J.M. Barrie. This inspired the playground's main Peter Pan theme. The site is dominated by a fully-rigged pirate ship that is seemingly grounded. Children can explore this, while the beach's cove is a waterplay area. There is also a wigwam camp with totem poles and tepees, a treehouse camp complete with 'tree-phones' and a music and movement garden. The Princess, who loved children, lived at nearby Kensington Palace and often sought refuge in Kensington Gardens.

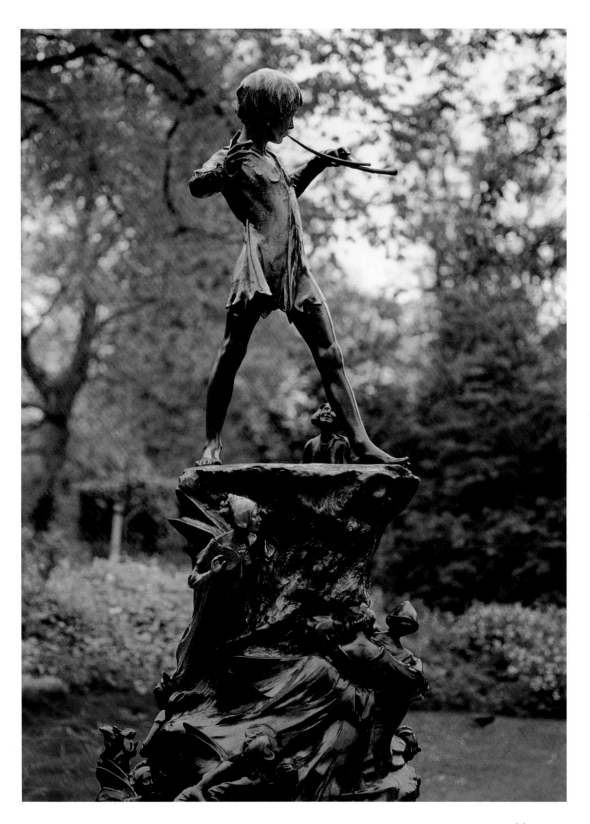

PETER PAN,
KENSINGTON GARDENS

Peter Pan was the boy who never grew up. He is the main character in J.M. Barrie's play which has never ceased to enthral children since it was first performed in 1904. Because of its success, Barrie later adapted it into a book. In 1929 he donated all rights to *Peter Pan* to Great Ormond Street Children's Hospital. In 1987, 50 years after Barrie's death, the copyright expired in accordance with British law. However, in an unprecedented move, the government passed an Act of Parliament restoring the royalty income from all versions of *Peter Pan* to the hospital.

J.M. Barrie, the son of a weaver, was born in the lowlands of Scotland in 1860. Despite the family's modest income, James was educated. At the age of 25 he moved to London to become a writer where he regularly used to walk in Kensington Gardens. It is here that he met the boys of the Llewellyn Davies family with whom he played games of Red Indians and pirates. The story of Peter Pan evolved from the stories he used to tell them and they became the Lost Boys who Peter Pan takes to Never Never Land. Wendy is inspired by Margaret Henley, a young girl whom Barrie adored. She always called him 'Wendy', a pet name for 'friendly'. Margaret died at the age of six and Barrie's use of the name was its debut into the English language.

The statue of Peter Pan and Wendy in Kensington Gardens is by Sir George Frampton and dates from 1912. Peter is featured standing on a tree trunk which is clustered with fairies, mice, rabbits and squirrels.

BERKELEY SQUARE

Max Beerbohm correctly noted Berkeley Square 'has no squareness', for it is indeed rectangular. Although the popular song refers to a nightingale singing here, it has been many years since their sweet melodies have been heard. When the square was laid out in 1730, townhouses were only erected on its east and west sides. The land was originally owned by Lord Berkeley who had a mansion facing Piccadilly. When it was sold in 1696, it was with the proviso that the view should never be spoiled, a condition which was respected for over 200 years. The 30 plane-trees in the centre of the square were planted in 1789.

THE ARK

One of the most striking modern buildings in London is permanently anchored in the busy environment of Hammersmith. Designed by the progressive British architect Ralph Erskine in the late 1980s, it was opened in April 1992. Containing 147,100 square feet (13,666m²) of office space, its interior nevertheless maintains an ambience of intimacy with staggered floors, suspended walkways, terraces and balconies designed around a large central atrium. Comprising nine floors on one side and five on the other, the building has 4500 glass panels. Every 10 weeks, it takes three days to clean the windows from top to bottom. The crow's-nest on the roof gives stunning panoramic views across London.

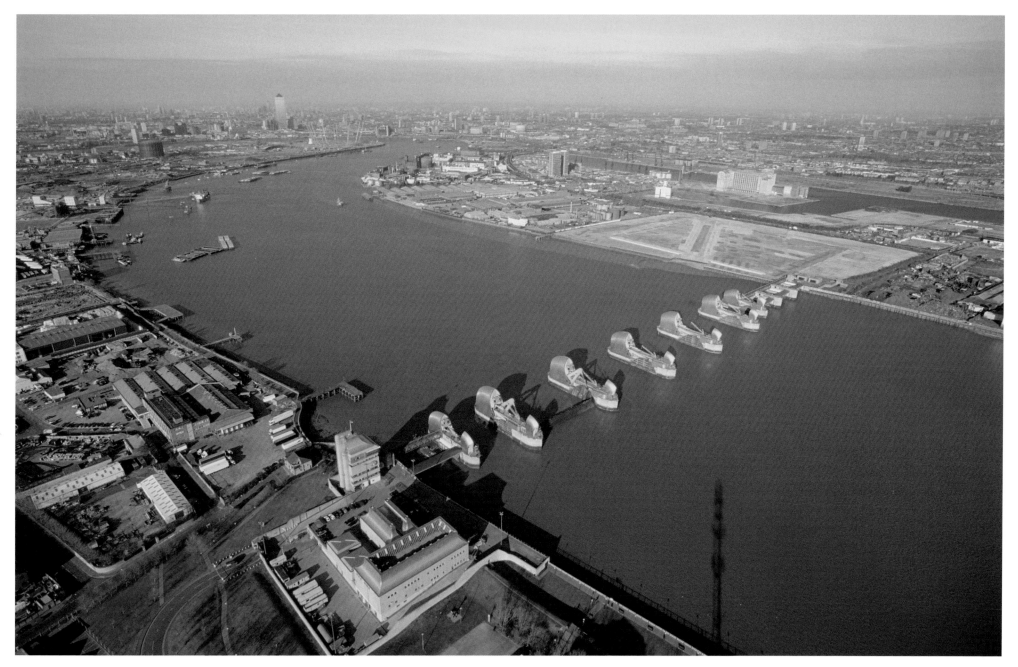

THAMES BARRIER

Central London was last flooded in 1928, and 14 people drowned. Sea levels are rising by 23.6 inches (60cm) a century, there is increasing storminess and greater tidal amplitude, and the southeastern corner of the British Isles is tipping downwards. To prevent another natural disaster, construction began on the Thames Barrier in 1974. It became operational during October 1982. The unique structure spans the 1706-feet (520m) wide Woolwich reach and comprises 10 separate movable gates, each pivoting and supported between concrete piers. When raised, the four main gates each weigh 3700 tonnes and stand as high as a five-storey building. The barrier has been raised as a precaution on many occasions.

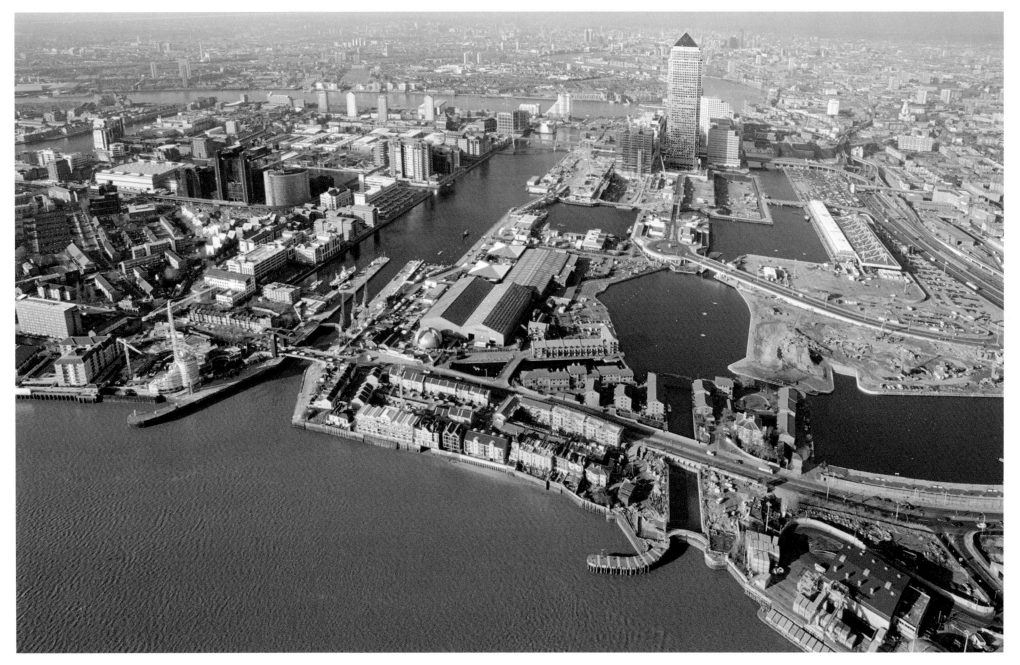

CANARY WHARF, DOCKLANDS

London's docks opened to the east of the City in 1802. Over the years a very busy port developed. However, in the 1960s the advent of containerisation resulted in shipping traffic moving to coastal ports that could handle larger vessels. This left a large expanse of unused land. In 1982 plans were made to regenerate Docklands. Today, Canary Wharf is the heart of the area. By 2004 it comprised 18 office buildings providing 6 million square feet (557,400m²) of office and retail space. A further 8.1 million square feet (752,490m²) is under construction. The Canary Wharf Tower has 50 floors and at 800.5 feet (244m) is Britain's tallest building.

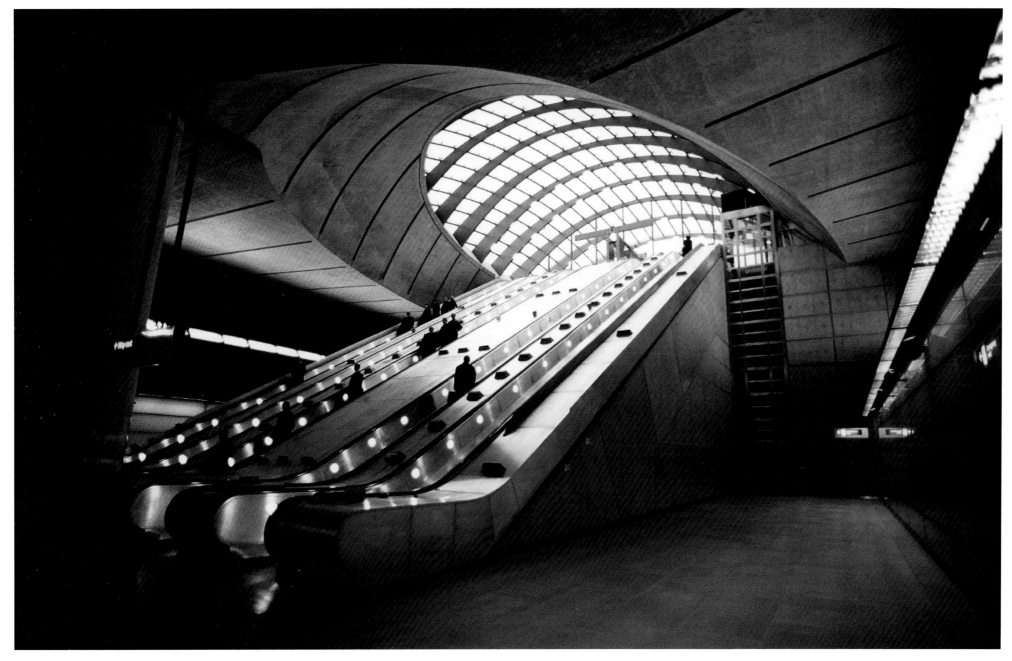

CANARY WHARF UNDERGROUND STATION

Work began in 1993 on extending the Jubilee line east so that it could serve the then up-and-coming Docklands area. It opened in November 1999 and is the only line on the Underground line to connect with all others. Eleven new stations were built, the largest of which is Canary Wharf. Built within the hollow of the former West India Dock, the only visible elements above ground are the glass canopies that cover the station's three entrances. Glowing with light at night, during the day they draw daylight deep into the station concourse. At peak times, more people use this station than any other on the Underground.

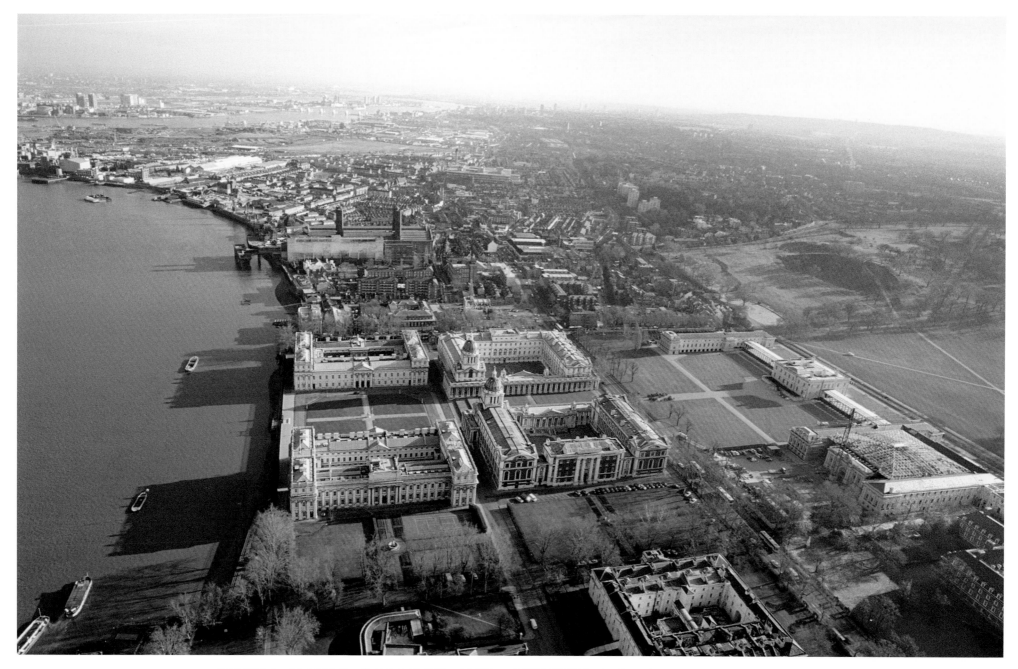

ROYAL NAVAL COLLEGE AND QUEEN'S HOUSE, GREENWICH

The name Greenwich is derived from the Anglo-Saxon 'green port' and with its verdant parkland one can appreciate why. Greenwich is steeped in the history of Britain's naval past. The Greenwich Meridian which passes through the Old Royal Observatory is the standard zero meridian from which the world measures longitude. Greenwich Mean Time is the standard of basic time throughout the world. The Royal Naval College originally designed as a naval hospital by Sir Christopher Wren, together with the Queen's House (now the National Maritime Museum) designed by Sir Inigo Jones, is one of the most impressive groupings of buildings in the whole of London.

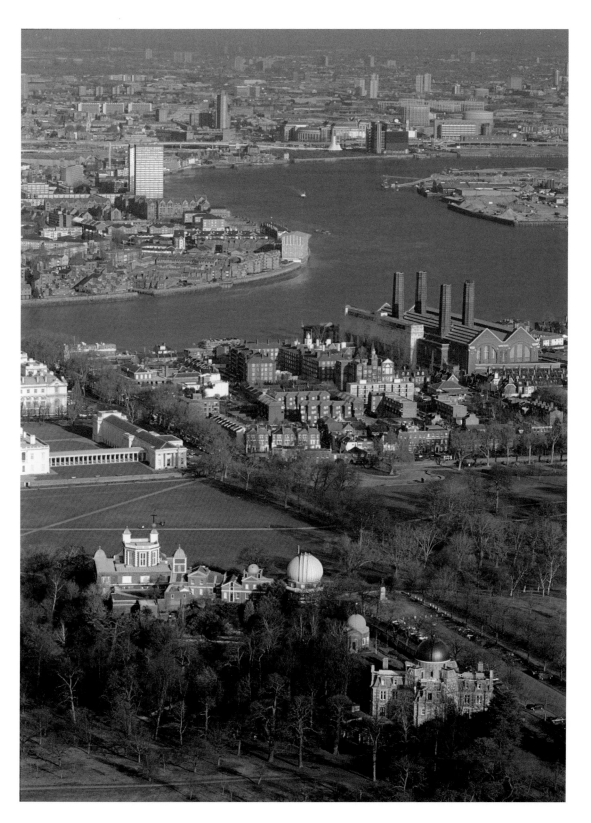

ROYAL OBSERVATORY, GREENWICH

Charles II granted £500, spare bricks from Tilbury Fort and some wood, iron and lead from a gatehouse demolished in the Tower of London to build the Royal Observatory. On the advice of Sir Christopher Wren, a distinguished astronomer and architect, the Reverend John Flamsteed, the first Astronomer Royal, chose Greenwich Hill for the observatory's location.

Some of Flamsteed's successors added buildings to the complex, but all of them added to humankind's knowledge. In 1766, Astronomer Royal Nevil Maskelyne, the fifth to hold the position, reduced all his predecessors' observations to the simple form of the nautical almanac, using Greenwich as the zero meridian. Published every year since 1767, it is still the indispensable handbook for all navigators. Until the almanac became established, each country tended to use its own capital as the zero point from which to measure longitude – that is the dividing line between the earth's eastern and western hemispheres. In 1884 an international conference held in Washington agreed that the meridian passing through the Royal Observatory at Greenwich should be the world's zero or prime meridian. The line is still marked by a brass rail set in the ground.

The red time ball placed on one of the observatory's turrets in 1833 is still dropped every day at 1pm, enabling navigators on the Thames to accurately set their chronometers.

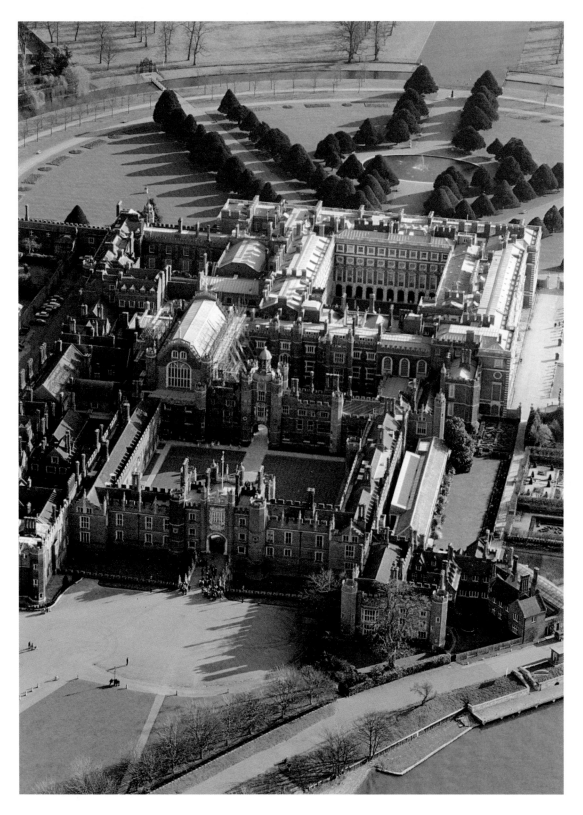

HAMPTON COURT –
ARCHITECTURAL STYLES

Thomas Wolsey, when appointed Cardinal and Lord Chancellor of England in 1515, actioned ambitious plans to turn Hampton Court into a home fit for a man of his status. In 1528, having fallen from favour with Henry VIII, he was forced to relinquish Hampton Court to the King. Henry had even more grandiose plans and added extensively to the palace. In 1689 William of Orange and Queen Mary commissioned Sir Christopher Wren to add a large baroque palace. Consequently, Hampton Court is a kaleidoscope of styles representing more than two centuries of Britain's architectural history.

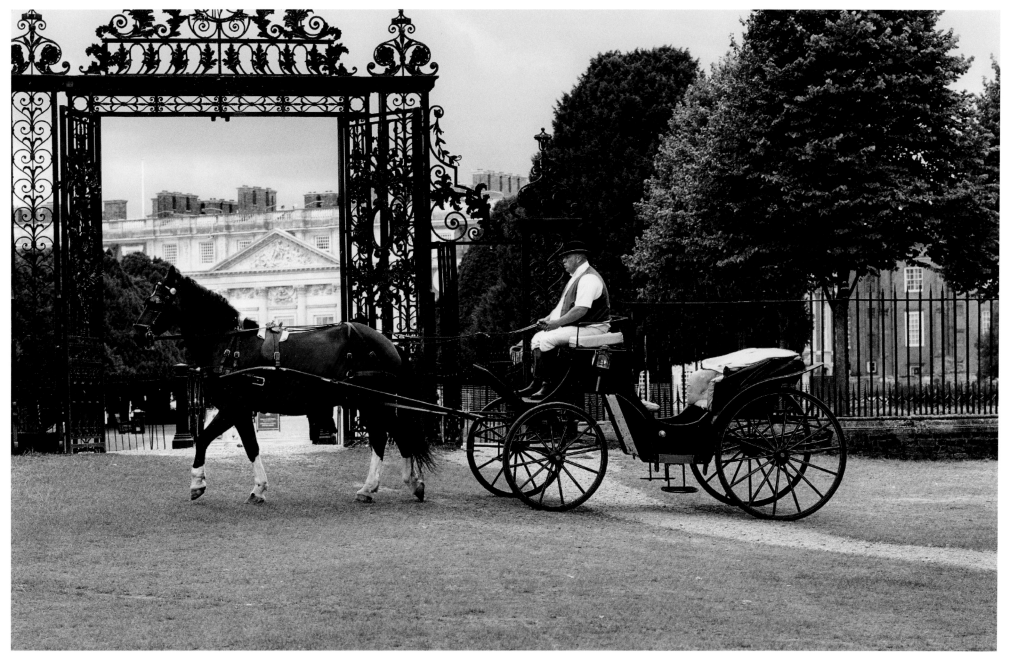

HORSE AND CARRIAGE, HAMPTON COURT

During the summer months visitors to Hampton Court may take a sedate jaunt round some of the palace's stunning grounds by horse-drawn carriage. Hampton Court's Home Park was probably a deer park in the early 16th century. Deer still wander freely there today. An oak tree from the original park still survives and is believed to be over 1000 years old. Seen here is William McWilliam driving his Victoria carriage, which is named after Queen Victoria, into Home Park. The doorless carriage is renowned for its elegance, and has a forward-facing seat for two covered with a folding top.

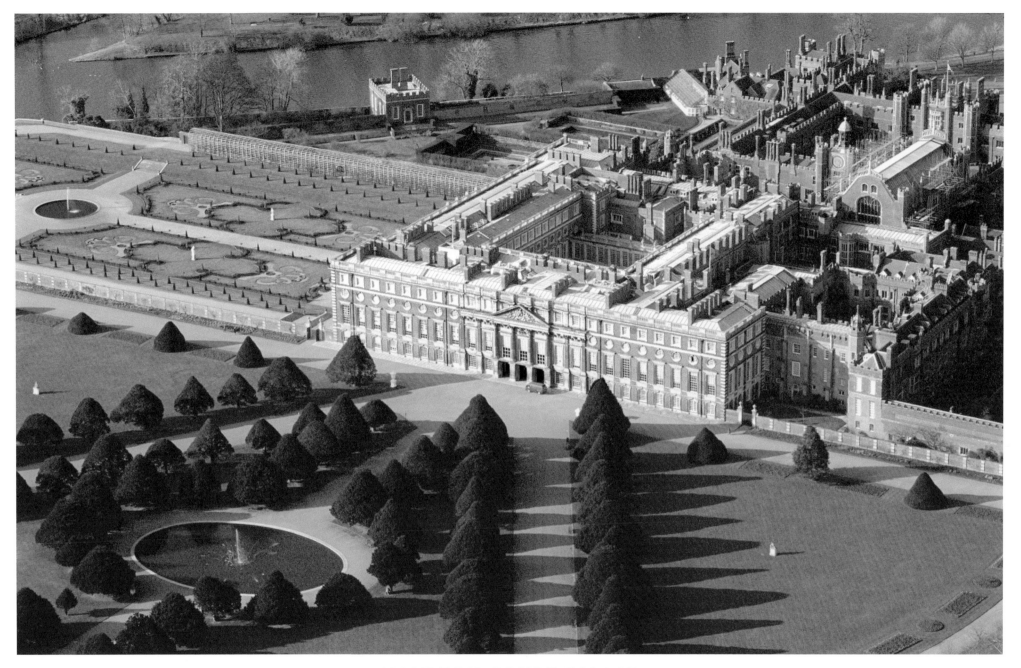

HAMPTON COURT PALACE

During the reign of George III, Hampton Court fell from favour as a royal residence. Indeed, after a small fire in some outbuildings during 1770, the King is reported to have remarked that he 'should not have been sorry if it had burnt down'. Early on Easter Monday 1986, the wing overlooking the river was devastated by a fire which broke out in a top-floor grace-and-favour apartment. Sadly, the occupant died. Thanks to 120 firemen fighting the blaze and the courageous action of the Court's salvage team, only one painting and one piece of furniture was lost. A team of restorers worked for six years to transform the ruin to its original glory.

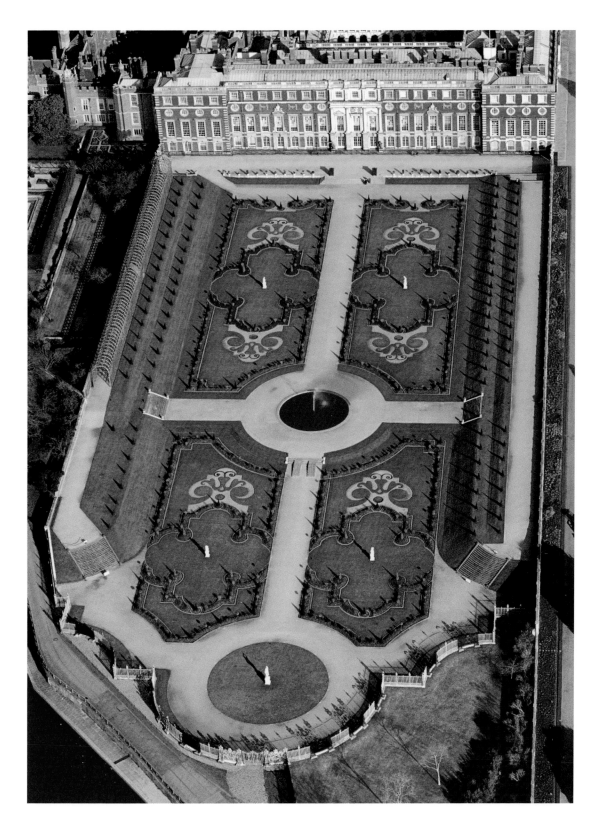

PRIVY GARDENS, HAMPTON COURT

At Hampton Court there are 61.8 acres (25ha) of gardens. The grounds are a kaleidoscope of styles, displaying gardening fashions popular through the centuries. There is a small Knot Garden with box hedging which shows how a 16th-century garden at the Court may have looked. Nearby, the Pond Gardens, now comprising three sunken gardens with impressive flowerbeds, were originally ornamental ponds in which freshwater fish were kept until required in the kitchens.

By the mid-16th century it was customary for royal palaces to have privy gardens in which the sovereign could find privacy and security away from the affairs of state. The first Privy Garden was established at Hampton Court between 1530 and 1538 for Henry VIII. Redesigned by the Stuarts in the first half of the following century, the garden was refashioned again in the baroque style for William III. Completed in 1702, the layout survived with minor alterations until the mid-18th century. By the middle of the next century the garden's layout was completely lost under a spreading canopy of trees, making it an informal and shady haven for visitors, rather than a private retreat for a monarch.

The original design of William III's Privy Garden was revealed in the early 1990s, thanks to a combination of archaeological and historical research. Following four years of careful work, it has now been restored to its original 1702 state featuring both the varieties of flowers and shrubs that grew there three centuries ago.

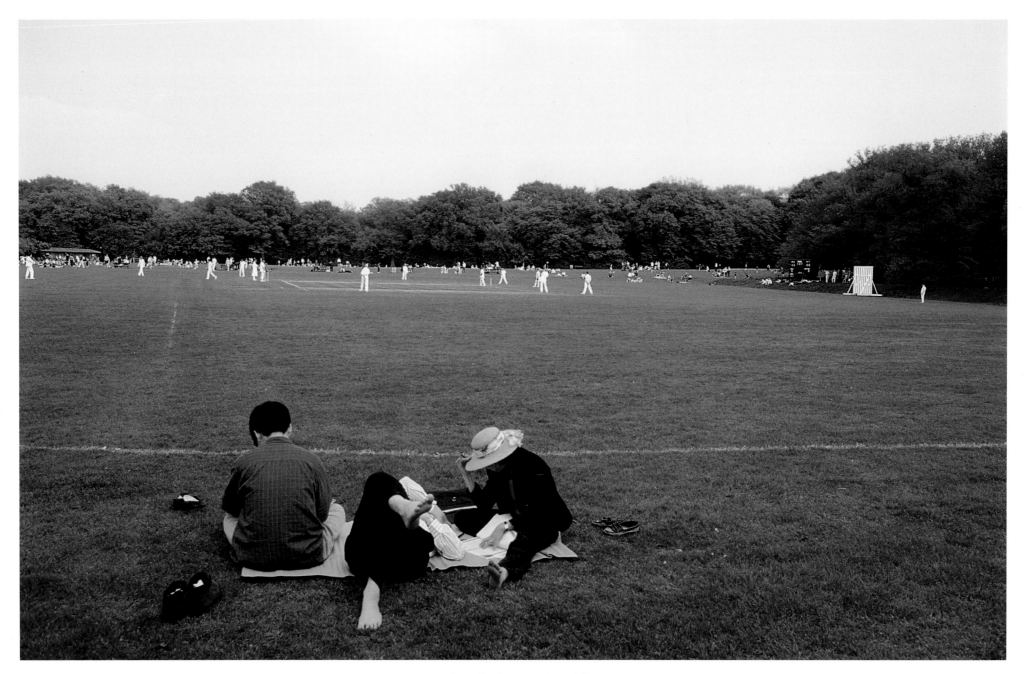

LONDON PARKS

The parks of London are the city's lungs. England's capital is fortunate in having a profusion of green open spaces. At the centre there are Hyde Park, St James's Park, Green Park, Kensington Gardens and Regent's Park, which are all royal parks covering hundreds of acres. They are used for activities ranging from sports to open theatre, from kite flying to cycling as well as being places in which to walk or relax. The suburbs are also blessed with many parks which are favourite areas for exercising dogs. Most have sports areas, children's playgrounds and plenty of park benches for the less energetic.

SPRING FLOWERS

Each spring the common theme of London's flowerbeds is the tulip. The bulbs were first imported into continental Europe from Turkey during the mid-16th century. They were held in the greatest esteem in Holland, where they were traded at absurdly high prices until the bubble burst in 1637. Although Charles I's gardener boasted that he had grown 50 varieties, tulips did not really become popular in England until the reign of William and Mary. They brought bulbs with them from Holland in 1688, together with very tall delftware 'pagoda' tulip vases in which to plant them. To show his loyalty to the Crown, the Duke of Devonshire ordered 42 for his new stately home.

SELECT BIBLIOGRAPHY

Binney, M. 1991. *Palace on the River: Terry Farrell's Redevelopment of Charing Cross*. London: Wordsearch Publishing.

Bradley, S. and Pevsner, N. 1997. *The Building of England London 1 The City of London*. London: Penguin Books.

Brewer, E.C. 1810–1897. *The Dictionary of Phrase and Fable*. Cassel, Petter and Galpin: London.

Brown, U. 1990. *Snuff*. Risborough: Shire Publications Ltd.

Burford, E.J. 1993. *The Bishop's Brothels*. London: Robert Hale.

Burford, E.J. and Wotton, J. 1995. *Private Vices – Public Virtues*. London: Robert Hale.

Davis, D. 1997. *A Guide to Parliament*. London: Penguin/BBC Books.

Eeles, F.C. 1952. *The Coronation Service*. London: A.R. Mowbray & Co. Ltd.

Encyclopaedia Britannica.

Everyman Guides. 1994. *London*. London: David Campbell Publishers.

Field, J. 1996. *Kingdom, Power and Glory*. London: James & James.

Fishlock, M. 1992. *The Great Fire at Hampton Court*. London: Herbert Press.

Girouard, M. 1981. *Alfred Waterhouse and the Natural History Museum*. London: Natural History Museum Publications.

Hobhouse, H. 1975. *A History of Regent Street*. London: Macdonald and Jane's.

Johnson, T. 1995. *The Story of Berry Bros. & Rudd Wine and Spirit Merchants*. London: Berry Bros. & Rudd.

Larwood, J. and Hotten, J.C. 1866. *The History of Signboards*. London: Hotten.

Mackay, J.A. 1970. *Antiques of the Future*. London: Studio Vista.

Mander, R. and Mitchenson, J. 1975. *The Theatres of London*. London: New English Library.

Nash, R. 1980. *Buckingham Palace – The Palace and the People*. London: Book Club Associates.

The Official Guide to the Old Bailey. 1992. London: Corporation of London.

Pitkin London Guide. 1994. *The Royal Mews – Buckingham Palace*. London: Pitkin Pictorials.

Pitkin London Guide. 1995. *The Guards: Changing of the Guard, Trooping the Colour, the Regiments*. London: Pitkin Pictorials.

Robinson, M. R. 1994. *Buckingham Palace – Official Guide*. London: Michael Joseph.

Weinreb, B. and Hibbert, C. (eds). 1995. *The London Encyclopaedia*. London: Macmillan.

Westminster Abbey – Official Guide. 1992. Norwich: Jarrold Publishing.

Winyard, T. 1985. *The Priory Church of St Bartholomew the Great*. London. (Privately printed.)

Wyndham, H. 1948. *This Was the News*. London: Quality Press.

Yonab, M.A. and Shatzman, I. 1976. *Illustrated Encyclopaedia of the Classical World*. Maidenhead: Sampson Low.

INDEX

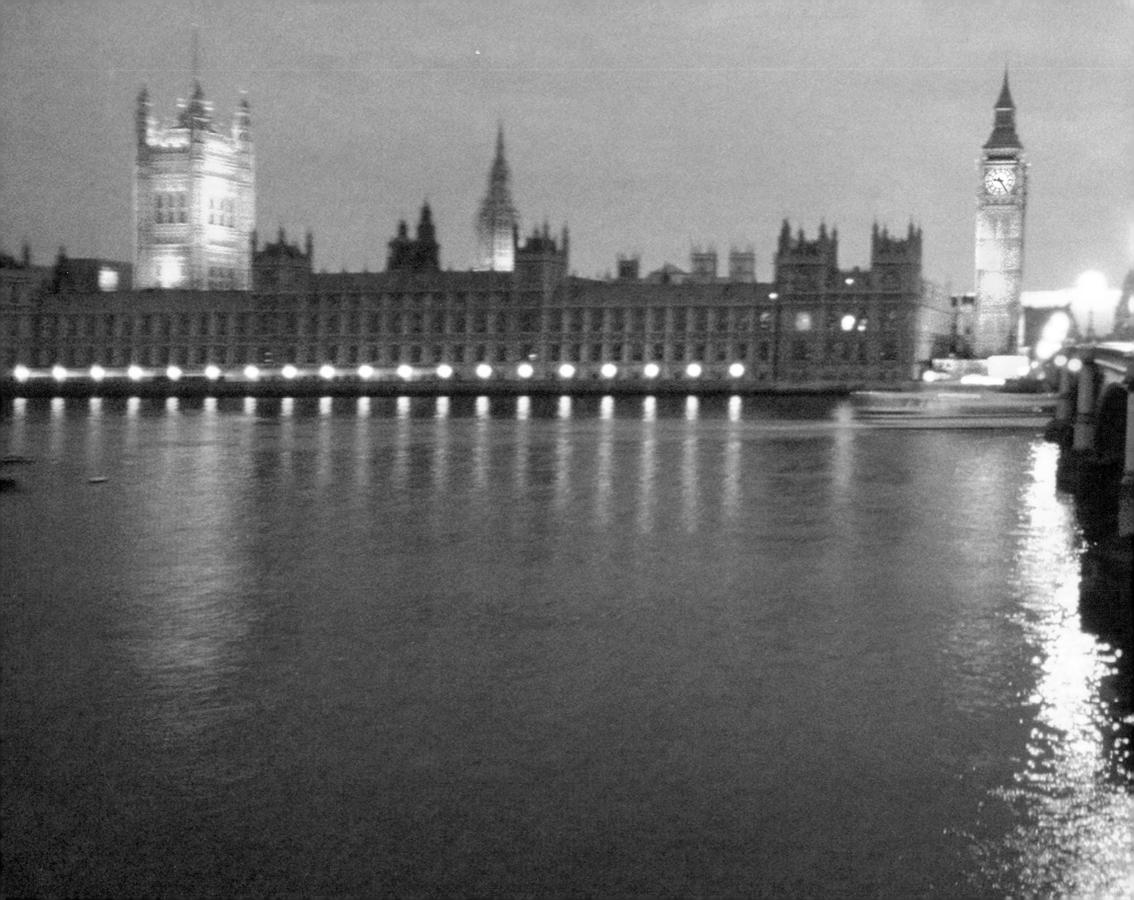